An Introduction to
DIGITAL IMAGING
with Photoshop© 7

An Introduction to
DIGITAL IMAGING
with Photoshop© 7

Philip Krejcarek

THOMSON

DELMAR LEARNING ™

Australia Canada Mexico Singapore Spain United Kingdom United States

THOMSON
TM
DELMAR LEARNING

BUSINESS UNIT DIRECTOR
Alar Elken

EXECUTIVE MARKETING MANAGER
Maura Theriault

CHANNEL MANAGER
Mary Johnson

EXECUTIVE EDITOR
Sandy Clark

EXECUTIVE PRODUCTION MANAGER
Mary Ellen Black

MARKETING COORDINATOR
Sarena Douglas

ACQUISITIONS EDITOR
James Gish

PRODUCTION MANAGER
Larry Main

COVER DESIGN
**Susan Mathews/
Stillwater Studio**

EDITORIAL ASSISTANT
Jaime Wetzel

PRODUCTION EDITOR
Tom Stover

Library of Congress
Cataloging-in-Publication Data
Krejcarek, Philip.
 Introduction to digital imaging with
Photoshop 7 / by Philip Krejcarek.
 p. cm.
Includes index.
 ISBN 0-7668-6323-9
 1. Computer graphics. 2. Adobe
Photoshop. 3. Image processing--Digital
techniques. I. Title.
 T385 .K74 2003
 006.6'869--dc21

2002009173

Contents

Introduction
Approach . XV
Using the Book . XVI
Exercises and Supplemental Material XVI
About the Companion CD-ROM XVII
Acknowledgments . XVII
Dedication . XVIII
About the Author . XVIII

Chapter 1
Introduction to a New Era in Photography

Introduction . 2
What Is Digital Imaging? 6
Some Advantages of an Electronic Image
 over a Conventional Photograph 6
Converting a Conventional Photographic
 Image into an Electronic Image 8
Printing Electronic Images 9

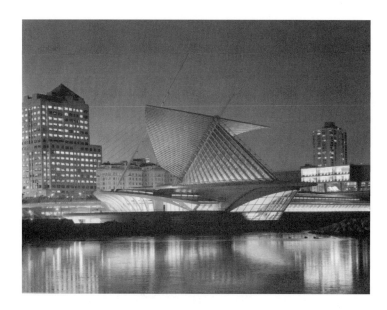

Milwaukee Art Museum (original in color). *Photograph by Willam Lemke*

Digital Imaging Hardware 10
Guidelines for Getting Started
 with Electronic Imaging 11

Chapter 2
Digitizing Images
Digital Cameras . 14
Advantages of Digital Camera
 over Film Cameras 17
Disadvantages of Digital Camera
 over Film Cameras 17
Digital Camera Basics 17
Digitizing Film and Other Images 19
Digitizing Prints: Flatbed Scanning 20
 Scanning Basics . 20
 Advanced Scanning 22
 Scanning Film . 22
Digitizing Resources and Alternatives 23
 Scanning Service Bureaus 23
 CD-ROM . 24
 The Internet . 24
 Kodak Photo CD 24

Chapter 3
Exercises for Getting Started
Introduction . 26
Preliminary Exercises 28
 Launching Photoshop 28
 Resetting Tools . 29
 Opening an Image 29
 Duplicating an Image 30
 Saving an Image 30
The Exercises . 31
 Exercise 3-1: Creating an Electronic Image 32
 Exercise 3-2: Adjusting Contrast 34
 Exercise 3-3: Cropping an Image 36
 Exercise 3-4: Dodging Out and Burning In 38
 Exercise 3-5: Selecting a Rectangular or Elliptical Area 40

Jesus and Georgia (original in color).
Digital image by Philip Krejcarek.

Exercise 3-6: Selecting a Freeform Shape Using the Lasso Tool . 42

Exercise 3-7: Selecting an Area by Color 44

Exercise 3-8: Copying and Pasting 45

Exercise 3-9: Creating Type . 47

Exercise 3-10: Rotating and Flipping 48

Exercise 3-11: Compressing and Expanding 50

Exercise 3-12: Creating a High-contrast Effect 51

Exercise 3-13: Solarization . 52

Exercise 3-14: Double Exposure and Sandwiched Negatives . 53

Exercise 3-15: Toning . 54

Exercise 3-16: Coloring . 54

Exercise 3-17: Removing Color 55

Exercise 3-18: Using the Brush Tool 56

Exercise 3-19: Retouching and Cloning 58

Exercise 3-20: Creating Layers 60

Exercise 3-21: Guides . 61

Exercise 3-22: Contact Sheets 62

Exercise 3-23: The Paint Bucket Tool and Paste Into Command . 63

Exercise 3-24: Creating an Abstract Design with the Gradient Tool 65

Exercise 3-25: Creating an Abstract Design Using the Pen Tool 67

Exercise 3-26: Working with Special Effects Filters 68

Exercise 3-27: Vignetting . 70

Exercise 3-28: Creating Uneven Edges 71

Exercise 3-29: Creating a Short Depth of Field 72

Exercise 3-30: Fading an Image 73

Chapter 4
Overview of Adobe Photoshop Functionality

Introduction . 74

Opening an Image in Adobe Photoshop 74

Adjusting an Image: First Steps 75

 Value Adjustment . 75

 Sharpness Adjustment . 79

 Color Adjustment . 80

Saving an Image . 83
The Toolbox . 84
 Selection Tools . 84
 Tools for Other Functions 93
Menus and Commands 108
 Menus . 108
 Basic Menu Commands 109
Modes . 117
Palettes . 118
 Layers Palette . 118
 Channels . 121
 Other Palettes . 122
Correcting Mistakes . 123
 Undo Command . 123
 Step Backwards Command 123
 History Palette . 123
 History Brush . 124
 Revert . 124
Managing Files . 125
 Save and Save As Commands 125
 About File Formats . 125
 Storing Images . 127

Midsummer's Night Dream
(original in color). *Digital image
by Brooks Boyd.*

Chapter 5
Electronic Printing

Types of Prints Made from the Computer 128
Printing from the Computer 132

Chapter 6
Assignments for Developing Creativity

Assignments Using
 Traditional and Digital Cameras 134
 Assignment 6-1: Two People in a Relationship 135
 Assignment 6-2: Asymmetrical Balance 137
 Assignment 6-3A: Light as the Subject 139
 Assignment 6-3B: Painting with Light 141
 Assignment 6-4A: Short Depth of Field 143
 Assignment 6-4B: Long Depth of Field 144
 Assignment 6-5: Portrait 146
 Assignment 6-6: Self-portrait 148
 Assignment 6-7A: Blurred Motion 150
 Assignment 6-7B: Panning 152
 Assignment 6-7C: Stop Action 153
 Assignment 6-8: Artificial Light 155
 Assignment 6-9: Famous Photographer 157
 Assignment 6-10: Macro, Larger Than Life 159

Student image by Caitlin Steelman (original in color).

Assignment 6-11: Documentary/
Performance Photography 160
Assignments Using Electronic Imaging 163
Assignment 6-12: Gulliver's Travels 163
Assignment 6-13: Words and Images 165
Assignment 6-14: Pop Art Portrait 167
Assignment 6-15: Genealogy . 170
Assignment 6-16: Toning,
Hand-Coloring, and Gradients 173
Assignment 6-17: Colors of Autumn/Spring 175
Assignment 6-18: Photogram 178
Assignment 6-19: Tabloid . 181
Assignment 6-20: Cartooning 184
Assignment 6-21: Absolut Photoshop 187
Assignment 6-22: Campus of the Future 188
Assignment 6-23: Mixed Media 190

Chapter 7
Composition and Aesthetics
Composition: The Tradition 192
Elements of Design . 192
Principles of Design . 198
Balance . 199
Harmony . 200
Dominance . 200
Variety . 202
Space . 203
Movement . 204
Proportion . 204
Economy . 205
Craftsmanship . 206
Asymmetrical Balance . 206
The Rule of Thirds . 206
Asymmetry: A Starting Point 208
The Fine Print Aesthetic of Edward Weston . . . 208
Henri Cartier-Bresson's Decisive Moment 210
The Cartier-Bresson Approach 210
Exploring the Intuitive Approach 211
Going Beyond the Rules with Diane Arbus 211

Chapter 8
Legal and Ethical Considerations of Image Making

Who and What Can Be Photographed? 214
 The Legal Picture . 214
 The Ethical Picture . 216
When Is Consent Necessary In Photographing? 217
 The Legal Picture . 217
 The Ethical Picture . 217
What Is Copyright? . 218
 Copyright as Ownership 219
 Copyright Notice . 219
 Fair Use . 220
 The Legal Picture . 221
 The Ethical Picture . 222
 Copyright-free Images 223

Chapter 9
Electronic Imaging: Careers

Commercial Arts . 224
Commercial Photography 226
Commercial Illustration, Layout, and Design . . . 229
Prepress . 229

***Bad Day, Number 1.** Student Image by Jason Gosa.*

Fine Art Photography . 229
Photojournalism . 230

Chapter 10
**Developing Creativity and a
Philosophy of Photographic Image Making**

The Tools of Creativity . 232
A Philosophy of Photography 235
Questions Toward a Philosophy 236

Chapter 11
Special Image Effects in Adobe Photoshop

Filters . 240
 Artistic, Brush Stroke, and Sketch 242
 Blur . 244
 Distort . 244
 Noise . 245
 Pixelate . 246
 Render . 246
 Stylize . 248
 Texture . 248

*Bad Day, Number 3. Student Image
by Jason Gosa.*

Other Effects . 248
Blending Modes 248
Layer Styles 250
Liquify . 252
Pattern Maker 253
Brush Commands 253
Define Brush 254
Brush Palettes 255
Curves Command 256
Digital Panorama 257
Digital Negatives 258
Web Tools . 258
ImageReady 258
Slice . 259

Chapter 12
Exercises for Developing Skills and Creativity

Exercise 12-1: Photomontage . 260
Exercise 12-2: Perspective Type 262
Exercise 12-3: "Attitude" Poster 264
Exercise 12-4: "Wish You Were Here" Postcard 266
Exercise 12-5: Translucent Type over an Image 268
Exercise 12-6: Mirrored Image 269
Exercise 12-7: Patterns . 270
Exercise 12-8: Textures . 272
Exercise 12-9: "Halo" Around a Shape 272
Exercise 12-10: Television Screen with Glow 273
Exercise 12-11: Faded Arrows 274
Exercise 12-12: Sphere with Shadow 275
Exercise 12-13: Cone with Shadow 277
Exercise 12-14: Cube with Shadow 278
Exercise 12-15: Cartoon Landscape 280
Exercise 12-16: Perspective Room Cartoon 282
Exercise 12-17: Cartoon Character 283

Chain of Life (original in color).
Digital image by Lane Last.

Appendix A
Resources
Traditional/Digital Photographic Materials 284
 Film, Chemicals, and Paper 284
 Cameras, Darkroom,
 Digital Printers, and Supplies 285
Electronic Imaging Materials and Services 286
 Ink-Jet Printer Supplies 286
 Printing Services . 286
 Photo CD . 286
Software and Documentation 287
 Software . 287
 Book Publishers . 287
 Periodicals . 287
Photography Organizations and Libraries 288
 Organizations . 288
 Internet Resource Guides 288

Appendix B
Basic Photoshop Keyboard Shortcuts 289

Appendix C
Recommended Reading 290

Appendix D
Glossary . 291

Appendix E
Index . 293

Introduction

This book is an introduction to the world of digital imaging through the use of Adobe Photoshop. It is designed for artists, photographers, and graphic designers who want to develop their creative skills through the use of the computer. Rather than taking a technical approach to digital imaging, the intent is to address the computer as another tool at the disposal of the artist.

Approach

There are no prerequisites for using this book. It is not a computer or software instruction manual, but a user-friendly guide for those getting started with digital image making. The computer should not change one's philosophy or approach to making art. It should simply broaden one's options and possibilities. As with the introduction of technologies that have confronted artists in the past, artists in the computer realm today should think of themselves as "pioneers" on the forefront of a new medium of expression.

Imagination is more important than knowledge.

—Albert Einstein

> ✎ NOTE: When using this book either a Macintosh or PC computer may be used. Although all of the instructions are written for Photoshop 7, the steps are very similar under Photoshop 6. In certain instances, the locations of commands have changed in the newer software.

The Last Step (original in color).
Digital image by Gerald Guthrie.

It should also be noted that this is an introduction to digital imaging, with an emphasis on the creative process. Explanation of technical detail ("how to") is therefore presented at a level appropriate to the goals of the book. For example, Photoshop's most commonly used commands are dealt with in some detail. Readers who want to explore software functionality and scope in depth are encouraged to seek out the sources cited in the "Recommended Reading" section at the back of the book. In addition, reference is made throughout to other sources.

Threshold. Photograph by Jerry Uelsmann

Using the Book

Rather than reading the chapters in chronological order, the best way to get started using this book is with the exercises in Chapter 3. Then, proceed to Chapter 4 for a more thorough understanding of the Photoshop software. Special techniques are explained in Chapter 11, and additional exercises are given in Chapter 12. Assignments for developing creativity are available in Chapter 6. The first set of assignments emphasizes the use of a camera, whereas the second set concentrates on the use of the computer.

The exercises and assignments will stimulate creativity and develop imagination without overwhelming you with technical information. Your objective should be to assimilate computer skill in the process of being creative. The process of creating and learning should be stimulating rather than draining. The approach of this book is to keep you thinking, not memorizing technical steps at the cost of losing sight of the larger picture of the creative process.

Exercises and Supplemental Material

The exercises are also meant to be practical and to involve you in activities that would be encountered in the real world of photography and graphics design. Whether they are relatively "straight" digital photography or highly manipulated images, the illustrations in this book have been selected for their artistic merit. One of the best ways to become creative is to be exposed to creative images. This book includes an insert of color images, as well as a companion CD-ROM at the back of the book. (See "About the Companion CD-ROM.")

Appendix A is a resource of digital supplies, organizations, and artists. Web sites are included in appendix A for easy access to information and images. There is also a companion teacher's manual available, which includes additional assignments and tips for teaching digital imaging.

About the Companion CD-ROM

The CD-ROM contains material from the portfolios of professional artists, as well as student examples (from assignments), both of which supplement images presented in the book. The CD-ROM also includes a gallery of stock photography images that could be utilized when undertaking the assignments.

Acknowledgments

Grateful acknowledgment is made to all of the image-makers who contributed to this work. Student photographers from Carroll College in Waukesha, Wisconsin, provided many of the images associated with the assignments. Special thanks goes to Richard O'Farrell, Professor Emeritus from Carroll College, who spent endless hours testing the exercises and reviewing the text. He also contributed images for illustrations.

Dedication

To Kristine Gunther, for her unending support and love.

About the Author

Philip Krejcarek is a professor of art and co-chairman of the Art Department at Carroll College, Waukesha, Wisconsin. He has taught there since 1977. Prior to that he was a high school art teacher for nine years. He is the author of *Digital Photography: A Hands-On Introduction*, published by Thomson Learning. He has taught courses in photography and electronic imaging, as well as art history, drawing, sculpture, and ceramics.

Cycladic Venus (original in color).
Digital image by Joan Harrison.

An Introduction to

DIGITAL IMAGING

with Photoshop© 7

Introduction to a New Era in Photography

You put your camera around your neck in the morning along with putting on yours shoes, and there it is, an appendage of the body that shares your life with you. The camera is an instrument that teaches people how to see without a camera.

—Dorothea Lange (1895–1965), photographer during the Great Depression

Introduction

In the fast-changing world of image making, the student of photography needs to prepare for not only a traditional understanding of the medium, but a technological one as well. This book is intended as an introduction to digital photography as a means of electronic image making.

For now, many photographers will continue to use film with conventional cameras. They may prefer the look that film printed on traditional photographic paper produces. Currently, the cost of traditional cameras remains much lower than comparably equipped digital cameras. Because of the demands of the industry, however, an increasing number of commercial photographers will convert to use digital cameras in the coming years.

As a means of manipulating an image and preparing it for commercial printing, the computer has rapidly become the tool of choice for many professional image makers. Commercial photographers now depend on computers for retouching, separating, creatively manipulating, and delivering images. Two reasons they have incorporated electronic imaging into their craft are that it permits them to work faster and more efficiently, and it has opened up new doors for crafting images that would be difficult—if not impossible—to create using traditional methods.

Figure 1-1 *These Sets Are Guaranteed* (original in color). Televisions and baby dolls were combined in this set construction. *Photograph by Philip Krejcarek.*

With the quality and permanence of the digital image approaching (and sometimes surpassing) that of traditional film media, photographers have fewer and fewer reasons *not* to include electronic methods in their arsenal of image making tools. As the chapter-opening quote suggests, the primary purpose of this text is to help photographers harness the digital tools at their disposal as a way to encourage visual thinking. The image maker should always learn to relate to the medium used—be it the camera, the darkroom, or the computer—to advance creative discovery. The intent of this book is to introduce digital photography directly and concisely, so that the computer novice does not become overwhelmed by the complexities of the technology. In short, it will help photographers develop skills in using the computer to enhance and manipulate images effectively. Many of the electronic techniques you will learn are similar to processes used in the darkroom.

This book also addresses the ethics involved in both traditional and digital photography. It raises questions concerning the responsibilities of the photographer and examines issues involving copyright law and the notion of "fair use."

To highlight what is possible when using the computer to create images, Chapter 3 presents 30 exercises for the student of electronic imaging to perform. You should undertake the first 20 exercises before reading about Adobe Photoshop 7 in Chapter 4. Chapter 12 provides an additional 17 exercises that are more advanced to help photographers further develop their "visual thinking" skills.

The 23 assignments presented in Chapter 6 are intended to stimulate creativity. You can undertake the first 11 assignments using either traditional film-and-darkroom techniques or a digital camera. The last 12 assignments, however, expressly involve the computer and electronic imaging tech-

Figure 1-2 Jerry N. Uelsmann's photograph was "constructed" in the darkroom from multiple negatives.

niques. You can complete the traditional-media assignments using either color or black-and-white film. Similarly, you can complete the digital assignments in either RGB (color) or grayscale mode.

Throughout this book you will find references to historical and contemporary photographers. Learn from the masters and be inspired by them.

I came to photography with the desire to conquer this machine, the camera, and make it my slave. Instead, I have now a respect for it and all machines as expanders of my awareness.

— Todd Walker (1917–1998), contemporary fine art photographer

What Is Digital Imaging?

A digital, or electronic, image is one that has been produced with a computer. The machine takes a visual image and translates it into a series of mathematical values, or **bits** of information. This image can be acquired via digital camera or by scanning any two-dimensional image, such as a photograph, a printed page, or any other type of picture. Indeed, even a three-dimensional object can be placed on a scanner and its surface captured. The scanner then digitizes the image and displays it electronically on the monitor.

Some Advantages of an Electronic Image over a Conventional Photograph

An electronic image can be:

- Quickly corrected, manipulated, or enhanced without destroying the original image;
- Sent by modem from one place to another, safely and instantly;
- Copied an unlimited number of times without losing detail or resolution;
- Printed without exposure to chemicals;
- Stored almost indefinitely, with little risk of deterioration.

Figure 1-3 *Storm Over Baraboo* (original in color). *Digital image by Karen Thompson.*

Figure 1-4 *Southern Gothic* (original in color). *Digital image by Maggie Taylor.*

No photographer should be blamed when, instead of capturing reality, he tries to show things he has seen only in his imagination. Photography is the youngest art form. All attempts to enlarge its frontier are important and should be encouraged.

—Philippe Halsman (1906–1979), <u>Life</u> magazine photographer

Converting a Conventional Photographic Image into an Electronic Image

The method for translating prints, negatives, or transparency film into digitized images is called **input.** The hardware typically used to perform this task is called a **scanner.** Flatbed and drum scanners can digitize prints or negatives; film and drum scanner can digitize negatives or transparencies. Although drum scanners are able to output to extremely high resolution, they are much more expensive to own and maintain than flatbed or film scanners. Some photographers prefer to send their pictures out to service bureaus, which can scan images professionally on high-end equipment and then provide a digitized file on disk.

Figure 1-5 Untitled (original in color). *Digital image by Julianne Kost.*

At the time of scanning, the photographer must choose a resolution for the image, usually measured in dots-per-inch, or **dpi.** The resolution is primarily determined by the size of the photograph and how the image will eventually be used. If the image is to be reproduced in a newspaper in a small format, the resolution can be lower than for a fine art print to be produced at a large size.

It is important to reproduce the original image faithfully in digital form. Enough information must be captured at the time of scanning to preserve a level of detail and range of tone and color equal to that of a traditional print.

Printing Electronic Images

There are a number of methods and types of hardware used to output electronic images, including these three categories of printers:

- *Laser printers,* which use dry toner
- *Ink-jet printers,* which spray ink onto the page
- *Light-jet printers,* which expose light-sensitive paper to a laser

Most such printers can print black-and-white as well as color images. Each is capable of outputting to a range of resolutions, from 72 dpi to thousands of dots per inch. A few can even produce continuous-tone images that are all but indistinguishable from traditional photographs. Because of the cost of high-quality electronic printers, some photographers prefer to use service bureaus to make their prints.

Digital Imaging Hardware

The following are some of the components typically used in the digital imaging process.

- A **computer** with sufficient random-access memory (**RAM**) to handle the steep memory requirements of processing large, high-resolution digital images. A minimum of 128 megabytes of RAM is recommended when using Adobe PhotoShop 6. The more RAM a computer has, the faster it can perform memory-intensive tasks.

- A **scanner** for acquiring images. Alternatively, you can use a digital camera or service bureau to digitize images.

- An electronic **storage** medium, such as the computer's hard drive, as well as removable media such as ZIP disks or rewritable CDs.

Figure 1-6 Untitled (original in color). *Digital image by Julianne Kost.*

- A **printer** for producing hard copies of digitally created images. Again, a service bureau can provide printed output if you do not have access to this kind of hardware.

Guidelines for Getting Started with Electronic Imaging

Keep the following points in mind as you begin exploring the digital imaging process.

1. *Anything that can be done on a computer can be done by hand.* The main advantages of using a computer are that certain tasks can be accomplished much faster, and the images produced can be stored more permanently and then recreated more easily.

Figure 1-7 Untitled (original in color). *Digital image by Julianne Kost.*

2. *In the beginning, everything will take longer than expected.* Computer education gobbles up hours of time.

3. *For "right brain" thinkers, learning the ins-and-outs of the computer may well cause stress and anxiety.* Don't despair! With time and patience, you will reach a threshold of comfort that can only come with familiarity.

4. *It is natural to become dazzled by the "gimmicks" of electronic imaging.* It will take time before you are actually "creating art."

5. *Be aware that if you use images outside the classroom, you may be violating copyright laws.* Reproducing and

Figure 1-8 *Strength in Numbers* (original in color). *Digital image by Gerald Guthrie.*

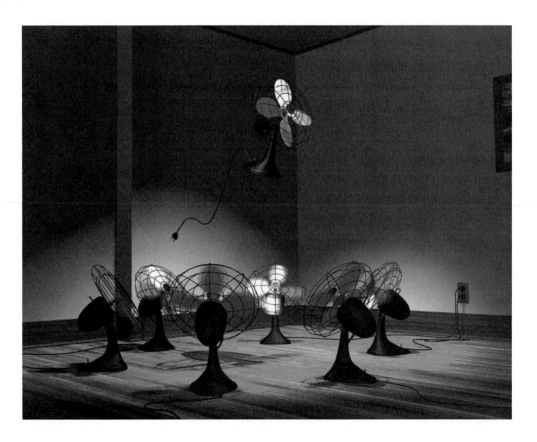

altering proprietary images in a school setting is viewed differently than it would be otherwise. Because students are exploring image making in an educational forum, there should be no problem unless they distribute, publish, or sell another's work as their own. In that case, students should acquire written permission from the owner of the copyright.

6. *As with any art medium, it is important to ask, "What is the nature of this material?"* What can this medium do best that cannot be done as easily with any other material?

7. *The knowledge you acquire in electronic imaging is probably going to be the most marketable of any of the skills developed as an art student.*

Figure 1-9 *Goddess of the Lettuce* (original in color). *Digital image by Philip Krejcarek.*

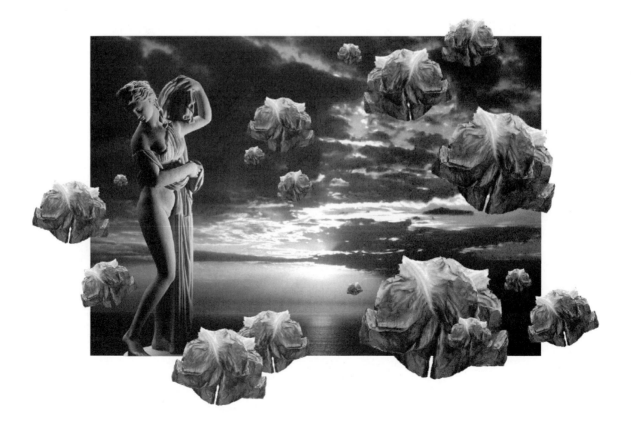

Digitizing Images

For me it is a constant source of wonder that the world becomes transformed through the finder of my camera.

—Beaumont Newhall (1908–1993), fine art photographer and author

Digital Cameras

There is an increasing variety of electronic cameras and camera backs capable of digitizing the image projected onto the "film plane." These cameras record the image without the use of film, converting the light into a series of electronic "picture elements," or **pixels**. These cameras store the information either in the memory of the camera or on removable media, such as flash cards, memory sticks, and microdrives. The cost

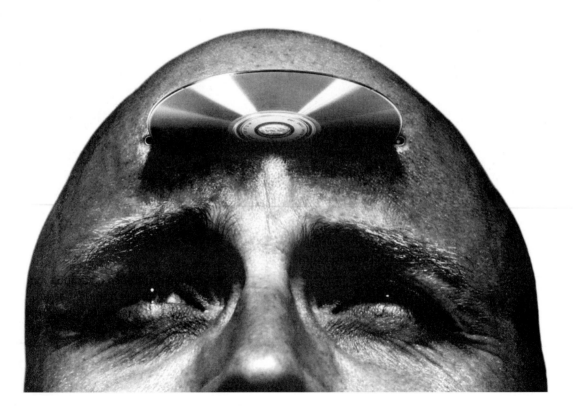

Figure 2-1 *CD Head* (original in color). *Digital image by Steve Puetzer.*

of "filmless" cameras still tends to be significantly greater than that of their counterparts in traditional photography; but the difference in price continues to narrow.

The new electronic cameras are available in a variety of formats and offer a wide range quality. The low-end cameras are similar to traditional "point-and-shoot" cameras, with a fixed focus and automatic exposure. The camera can be set for

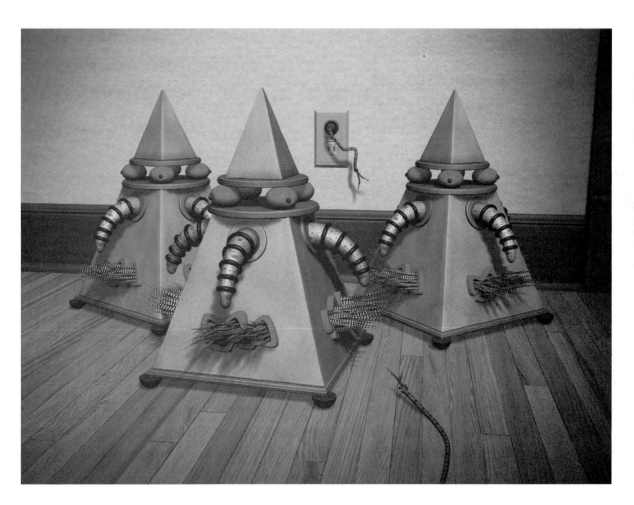

Figure 2-2 *Fear of the Unknown* (original in color). *Digital image by Gerald Guthrie.*

lower resolution with more exposures, or higher resolution with fewer exposures. Even at the higher resolution, the sharpness does not compare well with that of comparable film cameras.

Higher resolutions and quality are available with 35 mm-sized cameras that employ **digital capture screens** (DCSs). These cameras are capable of variable focus and exposure. Because of their higher resolution, such cameras require longer exposures than their traditional counterparts in similar lighting situations. However, aside from that restriction, the technology allows shutter speeds of up to 1/16,000.

Also available are film back-style digital recording screens that fit onto large-format cameras. These are available in medium formats such as 6 × 6 cm and 6 × 7 cm, as well as in view camera sizes of 4 × 5 inches and 8 × 10 inches. As with other digital technologies, the cost of these devices continues to decrease as quality increases.

Digital cameras offer three major advantages over traditional photography: time savings, conservation of natural resources, and safety from chemical exposure. First, images recorded on digital cameras can be transmitted directly into the computer. There is no film to be processed or negatives to be scanned. When time is an issue, such as in newspaper and commercial photography, digital cameras can shorten the time between shooting the assignment to going to press. Second, digital cameras do not consume film or chemicals. The electrical energy used in digital photography is small compared to the materials expended in shooting and chemically processing film. Moreover, the information storage medium of the camera can be used over and over; and images stored in the camera can be previewed directly, so that photographs that are incorrectly exposed, badly

focused, or poorly composed can be deleted immediately. Finally, a photographic process that is completely digital does not expose the user to the chemicals typically found in a darkroom.

Advantages of Digital Camera over Film Cameras

- *Speed:* Images recorded by the camera can be transmitted directly into the computer without processing.
- *Conservation:* Film and chemicals are not expended.
- *Safety:* There is no exposure to processing chemicals.

Disadvantages of Digital Camera over Film Cameras

- *Expense:* These cameras cost much more than comparable traditional cameras, and repair costs tend to be higher.
- *Image quality:* Only high-end digital cameras, with their superior resolution, can begin to compare with the quality of film.
- *Shutter speed:* Higher resolution demands slower shutter speeds.

Digital Camera Basics

Digital cameras vary in complexity, from low-resolution "point-and-shoot" models to those with adjustable exposure, focus, and resolution (ISO). Some digital cameras have exposure modes, including "program," "aperture priority," "shutter speed priority," and "manual." The most sophisticated digital cameras are capable of utilizing interchangeable lenses.

Although the specific directions for using digital cameras vary from one type to the next, most will name their functions in ways that are comparable to those of traditional cameras. The following functions can be selected on many types of digital cameras.

- Exposure mode

- Auto or manual focus

- ISO equivalence and image size (rendered in pixels)

Figure 2-3 *Persephone* (original in color). *Digital image by Patricia Goodan.*

- Light balance for color
- Self-timer, multiple exposures, and bracketing exposures
- Auto flash or synchronization with auxiliary flash units

Digitizing Film and Other Images

Despite rapid advancements in digital camera technology, the many photographers still prefer to record images using conventional photographic film rather than digital media. Instead of making darkroom prints, however, many of these same photographers are scanning negatives and transparencies and using electronic media for printing. The sections that follow discuss issues involved in image scanning.

As with every art, in photography the most important thing is that we feel fully what we are doing.

—André Kertész (1894–1985)

Figure 2-4 *Izzy Clouds* (original in color). *Digital image by Karen Thompson.*

Digitizing Prints: Flatbed Scanning

Flatbed scanners are ideal for digitizing two-dimensional photographic prints and flat art. This type of scanner functions very much like a copy machine. The image is placed face down onto a glass surface; the scanner then "reads" it and sends the image data to the computer for processing and display. The scanner retains sharpness for a short distance from the surface of the glass, so you can also use the equipment to scan 3D objects (see Assignment 6-18, Photogram, in Chapter 6).

Scanning Basics

The specific directions for using a flatbed scanner vary from one brand to another. However, this process involves the following basic steps.

1. Turn on the scanner.

2. Position the image to be scanned face down on the object glass.

3. Launch Adobe Photoshop. From the File menu, select Import, and then select the name of your scanner. In the Scanner dialog box, click on Prescan (or Preview) to initiate a preliminary scan.

4. Click and drag on the prescanned image to select the area to be scanned.

5. Establish the following settings.

 ✗ Color mode—RGB or Grayscale

 ✗ Output size of the scanned image

 ✗ Resolution

 ✗ Image adjustments—color balance, contrast, and sharpness

Figure 2-5 *Lettuce Dance. Digital image by Philip Krejcarek.*

6. Click on Scan.

7. The scanned image will be displayed in a new window in Photoshop. Select Save from the File menu, choose an image format and file location in the dialog box, and click on OK.

Advanced Scanning

To get the best quality in your scans, keep the following recommendations in mind.

- Always scan in RGB, even if the image is black and white.

- If possible, always scan at 36-bit color (rather than 24-bit). However, after the scan is completed, immediately change the bit depth of the image. To do so, select Mode > 8 Bits/Channel from the Image menu. Otherwise, you won't be able to perform many Photoshop functions.

- Scan at a minimum resolution of 300 dpi, with the image size at approximately the size of the final output. The important thing is to capture enough data (i.e., *pixels*) to produce a clear, detailed image. For example, if the image to be scanned is 4 × 5 inches and the final output is going to be 8 × 10 inches, scan with a resolution of 300 dpi at 200% image size. (Alternatively, you can scan with a resolution of 600 dpi at 100% image size, which would yield exactly the same number of pixels.)

Scanning Film

Negatives, slides, and transparencies can also be scanned. Some flatbed scanners have special adapters built into the cover for holding such media, so that light is projected through the film to illuminate it while it is being scanned. There are also scanners designed exclusively for capturing images from transparent media. The procedures involved in scanning those types of media are similar to those of flatbed scanning. The main difference is that smaller-format films, such as 35-mm, usually need to be scaled to a much larger image size.

Digitizing Resources and Alternatives

Scanning Service Bureaus

When scanning hardware is not available, conventional images can be sent to a service bureau to be scanned. You do not have control over the entire process, but you can specify the resolution and the format of the scanned files. Many service bureaus use expensive drum scanners, which are recommended if you require very high-quality images.

The older I get, the one thing I can trust in myself more than anything else is the way I feel about something. When I photograph I try to be as aware of my feelings as I can be to somehow try and get them out of me and onto the film in terms of the way I am responding or seeing the world.

—Judy Dater (born 1941)

Figure 2-6　***Relics of the order*** (original in color). *Digital image by J. Seeley.*

CD-ROM

A staggering number of photographic images are available for purchase through stock photography agencies. Images sold on CD-ROM are usually "copyright free." Typically, these images bear some type of notice as to restrictions of use, but the presence of such a notice is not required for a copyright to be enforceable.

The Internet

You can find many photographic images, for free and for purchase, on a wide variety of Web sites. These can be downloaded onto a computer and then opened in Photoshop.

NOTE: When using someone else's images, always be aware of your responsibilities under the laws governing copyright (see Chapter 8).

Kodak Photo CD

Kodak has developed a proprietary technique for scanning film and storing the images permanently on a CD. Up to 100 images can be stored on a single disk, at five different scan sizes (from 128 \times 192 pixels to 2,048 \times 3,072 pixels), suitable for a wide variety of low-end and high-end uses.

Figure 2-7 *Student image by Caitlin Steelman* (original in color).

Exercises for Getting Started

Figure 3-1 Statue in a Genoa, Italy cemetery.

Introduction

The "digital" darkroom is quickly replacing the "wet" darkroom in many areas of photography. The digital darkroom makes for more expedient work and eliminates exposure to chemicals, and the output of electronic methods often rivals in quality the photographic output of more conventional methods. From an artistic standpoint, however, photographers continue to work in the traditional darkroom to achieve certain effects that cannot be perfectly emulated on the computer.

This chapter explores how basic darkroom procedures can be performed on the computer and teaches you some basic Photoshop skills. A more in-depth exploration of the tools and commands of this program is found in Chapter 4. The purpose of this chapter is to help you begin experiencing the magic of electronic imaging through a series of hands-on exercises. Once you acquire a basic understanding of the software, you can move on to more complicated tasks and projects.

Figure 3-2 shows the main Photoshop interface. The basic components of the interface include:

- *Toolbox:* The vertical column of icons on the left.

- *Menus:* The horizontal band at the very top of the screen. Each menu item has a pull-down set of commands; some of these commands have submenus associated with them.

- *Options Bar:* The horizontal band below the menus. It allows the user to modify the behavior of certain tools, so the appearance of the bar will change according to the specific tool selected.

- *Palettes:* Mini-windows with settings that appear when selected from the Windows menu. Palettes can be repositioned on screen by dragging the title bar.

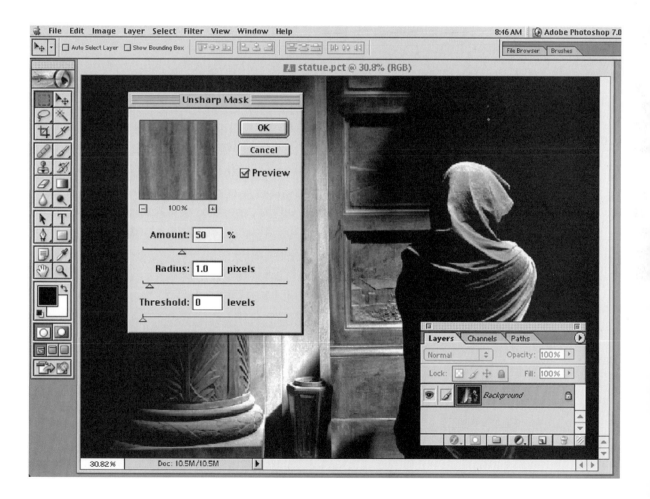

Figure 3-2 Main Photoshop interface.

- *Dialog boxes:* Special windows that require input from the user; they appear on screen when certain menu commands are invoked. For example, choose ing Levels from the Image menu opens the Levels dialog box.

- *Selection:* A defined area of an image to which the effect of a command will be restricted. For example, hitting the backspace key will delete a selection but leave the rest of the image intact.

- *Default:* Reset Tool (i.e., the selected tool) and Reset All Tools are two default choices. These can be accessed by clicking on the arrowhead to the right of the tool icon on the Options bar. In the Preset tool picker, click on the arrowhead in the upper right, and they are located in the tool menu. It is a good practice to reset all tools before beginning a new project.

- *Layers:* Separate planes of the image on which specific operations can be performed. For example, in a layered portrait, sharpening the features of the subject on the top layer will not affect the blurred background in the layer beneath.

Preliminary Exercises

The sections that follow take you through the steps involved in setting up the application. You will typically perform these basic Photoshop functions before starting work on any of the exercises.

Launching Photoshop

- On the **Apple Macintosh** running System 9 or earlier, locate the *Adobe Photoshop* folder on your hard disk— usually this can be found in the *Applications* folder. Open it, and double-click on the Photoshop icon. (For OS X users, consult your computer's documentation.)

- On an **IBM-compatible PC** running Windows, click on the *Start* button, drag to *Programs* in the menu, then drag to Adobe Photoshop in the submenu and release.

It will take a moment for Photoshop to launch. Note that the program's interface is nearly identical on both the Macintosh and Windows platforms. One important difference is the method of invoking keyboard shortcuts: Macs typically use the Command key in combination with other keys, whereas PCs use the Control key.

Resetting Tools

Returning all tools to their default settings before beginning a project will eliminate the frustration of not having the commands perform as expected. This is a good habit to cultivate even if the computer has only a single user.

1. Click on any tool in the Toolbox.
2. In the Options Bar, click on the arrowhead next to the Tool icon at the far left.
3. In the Tool Preset Picker, click on the arrowhead in the upper right. In the Palette menu, select Reset All Tools.
4. Click on OK to reset all tools to their default settings.

Opening an Image

1. From the File menu, choose Open.
2. In the Open dialog box, use the directory window to navigate to the folder containing the image you want to open.
3. Scroll to the file name of the image, select it, and click on OK (or double-click on the file name). Alternatively, from the desktop you can simply double-click on the icon of the image you want to open.

✎ *To open one of the sample images included with the software, navigate to the Photoshop folder and then open the Samples folder. Select a file name and double-click on it.*

Duplicating an Image

It's always a good practice to work on a duplicate of an image file so that the original image won't be lost when changes are made to it. Before beginning the first step of each exercise in this chapter, make a duplicate of the open image file.

1. From the Image menu, choose Duplicate.

2. In the Duplicate dialog box, enter a new file name. (If you choose not to enter a new name, the original name with the word *copy* at the end will be assigned automatically.) Click on OK.

3. Open the duplicate image file that you just created and begin the exercise.

Keep the original file open as a reference while you make changes to the working copy. See "Saving an Image" below for an alternate way to duplicate a file.

Saving an Image

• To save a new image for the first time, choose Save (or Save As) from the File menu. In the dialog box, specify a location for the file on your hard disk, give the file a name, and click on the Save button.

- Thereafter, as you continue to work on the image, periodically update your changes by choosing Save from the File menu.

- If you want to save the current version of the image you're working on, but with a different name, choose Save As from the File menu, and rename the file in the dialog box. In effect, this is the same as duplicating an image, except the copy remains on screen while the original file is closed.

Once you understand and can perform these basic functions, proceed to the exercises, where many of the most important Photoshop commands and concepts are introduced. These exercises are organized so that the process of learning new Photoshop skills builds on the skills you have mastered in previous exercises.

The Exercises

Many of the exercises in this chapter point out the relationship between electronic processes and those performed in traditional photographic printing. The first few exercises involve the commands you will use most often; therefore, it is recommended that you not skip exercises or perform them out of order.

Exercise 3-1: Creating an Electronic Image

This first exercise is an introduction to the magic of altering an image in Photoshop. Figure 3-3 shows an example of the effect you will create using the following procedure.

1. Open a grayscale or RGB flattened image (without layers).

2. Click on the Rectangular Marquee tool (left-hand column, top icon).

3. Select a small section of the image (approximately a half-inch square) by dragging over the area with the cursor. A rectangle of moving dotted lines (or "marching ants") indicates that this area has been selected.

4. From the Edit menu, choose Define Pattern. In the dialog box, click on OK. Nothing will appear to happen; but the selected area has been stored as a pattern, which you will use later.

5. From the Select menu, choose Deselect.

 ✎ *Now is a good time to learn the keyboard shortcut for this very useful command, which you will invoke repeatedly in these exercises. On the Mac, press Command + D; on the PC, press Control + D.*

6. Using the Foreground/Background Color Picker in the Toolbox, choose white as the background color.

 ✎ *If the background color is not already set to white, click on the Default Colors icon (the miniature, overlapping black-and-white squares next to the Color Picker) to reset the Foreground and Background colors to black and white, respectively.*

7. From the Image menu, choose Canvas Size. In the dialog box, increase the current Width and Height settings of the image by 3 inches. Click on OK.

Figure 3-3 Increased canvas size filled with a pattern.

8. A white border will appear around the image. Using the Rectangular Marquee tool, select the image and a little of the white border.

9. From the Select menu, choose Inverse. The selection will reverse itself to include only that portion of the image which was *not* selected previously.

10. From the Edit menu, choose Fill. In the dialog box, click on the Use button. In the Palette menu, click on Pattern. Click on the arrowhead (the Custom Pattern button). In the Pattern Picker, click on the last custom pattern icon in the list, which you had defined in step 4. Click on OK. A pattern will fill the selected area.

11. From the Select menu, choose Deselect. (Quicker yet, use the keyboard shortcut you learned in step 5: Cmd/Ctrl + D.)

Exercise 3-2: Adjusting Contrast

In traditional darkroom printing, contrast can be manipulated using graded papers or contrast filters with variable contrast paper. In Photoshop, you adjust the contrast values of an image with the Levels command.

> ✎ *You can also adjust contrast using the Brightness/Contrast or Curves command.*

1. Open a grayscale image.

> ✎ *You can also do this exercise with an RGB color file; but to get a better sense of how the Levels command works, first eliminate the color values. From the Image menu, select Adjustments > Desaturate, which will effectively render the image as grayscale.*

2. From the Image menu, choose Adjustments > Levels. This opens the Levels dialog box, shown in figure 3-4. In the dialog box, activate the Preview checkbox so that the adjustments you make can be seen immediately.

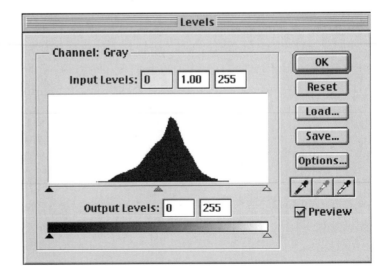

Figure 3-4 Levels dialog box.

3. To adjust the highlights of the image, move the high-light arrowhead (located to the right of the sliding scale) to the left until the black "mountain" starts to rise on the histogram. This will lighten the white areas of the image.

4. To adjust the shadows of the image, move the shadows arrowhead (located to the left of the sliding scale) to the right. This will darken the shadow areas of the image.

5. To adjust the contrast in the gray areas of the image, move the midtones arrowhead (located in the middle of the sliding scale) left or right until the gray areas look their best.

6. To compare the changes with the original image, deactivate the Preview checkbox and click on OK.

Compare figures 3-5 and 3-6 to see how the Levels command can bring out detail in an image.

Figure 3-5 Image before Levels adjustment.

Figure 3-6 Image after Levels adjustment. The black-and-white contrast was increased.

Exercise 3-3: Cropping an Image

In the darkroom, you can crop a negative by raising and positioning the enlarger. To perform a similar procedure in Photoshop, you use the Cropping tool, as shown in figure 3-7.

1. Click on the Cropping tool (left-hand column, third icon from the top).

2. Click and drag diagonally over part of the image, then release. Everything inside the Cropping marquee will be retained; the rest of the image will be cropped.

3. Click on any of the toolbox icons.

4. In the dialog box, click on Crop. Figure 3-8 shows the cropped image.

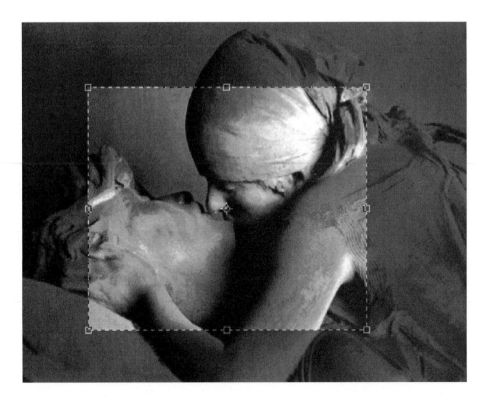

Figure 3-7 Cropping tool. Shaded area indicates what will be cropped.

Here are some tips on using the Cropping tool.

- To adjust the size of the selection, place the cursor over a corner or middle handle on the marquee and drag (a double arrow will appear when the mouse is positioned correctly).

- To rotate the selection, drag outside the selected area.

- To crop the selected area without a dialog box, press the Enter or Return key.

- To remove the marquee and cancel the cropping procedure, press the Escape key. Alternatively, you can click on any of the toolbox icons; in the dialog box, click on Don't Crop.

Figure 3-8 The cropped image.

Exercise 3-4: Dodging Out and Burning In

In the darkroom, a section of a print can be given less light (dodging out) or more light (burning in) than the rest of the image. In Photoshop, you perform these functions using the Dodge/Burn tool.

1. Click on the Dodge tool (right-hand column, seventh icon from the top); or click and hold the Dodge tool, then drag to the Burn tool (second icon down).

2. In the Options Bar, click on the arrowhead to the right of the Brush icon. In the Brush Picker, click on a soft-edged brush.

3. Click on the Range button and choose Shadows, Midtones, or Highlights.

4. Click on the Exposure arrowhead and move the slider to the desired percentage.

5. On the image, drag over the areas to be lightened (dodged) or darkened (burned). Compare figures 3-9 and 3-10 to see a before-and-after example of dodging an image.

You can also use the Levels command selectively to lighten or darken areas of an image.

1. Click on the Lasso tool (left-hand column, second icon from the top). Drag around the area of the image you want to adjust.

2. From the Select menu, choose Feather. In the dialog box, enter *15* pixels in the Feather Radius field. This will soften the edge of the selection to eliminate harsh transitions between the selected and unselected areas.

3. From the Image menu, choose Adjustments > Levels. In the dialog box, adjust the sliders to change the highlight and shadow values of the selected area.

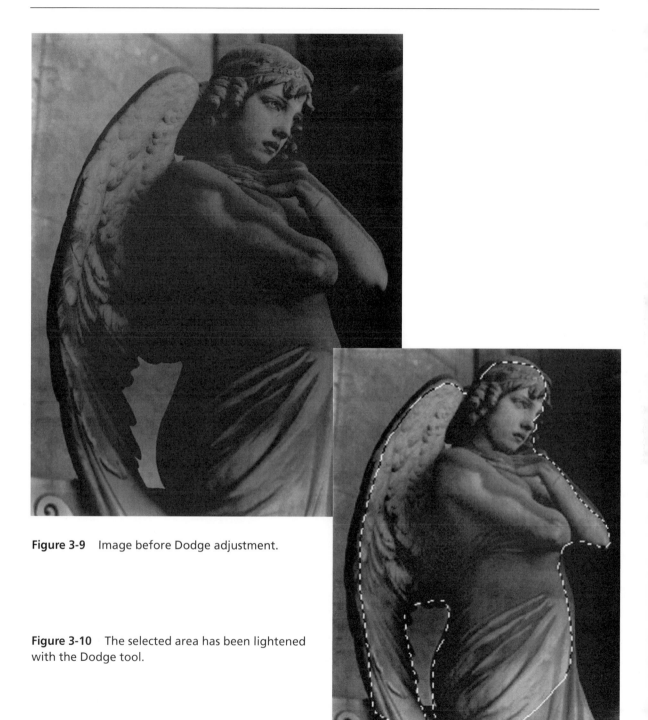

Figure 3-9 Image before Dodge adjustment.

Figure 3-10 The selected area has been lightened with the Dodge tool.

Exercise 3-5: Selecting a Rectangular or Elliptical Area

Use the Rectangular and Elliptical Marquee tools to select a specific, geometrical area of an image. Figure 3-11 shows a selection made with the Rectangular Marquee tool.

1. Click on the Rectangular Marquee tool (left-hand column, top icon); or click and hold on the Rectangular Marquee tool, then drag to the Elliptical Marquee tool (left-hand column, second icon down).

2. On the image, position the cursor in the upper left-hand corner of the area to be selected, drag the mouse diagonally to the lower right-hand corner, and release. This will select a rectangular (or elliptical) area.

3. Once an area has been selected, changes made to the image will occur only in that area. For example, from the Image menu, choose Adjustments > Invert. As you can see in figure 3-12, the light and dark values of the image

Figure 3-11 Rectangular Marquee tool selection.

have been reversed, as in a negative—but just in the selected area.

Here are some tips on using the Rectangular and Elliptical selection tools.

- To constrain the selection to a perfect square or circular shape, hold down the Shift key while dragging. After you finish dragging, release the mouse button before releasing the Shift key.

- With a selection tool active, dragging within the selected area *will move the selection marquee alone* and leave the image unaffected. However, if the Move tool is active, dragging *will move the selected area of the image itself.*

- Clicking anywhere on the image will cancel the selection, as will the keyboard shortcut Cmd/Ctrl + D.

- To quickly select the unselected area of an image while at the same time deselecting the selected area, choose Inverse from the Select menu. (Don't confuse this command with Adjustments > Invert from the Image menu!)

Figure 3-12 Elliptical Marquee selection with the Invert command applied.

Exercise 3-6: Selecting a Freeform Shape Using the Lasso Tool

Use the Lasso tool to select a non-geometric shape, as shown in figure 3-13.

1. Click on the Lasso tool (left-hand column, second icon from the top).

2. Drag around the edge of the shape to be selected.

3. When you get to the starting point of your shape, release the mouse button.

 ✎ *If you release the mouse button before reaching the starting point of the shape, the selection will be close automatically with a straight line between the starting and ending points.*

Figure 3-13 Lasso tool selection.

A selection can be fine-tuned by magnifying the image on screen and then adding to or subtracting from the original shape.

4. Double-click on the Hand tool (left-hand column, eleventh icon from the top). If all of the palette windows are closed, the image will expand to the edge of the screen.

5. Click on the Zoom tool (right-hand column, eleventh icon from the top) and click in the middle of the selection. This will enlarge and center that portion of the image on screen. If the selection shape does not fill the window, click again. If the shape extends beyond the edge of the window, hold down the Option key (Mac) or Alt key (Windows) and click once to decrease the level of magnification.

6. Modify your selection as follows.

 a. To extend the original shape or add a new shape, choose any selection tool and press the Shift key. Start dragging inside or outside the original selected area.

 b. To subtract from an existing selection, press the Option key (Mac) or Alt key (Windows). Start dragging inside or outside the original selected area.

Exercise 3-7: Selecting an Area by Color

Use the Magic Wand tool to select areas of similar color or gray value within a given tolerance, as illustrated in figure 3-14.

1. Click on the Magic Wand tool (right-hand column, second icon from the top).

2. In the Options Bar, enter *32* in the Tolerance field. The lower the tolerance, the smaller the range of color values detected by the Magic Wand.

3. Click on the area you want to select. All adjacent colors within the specified tolerance will be selected. If the initial selection is too small or too large, increase or decrease the Tolerance setting.

4. As with the other selection tools, hold down the Shift key while clicking again to add to the selection. If the Contiguous box in the Options Bar is unchecked, all pixels of the same color throughout the image will be selected, whether they are adjacent or not.

TIP: You can switch from one selection tool to another to add to or subtract from a selection. For example, the Lasso tool could be used when the Magic Wand tool cannot successfully select a desired area.

Figure 3-14 Magic Wand tool selection.

Exercise 3-8: Copying and Pasting

One image or selected area can be copied and pasted onto another image.

1. Open the image to be copied.

2. From the Select menu, choose All. The entire image will be selected, as shown in figure 3-15. Alternatively, select a portion of the image using any of the selection tools (Rectangular, Elliptical, Lasso, or Magic Wand).

3. From the Edit menu, choose Copy.

 ✎ *Before copying, you can "soften" the edges of the selection with the Select > Feather command.*

4. Open a second image.

5. From the Edit menu, choose Paste. The copied selection will be pasted onto the second image.

 ✎ *Pasting will automatically create a new layer in the second image.*

To resize the pasted image, continue with the following steps.

6. From the Edit menu, choose Transform > Scale. Drag a handle on the Transform marquee to resize the selection.

Figure 3-15 Select All command.

✎ *To constrain the proportions of the pasted image as you adjust its size, hold down the Shift key while dragging a corner handle of the Transform marquee.*

8. Click inside the Transform marquee and begin dragging to move the selected area of the image to a new location. Be careful not to drag from the center point which will not move the selected area.

9. Press Enter (Return) to "lock in" the new image size and location, as shown in figure 3-16.

To move the pasted image, continue with the following steps.

10. Click on the Move tool (right-hand column, top icon).

11. Click on the pasted image and drag to reposition it.

Here's a quicker way to copy and paste.

1. Open two images and position the windows side by side.

2. Click on the window with the image to be copied to make it active. If you want to copy just a portion of the image, make a selection with one of the selection tools.

3. Click on the Move tool.

4. Drag from the first image onto the window of the second image. The image will be copied and pasted automatically.

Figure 3-16 Pasted image after applying the Transform command.

Exercise 3-9: Creating Type

Use the Type tool to insert and edit text in an image file.

1. Create a new document. From the File menu, choose New. In the dialog box, enter *7* inches in the Width field and *5* inches in the Height field. In the Resolution field, enter *200* pixels. Select RGB from the Mode pop-up menu.

2. Click on the Horizontal Type tool. On the Options Bar, choose a font family and enter *100* points in the Size field. Click on the image approximately where you want the text to appear and begin typing. A new Type layer will be created to hold the text.

3. Click on the Move tool and drag to reposition the text.

4. To change the appearance of the text, click on the Type tool again.

5. Highlight the text to be edited by dragging over it.

6. On the Options Bar, choose a new font family and size.

The text remains editable on its own layer, which you can further modify using the Layer Style command. For example, figure 3-17 shows text with a drop shadow. To create this effect, choose Layer Style > Drop Shadow from the Layer menu. In the dialog box, enter *50%* in the Opacity field, *30* pixels in the Distance field, and *15* pixels in the Size field. Alternatively, move the sliders in the dialog box to adjust these amounts manually. Then click on OK.

To curve the text, as shown in figure 3-18, continue with the following steps.

7. With the Type tool still active, click on the Create Warp Text icon (second icon from the right) on the Options Bar.

8. In the dialog box, click on the Style pop-up menu and choose the Arc icon. Click on OK.

Figure 3-17 Type with Drop Shadow applied.

Figure 3-18 Type with Arc Style and Drop Shadow applied.

Exercise 3-10: Rotating and Flipping

Figure 3-19 shows an original image before being rotated and flipped.

1. From the Image menu, choose Rotate Canvas.

2. From the Rotate Canvas submenu, choose one of the following: 180°, 90° CW (clockwise), 90° CWW (counterclockwise), Arbitrary, Flip Horizontal, or Flip Vertical.

✎ *The Arbitrary command permits free rotation to any angle and in either direction. It also increases the canvas size to fit the image if necessary. The background color will fill the resulting open spaces.*

Figure 3-19 Original image before flipping and rotating.

Figure 3-20 Flip Horizontal command.

Figure 3-21 Rotate 90° CW command.

Figures 3-20 and 3-21 illustrate the Flip Horizontal and 90° CW commands, respectively.

You can also rotate and flip a selected area of the image.

1. Click on the Rectangular Marquee tool and drag to select an area of the image.

2. From the Edit menu, choose Transform, and choose any of the rotation commands from the Transform submenu. Figure 3-22 shows the selected area after being flipped horizontally.

✎ *Rotating part of an image may expose the background color in the blank areas formed when the selected area is rotated.*

Figure 3-22 Selected area after applying the Transform > Flip Horizontal.

Exercise 3-11: Compressing and Expanding

You can easily compress or expand images in Photoshop by selectively resizing them. Figures 3-23 and 3-24 show an image before and after compression, respectively.

1. From the Image menu, choose Image Size.

2. In the dialog box, uncheck the Constrain Proportions checkbox.

3. In the Width and/or Height fields, enter a smaller number (for compression) or a larger number (for expansion). The image will shrink or stretch to the dimensions you specified.

Figure 3-23 Original image before compression.

Figure 3-24 Image compressed horizontally (with the Constrain Proportions box unchecked).

Exercise 3-12: Creating a High-contrast Effect

In the darkroom, a high-contrast print can be made using a high-numbered (#5) contrast filter with variable contrast paper. High-contrast effects can also be achieved using graphic arts film. This film can be used to produce posterized and line print effects. In Photoshop, you can create a high-contrast image using a variety of commands.

To create a very high-contrast, black-and-white effect, use the Threshold command, as shown in figure 3-25.

1. Open a new image. From the Image menu, choose Adjustments > Threshold.

2. In the dialog box, move the slider to adjust the amount of black and white. Click on OK.

To specify a limited number of contrasting tonal levels or color values in an image, use the Posterize command, as shown in figure 3-26.

1. Open a new image. From the Image menu, choose Adjustments > Posterize.

2. In the dialog box, enter a number value (between 2 and 255) in the Levels field. Smaller numbers will yield fewer tonal levels and larger areas of flat color. Click on OK.

To create a line print effect, use the Trace Contour command, as shown in figure 3-27.

1. Open a new image. From the Filter menu, choose Stylize > Trace Contour.

2. In the dialog box, move the slider to adjust the amount of edge highlighting. Click on OK.

Figure 3-25 Image with the Threshold command applied.

Figure 3-26 Image with the Posterize command applied.

Figure 3-27 Image with the Trace Contour filter applied.

Exercise 3-13: Solarization

In the darkroom, the so-called "Sabattier effect" can be applied to a print by re-exposing it to white light part way through the developing process. The result is a reversal of image tones, along with a distinctive halo (called Mackie lines) around contrasting shapes.

In Photoshop, this same effect can be simulated using the Solarize command, as shown in figure 3-28. To apply the effect to an image, choose Stylize > Solarize from the Filter menu.

Figure 3-28 Image with the Solarize filter applied.

Exercise 3-14: Double Exposure and Sandwiched Negatives

With a camera, you can create a double exposure by exposing the same section of film twice. In the darkroom, you can achieve a similar effect by sandwiching negatives in the negative holder of the enlarger. To create this same effect in Photoshop, you perform a simple copy-and-paste and then adjust the opacity of the image layers, as shown in - figure 3-29.

1. Open the first image and from the Select menu, choose Select > All (Cmd/Ctrl + A).

2. From the Edit menu, choose Copy (Cmd/Ctrl + C).

3. Open the second image.

4. From the Edit menu, choose Paste (Cmd/Ctrl + V). The copied image will be pasted onto a new layer.

5. From the Edit menu, choose Transform > Scale. Drag the handles on the Transform marquee to adjust its size. Drag inside the marquee to reposition the scaled selection. Press the Enter or Return key to lock in the changes.

6. From the Windows menu, choose Layers. In the Layers palette, click on the layer with the pasted image. Type 50% in the Opacity field.

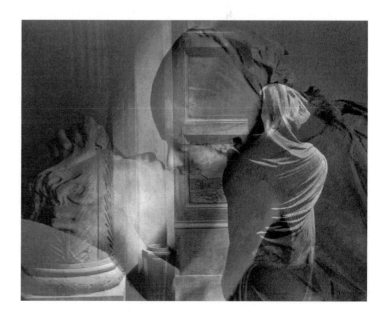

Figure 3-29 Pasted image at 50% opacity.

Exercise 3-15: Toning

A black-and-white photographic print can be toned using such chemicals as selenium or sepia. In Photoshop, you can "colorize" images to simulate this effect.

1. Open an RGB color image, or open a grayscale image and convert it to RGB (from the Image menu, choose Mode > RGB).

2. From the Image menu, choose Adjustments > Hue/Saturation.

3. In the dialog box, activate the Colorize button.

4. Select a tint using the Hue slider; choose an intensity using the Saturation slider; and adjust the light value using the Lightness slider. Click on OK.

 ✎ *See plate 11 of the color insert, which shows a continuous-tone black-and-white image that has been tinted.*

Exercise 3-16: Coloring

You can hand-color a black-and-white photographic print using a variety of media, including oils, watercolors, oil pastels, dyes, colored pencils, and markers. To simulate this effect in Photoshop, you can colorize selected areas of the image.

1. Open an RGB color image. From the Image menu, choose Adjustments > Desaturate to convert the color values to grayscale values. If necessary, adjust the contrast using the Levels command (from the Image menu, choose Adjustments > Levels). Alternatively, open a grayscale image and convert it to RGB mode.

2. Click on the Lasso tool. Drag to select the area to be "tinted." Hold down the Shift key to select more than one area.

3. From the Select menu, choose Feather. In the dialog box, enter 5 pixels in the Feather Radius field. Click on OK.

4. From the Image menu, choose Adjustments > Hue/Saturation. In the dialog box, check the Colorize box and adjust the Hue, Saturation, and Lightness sliders to achieve the desired effect. Click on OK.

 ✎ *See plate 12 of the color insert, which shows a continuous-tone black-and-white image that has been tinted in selected areas.*

Exercise 3-17: Removing Color

An alternate method of colorizing an image in Photoshop involves eliminating color values from selected areas.

1. Open an RGB color image. Click on the Lasso tool. Select areas in which the original color is to be retained. Hold down the Shift key while dragging to select additional areas.

2. From the Select menu, choose Feather. In the dialog box, enter 5 pixels in the Feather Radius field. Click on OK.

3. From the Select menu, choose Inverse. The selected areas will now be deselected, while the previously unselected areas will be selected.

4. From the Image menu, choose Adjustments > Desaturate. If necessary, adjust the contrast of the desaturated areas using the Levels command.

Exercise 3-18: Using the Brush Tool

Use the Paintbrush tool to lay down strokes of color in an image. This tool will paint with a color from the Foreground Color Picker.

1. From the File menu, choose New. In the dialog box, specify the dimensions and resolution of a blank RGB file with a white background.

2. Select a foreground color using the Color Picker, the Color palette, or the Swatches palette.

3. Click on the Paintbrush tool (right-hand column, fourth icon from the top). On the Options Bar, click on the Brush arrowhead to show the Brush Preset picker of available brush shapes and sizes.

Use the following options and techniques to achieve different types of brush effects, as shown in figure 3-30.

Figure 3-30 A variety of brush strokes.

CREATING THIN/THICK, HARD/SOFT, AND ROUGH BRUSH STROKES

1. In the Brush Preset picker, choose a thin, hard brush.

2. Drag across the image to create a brush stroke.

3. Select a thick, soft brush, and repeat step 2.

4. Select a rough-edged brush and repeat step 2.

CREATING STRAIGHT-LINE BRUSH STROKES

1. Click once on the image to set the starting point of the stroke.

2. Hold down the Shift key and position the cursor at the ending point of the stroke. Click again. (Do not drag the brush across the image.) A straight line will be created between the two points. Continue holding down the Shift key and move the cursor to a new location and click again. A new straight line will be connected to the end of the last line.

CREATING FADED BRUSH STROKES

1. On the Options Bar, click on the far right icon to open the Brushes palette. In the palette, click on the Shape Dynamics button. In the dialog box (to the right), under Size Jitter, click on the Control button.

2. In the palette menu, click on Fade. Enter a number of pixels in the Fade field. A thumbnail illustration will preview the effect your adjustments will have on the Shape Dynamics.

3. Drag across the image to create a faded brush stroke.

CONTROLLING THE SPACING OF BRUSH STROKES

1. On the Options Bar, click on the far right icon to open the Brushes palette. In the palette, click on the Brush Tip Shapes button. In the dialog box (to the right), move the Spacing slider past 100% to create spaces in the brush stroke. A thumbnail illustration will preview the effect your adjustments will have on the Brush Tip Shape.

2. Drag across the image to create a "dotted" brush stroke.

CONTROLLING THE ANGLE AND
ROUNDNESS OF BRUSH STROKES

1. On the Options Bar, click on the far right icon to open the Brushes palette. In the palette, click on the Brush Tip Shape button. In the dialog box (to the right), drag the arrow that is outside the circle to alter the angle of the brush. Drag on either of the two anchor points of the circle to alter the roundness of the brush. A thumbnail illustration will preview the effect your adjustments will have on the Brush Tip Shape.

2. Drag across the image to create a brush stroke that resembles a "chiseled" calligraphy line.

Exercise 3-19: Retouching and Cloning

You can eliminate blemishes, flaws, and other imperfections from photographic prints by retouching and correcting them using traditional painting and airbrushing techniques. Using Photoshop's Clone Stamp tool (formerly called the Rubber Stamp tool), you can perform similar magic on a digital image. Specks of dust and lint marks picked up in the scanning process can be removed. Unwanted objects (such as a telephone pole sprouting from a subject's head) can be erased, leaving the background otherwise untouched. Photographs with rips, water stains, missing pieces, and other damage can be repaired and made to look as good as new. The Clone Stamp tool works much like the Paintbrush, but it corrects an image by copying (or "cloning") an intact area of the image and applying it over a damaged area. Figure 3-31 shows an uncorrected image prior to cloning.

1. Open an image. Click on the Clone Stamp tool (left-hand column, fifth icon from the top).

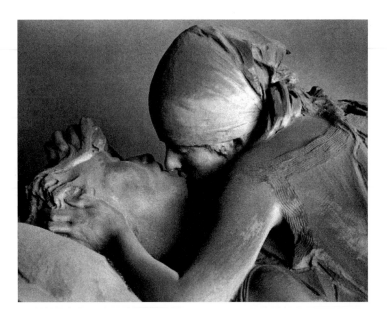

Figure 3-31 Original image before retouching.

2. On the Options Bar, click on the arrowhead to the right of the brush icon to open the Brush picker. Select one of the soft brush sizes.

3. Hold down the Option key (Mac) or Alt key (Windows) and click once on an intact area near the part of the image to be corrected. This will establish an initial "source point" for your corrections.

4. Press the Caps Lock key to hide the brush shape and replace it with a more precise crosshairs cursor.

5. Release the Option/Alt key. Drag over the area to be corrected. The solid crosshairs indicate the area being copied relative to the source point. The target crosshairs show the location of the brush cursor over the area being covered. If the Aligned box on the Options Bar is unchecked, the cloning will start again from the source point each time you click and drag. Figure 3-32 shows the result of using the Clone Stamp tool.

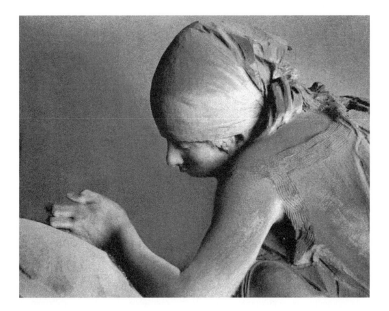

Figure 3-32 Left-hand figure removed using the Clone Stamp tool.

Exercise 3-20: Creating Layers

Layers are separate planes of the image on which specific commands can be performed. Every new image starts out as a "background" layer. Additional layers, each with its own image element, can be created on top of it. Think of them as clear plastic sheets stacked one over the other. They can be removed by dragging them to the Trash icon in the Layers palette. They can be rearranged by dragging up and down the list of layers. A new layer is automatically formed whenever you use the Type or Paste commands. Figure 3-33 shows Photoshop's Layers feature in action.

1. Open an existing image file, or create a new one.

2. From the Windows menu, choose Layers. The Layers palette will appear.

3. From the Layer menu, choose New > Layer. In the dialog box, type *Brush Layer* in the Name field. Click on OK.

4. Click on the Brush tool. On the Options Bar, choose a large brush size. With the layer you just created still active, drag across the image to create some brush strokes.

5. In the Layers palette, click on the "Eye" icon to the left of the "Brush" layer. The brushed lines will become inactive (disappear). Click again to reactivate the layer, and the lines will reappear.

6. In the Layers palette, click on the arrowhead to the right of the Opacity field and move the slider to change the opacity of the brushed strokes.

7. In the Layers palette, click on the Blending Mode button and choose Dissolve. The soft brushed lines will now take on a hard speckled look.

Figure 3-33 Brushed line on a layer using the Dissolve blending mode.

Exercise 3-21: Guides

In the following exercise, you will use Photoshop's non-printing guidelines to align a montage of images automatically with the Snap To command.

1. From the File menu, choose New. Specify an image size large enough to contain a montage of three images.

2. From the View menu, choose Show Rulers.

3. From the View menu, choose Snap To > Guides. Hold the cursor inside the top ruler and drag down to create horizontal guides. Similarly, hold the cursor inside the left-hand ruler and drag right to create vertical guides. These will appear as blue lines on the screen, but they will not print with the image.

To reposition or remove guides, continue with the following.

4. Click on the Move tool.

5. Position the cursor over a guide; the cursor will change to two parallel lines.

6. Drag the guide to a new location.

7. To remove a guide, drag the guide back into the ruler area. To remove all guides at once, choose Clear Guides from the View menu.

To create a montage by aligning pasted images with the guides, continue with the following steps.

8. Open an image, copy it, and paste it into the file containing the guides you just created.

9. From the Edit menu, choose Transform > Scale, and then resize the pasted image.

10. Click on the Move tool. Drag the pasted image toward a guide. When it gets close, it will "snap" to the edge of the guide line. When two perpendicular guides intersect, the image will snap to their corner point.

11. Repeat steps 8 through 10 to paste and align additional images, as shown in figure 3-34.

✎ *To disable automatic alignment, deselect the Snap to Guides option in the View menu.*

Figure 3-34 Images aligned using the Snap To > Guides command.

Exercise 3-22: Contact Sheets

In the darkroom, you can contact-print a group of negatives onto a single sheet of photographic paper. In Photoshop, use the Contact Sheet II command to generate thumbnails of all images in a folder and then group them in a single file, as shown in figure 3-35.

1. On the desktop, create a new folder and drag into it all the images you want to contact-print.

2. From Photoshop's File menu, choose Automate > Contact Sheet II. In the dialog box, click on the Source Folder button, locate the folder you created in step 1, and click the Select [Folder] button.

3. Enter values in the Width, Height, and Resolution fields and choose a color mode. If you want the file name of each image to appear below the thumbnail, check the Use File Name as Caption box. Click on OK.

Figure 3-35
Thumbnails generated from a folder of images using the Contact Sheet II command.

Exercise 3-23: The Paint Bucket Tool and Paste Into Command

In this exercise, you will create intersecting vertical and horizontal lines to form a series of rectangles, which you can fill with colors or images, as shown in figure 3-36.

1. From the File menu, create a new blank RGB document.

2. Reset the Foreground/Background Color Pickers to their defaults (black and white, respectively).

3. Click and hold on the Rectangular Marquee tool, and then drag to the Single Row Marquee tool (third icon down). Click once anywhere on the blank canvas, and a horizontal line selection will automatically appear. Hold down the Shift key and click in other locations to add additional line selections.

4. Click and hold on the Single Row Marquee tool and drag to the Single Column Marquee tool (fourth icon down). Hold down the Shift key and click several times on the image to add additional vertical line selections.

5. From the Edit menu, choose Stroke. In the dialog box, enter *4* pixels in the Width field and check the Center box. Click on OK.

6. From the Select menu, choose Deselect to remove the selection marquees. A series of perpendicular, stroked lines should now be visible.

7. From the Windows menu, choose Swatches. Click on a color in the Swatches palette to specify a new foreground color.

8. Click and hold on the Gradient tool, and then drag to the Paint Bucket tool (second icon down). Click on any white rectangular space in the image. It will fill with the new foreground color.

Figure 3-36 Rectangular spaces filled with colors and images.

9. Repeat steps 7 through 8, filling more rectangles with different foreground colors chosen from the Swatches palette.

To fill the rectangles with images instead of colors, continue with the following optional steps.

10. From the File menu, choose Open, locate a new image, and double-click it.

11. Select a part of the new image with the Rectangular Marquee tool, or choose Select > All (keyboard shortcut: Cmd/Ctrl + A).

12. From the Edit menu, choose Copy (keyboard shortcut: Cmd/Ctrl + C).

13. Click on the file with colored rectangles. Click on the Magic Wand tool, then click on one of the rectangles you want to fill with an image. A new selection will appear inside the rectangle.

14. From the Edit menu, choose Paste Into (keyboard shortcut: Shift, Cmd/Ctrl + V). The copied image will be pasted into the selected rectangle.

15. From the Edit menu, choose Transform > Scale to adjust the size of the pasted image.

16. Repeat steps 10 through 15 to fill other rectangles with different images.

Exercise 3-24: Creating an Abstract Design with the Gradient Tool

1. Create a new, blank RGB file.

2. Click on the Gradient tool (right-hand column, sixth icon from the top).

3. On the Options Bar, click on the arrowhead to the right of the Gradient Editor and choose any gradient with colors in the Gradient Picker.

4. Click on the Radial Gradient icon (second icon from the left).

5. Click on the Mode button and choose the Difference blending mode.

6. Drag on the image to create the first gradient.

7. Position the cursor in a new location and repeat step 6. Because the Difference mode was chosen, new colors and values will be formed by the overlapping colors, as shown in figure 3-37.

Figure 3-37 Overlapping Gradient tool effects using Difference mode.

To create hard-edged gradients, as shown in figure 3-38, perform the following optional steps.

1. Click on the gradient thumbnail on the Options Bar.

2. In the Gradient Editor dialog box, click below the gradient color bar to add a stop point. The foreground color will determine the color of that stop point.

3. Double-click on the stop point to change its color using the Color Picker.

4. Select a color and click on OK. Repeat to create additional stops.

5. Drag one stop point on top of another to create a hard-edged change in the gradient. Repeat to create additional hard edges. When you're done, click on OK.

6. On the Options Bar, click on the Mode button and choose the Difference blending mode.

8. Drag across the image to create a gradient with hard edges within it. Repeat to create intersecting hard-edged gradients.

Figure 3-38 Gradient tool effects using hard edges with Difference mode.

TIP: The Gradient Editor can be returned to its default presets by clicking on the arrowhead in the upper right-hand corner of the Gradient Picker. Choose the Reset Gradient command and click on OK.

Exercise 3-25: Creating an Abstract Design Using the Pen Tool

1. Create a new, blank RGB file.

2. Click on the Pen tool (left-hand column, ninth icon from top). Click on the image to establish a starting point. Move the cursor to a new point, and drag. A curved path will be created between the starting point and the second anchor square. Continue moving and dragging to add new curved line segments to the path. These segments can intersect one another.

3. From the Windows menu, choose Paths. In the Paths palette, click on the arrowhead in the upper right-hand corner. Click on Make Selection. Alternatively, click on the Selection icon (dotted circle) at the bottom of the palette. The working path will become outlined with a selection.

TIP: To remove a working path, drag it to the trash in the Paths palette. The selection will remain behind.

4. Select a foreground color.

5. From the Edit menu, choose Fill. In the dialog box, click on the Use button and choose Foreground in the menu. Click on OK.

6. Deselect, and choose a new foreground color.

7. Create a new curved path using the Pen tool and make it a selection.

8. From the Edit menu, choose Fill. Click on the Mode button and choose the Difference blending mode. Click on OK. New colors will be formed where the filled shapes overlap, as shown in figure 3-39.

Figure 3-39 Overlapping Pen tool selections filled with colors using Difference mode.

Exercise 3-26: Working with Special Effects Filters

The Filter menu contains a variety of special effects commands that can be applied to an image or selection, as shown in the sampler of filter effects in figure 3-40. Many of these filters simulate drawing, painting, and photographic darkroom techniques.

1. Open an RGB image.

2. Click on the Cropping tool. Drag across a vertical area of the image. Press Enter or Return to crop it.

3. From the Image menu, choose Canvas Size. In the dialog box, increase the overall dimensions of the image by adding .5 inches to both the Width and Height fields.

4. From the Image menu, choose Image Size. With the Constrain Proportions box checked, enter *2* inches in the Width field and *100* in the Resolution field. Click on OK.

5. Select the entire image.

6. From the Edit menu, choose Define Pattern.

7. Close the image without saving.

8. From the File menu, choose New. In the dialog box, enter *8* inches in the Width field, *10* inches in the Height field, *100* in the Resolution field, and RGB. Click on OK.

9. From the Edit menu, choose Fill. In the dialog box, click on the Use button and choose Pattern in the menu. Click on the arrowhead in the Custom Pattern field. In the Pattern picker, click on the Defined Pattern icon (in the bottom row of boxes). Click on OK.

10. Click on the Cropping tool and drag to select all complete images. Press Enter or Return. There should be approximately 12 small copies of the original image.

11. Click on the Rectangular Marquee tool and select the first image in the upper left-hand corner.

12. From the Filter menu, choose a filter type, and in the submenu, choose a filter. Some filters will be applied immediately. If a dialog box appears, you can make adjustments to that filter effect. Click on OK after making any adjustments.

13. Select the second image and try out another filter. Continue applying filter commands to each image. On a separate piece of paper, keep track of the filters used.

TIP: Special effects can also be created with commands in the Image > Adjustments menu, such as Invert, Threshold, and Posterize.

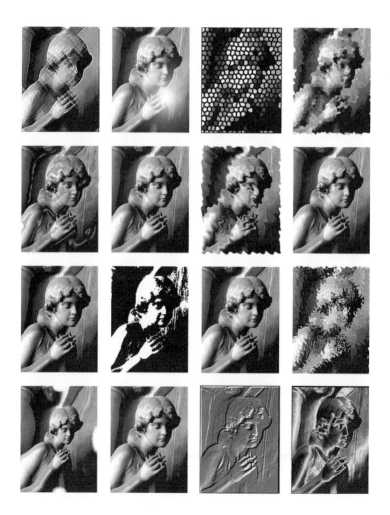

Figure 3-40　Various filter effects applied to multiple images.

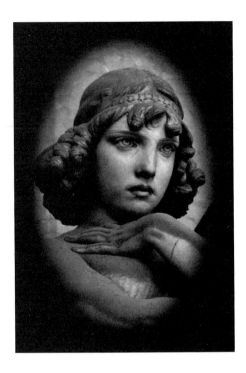

Figure 3-41 Image vignetted to a black background.

Exercise 3-27: Vignetting

Vignetting is a darkroom technique used in traditional photography to gradually darken a print toward its edges. The term is also used to indicate softening or blurring around the outside of an image. In Photoshop, this effect can be created using the Feather and Fill commands, as shown in figure 3-41.

1. Open an image. Reset the Foreground and Background colors to their defaults (black and white, respectively).

2. Click on the Elliptical Marquee tool and drag on the image to make an oval selection. Drag inside the selection to center it on the image.

3. From the Select menu, choose Feather. In the dialog box, enter *20* pixels in the Feather Radius field. Click on OK.

4. From the Select menu, choose Inverse.

5. From the Edit menu, choose Fill. In the dialog box, click on the Use button and choose Foreground in the menu. Click on OK.

Exercise 3-28: Creating Uneven Edges

You can create uneven edges on a photographic print in the darkroom by roughly cutting a negative holder out of cardboard. In Photoshop, this can be accomplished using filters, as shown in figure 3-42.

1. Open an image and reset the Foreground and Background colors to their defaults (black and white).

2. From the Image menu, choose Canvas Size. In the dialog box, enter a width and height that is larger than the current image size. Click on OK. A white border will be created around the image.

3. Click on the Rectangular Marquee tool and drag just inside the edges of the image (not the border area).

4. From the Select menu, choose Inverse.

5. From the Select menu, choose Feather. In the dialog box, enter *20* pixels in the Feather Radius field. Click OK.

6. From the Filter menu, choose Distort > Ripple. In the dialog box, move the slider all the way to the right (999). Click on OK.

✎ *Other filters under Distort can be used to create uneven edges.*

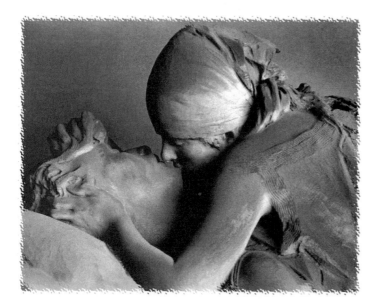

Figure 3-42 Ripple filter applied to create an uneven edge around the image.

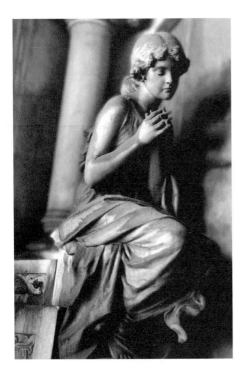

Figure 3-43 Background with Gaussian blur applied to simulate a short depth of field.

Exercise 3-29: Creating a Short Depth of Field

A photographer can create a short depth of field by using a low *f*-stop number on the camera, attaching a telephoto lens, or shooting very close to the subject. In Photoshop, you can simulate this effect using the Blur filters, as shown in figure 3-43.

1. Open an image. Use the Lasso tool to select the center of interest in the image.

2. From the Select menu, choose Inverse.

3. From the Select menu, choose Feather. In the dialog box, enter *20* pixels in the Feather Radius field. Click on OK.

4. From the Filter menu, choose Blur > Gaussian Blur. In the dialog box, move the slider to adjust the amount of blur. Click on OK.

Exercise 3-30: Fading an Image

You can gradually fade an image into the background color using Quick Mask mode and the Gradient tool, as shown in figure 3-44.

1. Open an image and reset the Foreground and Background colors to their defaults.

2. Click on the Quick Mask Mode tool (right-column, below the Color Picker boxes).

3. Click on the Gradient tool. In the Options Bar, click on the arrowhead to the right of the Gradient Picker, then click on the Foreground to Background icon (top left). In the Options Bar, click on the Linear Gradient icon (leftmost box in second group).

 ✎ *Instead of fading an image to the background color, you can fade it to transparency. To do so, click on the Foreground to Transparent icon (second icon from top left).*

4. On the image, drag from the area that you wish to preserve to the area that will blend to white (or transparent). A red, semitransparent mask will appear over the area to be preserved.

5. Click on the Standard Mode tool (to the left of the Quick Mask Mode icon). The red color will be replaced with a selection.

6. Press the Delete key. The image will gradually fade to white (or transparent).

Figure 3-44 Fade-to-white effect applied to image using Quick Mask and Gradient tools.

Overview of Adobe Photoshop Functionality

Perhaps why so much of today's photography doesn't "grab us" or mean anything to our personal lives is that it fails to touch upon the hidden life of the imagination and fantasy, which is hungry for stimulation.

—Arthur Tress (born 1940), fine art photographer

Introduction

This chapter serves as an overview of the major commands used in Adobe Photoshop 7. The complexities of the Photoshop software are enormous. To avoid overwhelming the reader, only the most pertinent tasks are explained here. Special-effects filters and more advanced tasks are discussed in Chapter 11.

Once an image has been scanned, or **digitized,** as shown in figure 4-1, it can be manipulated on the computer to achieve many of the same effects rendered in the darkroom or artist's studio. The advantage of using the computer is speed. The basic commands for altering an image electronically are specific to Adobe Photoshop version 7. However, the commands in Photoshop 6 are very similar. The major differences involve their physical location in the interface.

Opening an Image in Adobe Photoshop

1. On a Mac, locate the Adobe Photoshop application icon on the hard drive of the computer (typically in the *Applications* folder) and double-click on it. On a PC running Windows, launch the application from the Start menu.

2. Insert the disc with the image (or select an image from the Photoshop *Samples* folder).

3. From the File menu, shown in figure 4-2, choose Open. In the dialog box, navigate to the file location, choose the image name to highlight it, and click on Open (or double-click on the file name).

Figure 4-1 Scanned image.

Adjusting an Image: First Steps

Often, the values, sharpness, and colors of an image should be adjusted and saved before additional commands are applied.

Value Adjustment

The three main commands for adjusting the tonal values of an image are **Levels, Brightness/Contrast,** and **Curves.**

> ✏️ *Adjusting color images with these commands will also affect the color balance.*

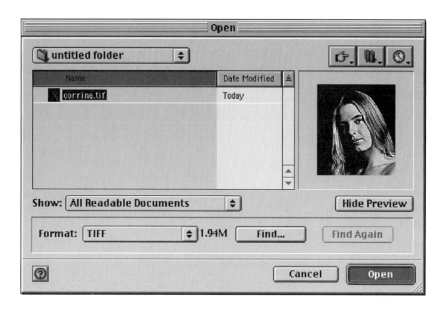

Figure 4-2 Open dialog box from the File menu.

Levels

The Levels command adjusts tonal values numerically.

1. From the Image menu, choose Adjustments > Levels. In the dialog box, shown in figure 4-3, click on the Preview box so that the changes can be seen immediately.

2. To adjust the values in the highlights of the image, move the highlight-point triangle (located to the right of the Input Levels slider) to the left until the black "mountain" starts to rise on the histogram. This will lighten the highlight areas of the image. To darken the values in the shadow portions of the image, move the shadows-point triangle (located to the left of the Input Levels slider) to the right until the black "mountain" starts to rise on the histogram. To adjust the midtone values of the image, move the midtones-point triangle (located in the middle of the Input Levels slider) either to the left or right.

3. The range of values can also be adjusted using the Output Levels sliders. To lessen the range of white values in the image, move the highlight triangle (located to the right of the Output Levels slider) to the left. To

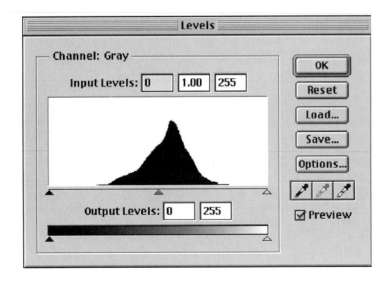

Figure 4-3 Levels dialog box.

lessen the range of black values in the image, move the shadow triangle (located to the left of the Output Levels slider) to the right.

4. To compare the adjusted image with the original image, uncheck the Preview box. Click on OK to apply the changes, or Cancel to close the dialog box and return to the original image.

Here is an alternate method of adjusting image levels.

1. In the Levels dialog box, choose the left-hand Eyedropper (for shadowed areas). Position the cursor over the darkest shadow on the image and click.

2. Click on the right-hand Eyedropper (for highlight areas). Position the cursor over the brightest area on the image and click.

3. To cancel the levels adjustments, click on Cancel. To accept adjustments, click on OK.

Brightness/Contrast

The Brightness/Contrast command adjusts overall values and contrast.

1. From the Image menu, choose Adjustments > Brightness/Contrast.

2. In the Brightness/Contrast dialog box, shown in figure 4-4, move the top slider to adjust the values and the bottom slider to adjust the contrast. Click on OK.

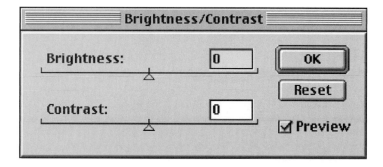

Figure 4-4 Brightness/Contrast dialog box.

Curves

The Curves command provides a more complex and precise method of adjusting values. It also can be used to create special effects and colors (see Chapter 11).

1. From the Image menu, choose Adjustments > Curves. In the dialog box, shown in figure 4-5, check the Preview box. Make sure the "curved line" icon at the bottom is active and that the bar at the bottom of the graph has white on the right and black on the left. If not, click on the double arrow in the middle to reverse the values. The diagonal line represents the values in the image, from white (0%, in the upper right) to black (100%, in the lower left).

2. Position the cursor over any area of the image. The relative value of that area will be indicated by a round point on the diagonal line. Hold and drag that point until the line begins to curve. Lighten values by drag-

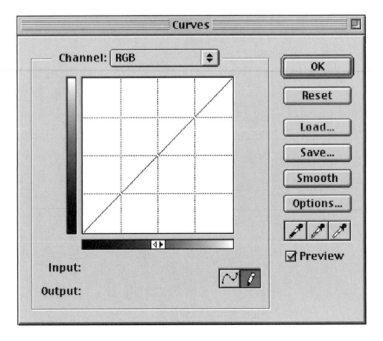

Figure 4-5 Curves dialog box.

ging higher; darken them by dragging lower. Click on OK.

TIP: Click on the Auto button to automatically adjust the values.

Sharpness Adjustment

Despite its name, the **Unsharp Mask** command, shown in figure 4-6, adjusts image sharpness.

1. From the Filter menu, choose Sharpen > Unsharp Mask.

2. Check the Preview box.

3. Move the Amount slider to 50%. Move the Radius slider to 1.0 pixels. Move the Threshold slider to 0 levels. Click on OK.

TIP: Image sharpness can also be adjusted by using other commands in the Sharpen submenu.

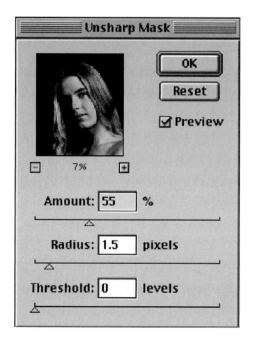

Figure 4-6
Unsharp Mask filter adjustment dialog box.

Color Adjustment

Use the **Color Balance, Hue/Saturation,** and **Variations** commands to adjust the colors in RGB and CMYK images.

Color Balance

The Color Balance command adjusts colors in shadows, midtones, and highlights.

1. From the Image menu, choose Adjustments > Color Balance. In the dialog box, shown in figure 4-7, check Preview.

2. Adjust the Color Balance sliders separately for each of the Tone Balance options: Shadows, Midtones, and Highlights.

3. Uncheck the Preserve Luminosity box if you want your adjustments to lighten or darken the image. Click on OK.

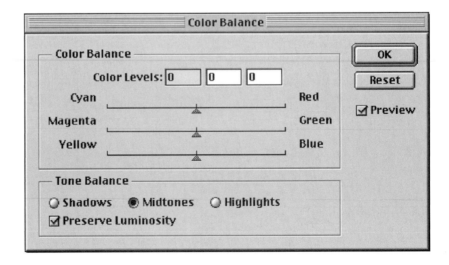

Figure 4-7 Color Balance dialog box.

Hue/Saturation

The Hue/Saturation command adjusts the hue, saturation, and lightness of individual color components.

1. From the Image menu, choose Adjustments > Hue/Saturation. In the dialog box, shown in figure 4-8, check Preview.

2. Move the Hue, Saturation, and Lightness sliders. The upper color bar shows unadjusted colors of the color wheel; the lower bar shows how the adjustment affects hues at full saturation.

3. To create a monotone effect, check the Colorize box. Click on OK.

Variations

The Variations command lets you interactively adjust colors in shadows, midtones, and highlights by displaying side-by-side "thumbnail" previews of several color variations at once.

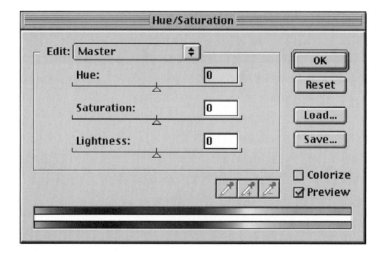

Figure 4-8 Hue/Saturation dialog box.

1. From the Image menu, choose Adjustments > Variations. In the dialog box, shown in figure 4-9, click on the Shadows, Midtones, or Highlights button.

2. Move the Fine/Course slider to decrease or increase the relative degree of color change in each of the dark, middle, and light ranges separately. Clicking on the Saturation button lets you adjust the degree of hue throughout the image.

3. To add color to the image, click on any of the color thumbnails.

4. To change the brightness, click on either the Lighter or the Darker thumbnail.

5. Every time you click a thumbnail, all the thumbnails change. Click on OK.

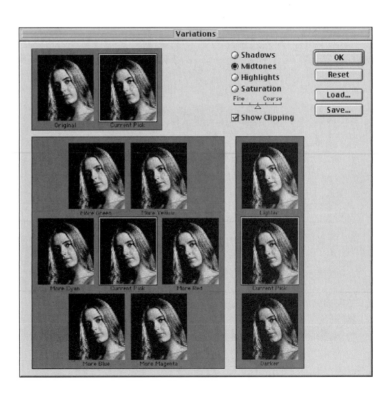

Figure 4-9 Variations dialog box.

TIP: Click on the Original box to reset the Preview thumbnail to its original values.

Saving an Image

Once an image has been adjusted, use the **Save** or **Save As** command, shown in figure 4-10, to save the file to disk.

1. From the Edit menu, choose Save or Save As. The Save command updates changes to an existing file. The Save As command creates a new file. If you're saving a new image for the first time, the Save and Save As commands function identically.

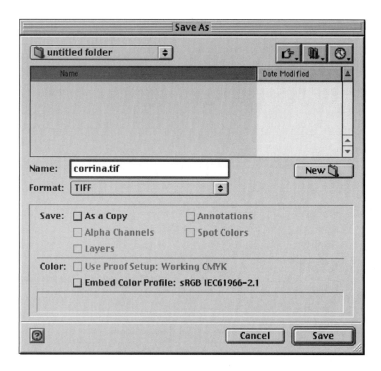

Figure 4-10 Save/Save As dialog box from the File menu.

Figure 4-11 Photoshop's toolbox.

2. In the dialog box, navigate to a location on your hard disk where you want the file to be saved. Give the file a name and, if appropriate, choose an image format.

3. Click on Save.

The Toolbox

Adobe Photoshop's toolbox commands are located in two vertical columns on the left-hand side of the screen, as shown in figure 4-11. You access a tool by clicking on its corresponding icon. A number of alternate tools are "hidden" behind other tools. You can access them by clicking and holding on the displayed tool; when the pop-up box appears, drag to one of the alternate tool.

Selection Tools

Selection tools define or restrict commands to a specific area or areas of an image. The edge of the selected area is indicated by a series moving dashed lines (or "marching ants"). A selected area can be altered, moved, or copied and pasted. Once an area has been selected, adjustments made to the image will only occur within the selected area. Four of the most frequently used selection tools are the Rectangular Marquee, the Elliptical Marquee, the Lasso, and the Magic Wand.

Selecting Geometric Areas

Use the **Rectangular Marquee** and **Elliptical Marquee** tools to select geometric areas of the image, as shown in figures 4-12 and 4-13.

1. Click on the Rectangular Marquee tool to choose it; or hold and drag to the second icon, the Elliptical Marquee tool.

2. On the image, position the cursor in the upper left-hand corner of the area to be selected. Drag the cursor diagonally to the lower right-hand corner of the area to be selected, and release.

TIP: To constrain your selection to a perfect square or circular shape with these tools, hold down the Shift key while dragging. When you finish dragging, release the mouse button first, then the Shift key.

Use the following tool options to further refine your selections.

CONSTRAINED ASPECT RATIO

The **Constrained Aspect Ratio** option restricts the width-to-height ratio of a selection you make with the Rectangular or Elliptical Marquee tool.

1. On the Options Bar, click on the Style button and drag to Constrained Aspect Ratio.

2. Enter a number in both the Width and Height fields. This will determine the width-to-height ratio.

3. On the image, drag to select an image area of any size, but with a constant ratio of width to height.

FIXED SIZE

The **Fixed Size** option lets you specify an exact value for the size of the selection.

1. On the Options Bar, click on the Style button and drag to Fixed Size.

2. Enter a number in both the Width and Height fields to set the dimensions of the selection, measured in pixels.

3. Click once (don't drag!) on the image to create a fixed-size selection.

Figure 4-12 Rectangular selection.

Figure 4-13 Elliptical selection.

Figure 4-14 Lasso tool selection.

Selecting a Free-form Area

Use the **Lasso** tool to select a non-geometric area of an image with a freehand drawing technique, as shown in figure 4-14.

1. Click on the Lasso tool.
2. On the image, drag around the edge of the shape to be selected. Release the mouse button near the starting point of your selection. The path will automatically be closed.

TIP 1: For accuracy, enlarge the image using the Zoom tool before you begin the selection.

TIP 2: To create a straight-line selection, hold down the Option key, click once, move the cursor to a new location, and click again. Each time you click, a straight-line selection will connect to the last point.

Figure 4-15 Polygon Lasso tool selection.

Selecting a Straight-Edged Area

Use the **Polygon Lasso** tool to select a straight-edged area, as shown in figure 4-15.

1. Click and hold on the Lasso tool, then drag to the Polygon Lasso tool (second icon down).
2. Click on the image to set the starting point of the selection.
3. Move the cursor to a new location and click again. A straight line will join the two points. Click elsewhere to establish the next straight line.
4. To close the selection, double-click.

TIP: Press the Escape key to cancel an unfinished selection. Press the Return or Enter key to complete an unfinished selection.

Selecting Edges Automatically

Use the **Magnetic Lasso** tool to find the edge between a shape and the surrounding areas while creating a selection.

1. Click and hold on the Lasso tool, then drag to the Magnetic Lasso tool (third icon down).

2. Click at a starting point on the image and move along the edge of the shape you wish to select. A selection line will automatically "grab" the edge of the shape and form temporary fastening points. At any time in the selection process you can:

 ✗ Move and click to create additional points;

 ✗ Double-click to close the selection; or

 ✗ Press the Escape key to cancel an unfinished selection.

TIP: Use the Options Bar to control the sensitivity of the Magnetic Lasso. Enter a percentage in the Edge Contrast field to set the degree of contrast necessary for the tool to establish a selection point.

Selecting an Area of Similar Values or Colors

Use the **Magic Wand** tool to select an area of an image that has similar tonal values or colors, as shown in figure 4-16.

1. Click on the Magic Wand tool.

2. On the Options Bar, enter *32* in the Tolerance field.

3. Click on the area of the image to be selected. All adjacent values or colors within the tolerance will be selected.

TIP: Uncheck the Contiguous box on the Options Bar to select *all* pixels of the same value or color at once, whether they are adjacent or not. If the selected area is too small, increase the tolerance number. If it is too large, decrease it.

Figure 4-16 Magic Wand tool selection.

4. Click outside the selection and a new area will be selected. Click inside the selection to deselect. As with the other selection tools, hold down the Shift key and click elsewhere on the image to add to the selection.

Additional Selection Tools

SINGLE ROW/SINGLE COLUMN MARQUEE TOOLS

Use the **Single Row Marquee** and **Single Column Marquee** tools to select a single straight line of pixels. They are limited in their use, because they do not select areas.

1. Click and hold on the Rectangular Marquee tool, then drag to the Single Row Marquee tool (third icon down) or the Single Column Marquee tool (fourth icon down).

2. Click on the image. A horizontal (row) or vertical (column) line selection will be created.

TIP: In the Select menu, choose the Modify > Expand command to increase the width of the selection. When a row or column of pixels has been selected in this fashion, you can use the Stroke command in the Edit menu to create lines of any width on the image.

TYPE MASK TOOLS

Use the **Horizontal** and **Vertical Type Mask** tools to create a selection marquee in the shape of any text you type.

1. Click and hold on the Type tool, then drag to either the Horizontal or Vertical Type Mask tool.

2. On the Option Bar, choose a font family, size, and style.

3. On the image, click where the type should begin. The screen will temporarily be covered with a translucent, red mask. As you type, part of the mask will be replaced by text characters.

4. Click on the Commit Any Current Edits button on the Option Bar. The typed text will become a selection marquee, which you can fill with color, a pattern, or an image.

TIP: In the Select menu, choose the Modify > Expand command to increase the width of the selection.

SELECT ALL
The Select > All menu command selects the entire image.

TIP: When an image has been selected in this fashion, you can use the Edit > Stroke command to draw a border around the image.

QUICK MASK
Use the Paintbrush and Eraser tools in **Quick Mask Mode** to create soft-edged selection areas.

1. Click on the Quick Mask Mode icon.

2. Click on the Paintbrush tool. On the Options Bar, choose a brush size. Drag on the image to paint a mask over areas that you do *not* want to be selected. A translucent red brushed stroke will appear over the image.

3. Click on the Standard Mode icon. The red mask will disappear, and all unmasked areas will become selected.

4. To add to or subtract from the selected areas, return to Quick Mask Mode. Use the Eraser tool to remove part of the mask (enlarge the selection area); or continue painting with the Paintbrush tool to add to the mask (decrease the selection area). Return to Standard Mode to transform the mask back into a selection.

TIP: The Gradient tool can also be used in Quick Mask Mode to mask large areas with a gradual edge.

PEN TOOL AND PATHS PALETTE

The Pen tool creates vector paths made up of straight or curved lines. These paths, which you can save and adjust very precisely, can then be converted into selections.

1. Click on the Pen tool, and click on the Create a New Work Path icon in the options bar click.

2. Click at various points on the image to create a path of segments with straight lines.

3. Click and drag to create path segments with curved lines.

4. From the Windows menu, choose Show Paths.

5. In the Paths palette, click on the arrowhead in the upper right-hand corner.

6. In the palette menu, choose Make Selection. Alternatively, you can click on the Selection icon at the bottom of the palette. The path will become a selection.

 ✎ *A more thorough explanation of the Pen tool appears later in this chapter.*

COLOR RANGE

Use the Color Range command to select parts of the image according to their color.

1. From the Select menu, choose Color Range.

2. On the image, click on the color to be selected.

3. In the Color Range dialog box, click on the Selection button and move the Fuzziness slider to increase or decrease the range of colors.

4. Click on OK. Selection lines will appear around the colors chosen.

Related Selection Procedures

- To cancel a selection, choose Deselect from the Select menu, or press Cmd/Ctrl + D. Alternatively, clicking once outside the selection area with the Rectangular Marquee, Elliptical Marquee, or Lasso tools will also cancel a selection.

- To add to an existing selection, hold down the Shift key while using one of the selection tools. Alternatively, activate the "Add to Selection" icon on the Options Bar.

- To subtract from an existing selection, hold down the Option (Mac) or Alt (PC) key while using one of the selection tools. Alternatively, activate the "Subtract from Selection" icon on the Options Bar.

- To save a selection so you can reuse it later, choose Save Selection from the Select menu. In the dialog box, enter a title for the selection and click on OK. The selection will be saved as part of the file in the Channels palette.

- To load a saved selection, choose Load Selection from the Select menu. In the dialog box, choose the name of the selection you previously saved. Click on OK.

- To reverse a selected area, choose Inverse from the Select menu.

- To increase a selection by adding areas of similar value or color *adjacent to the selection,* choose Grow from the Select menu.

- To increase a selection by adding areas of similar value or color *throughout the image,* choose Similar from the Select menu.

- To soften the edges of a selected area, choose Feather from the Select menu. In the dialog box, specify the degree of feathering, in pixels, by entering a numerical value in the Feather Radius field. Click on OK.

Figure 4-17 Moving a selected area to expose the background color.

Figure 4-18 Moving and duplicating a selection.

- To enlarge the edges of a selected area, choose Modify > Expand from the Select menu. In the dialog box, specify the degree of expansion, in pixels, by entering a numerical value in the Expand By field. Click on OK.

- To shrink the edges of a selected area, choose Modify > Contract from the Select menu. In the dialog box, specify the degree of contraction, in pixels, by entering a numerical value in the Contract By field. Click on OK.

- To smooth the edges of a selected area, choose Modify > Smooth from the Select menu. In the dialog box, specify the degree of smoothing, in pixels, by entering a numerical value in the Sample Radius field. Click on OK.

- To move a selection marquee, click inside the selected area and drag to reposition the marquee. To move a selection marquee one pixel at a time, press any of the Arrow keys. To move it ten pixels at a time, hold down the Shift key and press an Arrow key.

- To move a selected area of the image itself, drag the selection while holding down the Command key (Mac) or Control key (PC). This action will expose the background color of the image, as shown in figure 4-17.

TIP: You can also use the Move tool to reposition a selected area of an image. See "Tools for Other Functions" below.

- To *duplicate* a selected area of the image while you move it (leaving the original selected area in place), drag the selection while holding down the Command + Option keys (Control + Alt keys), as shown in figure 4-18.

TIP: You can also duplicate a selected area of an image by holding down the Option key (Alt key) while using the Move tool.

Tools for Other Functions

Move Tool

Use the Move tool to reposition a selected area or layer, or to copy and paste from one image to another.

- If an area of an image is selected, dragging with the Move tool will reposition that part of the image.

 ✎ *To make a duplicate of the selected area (while leaving the original selection in place), hold down the Option key (Alt key) while you drag with the Move tool.*

- If nothing is selected, the entire layer will be repositioned on the canvas when you drag. Before dragging, make sure you first use the Layers palette to activate the layer you want to reposition

 ✎ *The background layer cannot be repositioned.*

- You can also use the Move tool to copy a selection or an entire layer and paste it onto another image. With two files open and visible on screen, simply drag a selected area or active layer from one window to another. The image from the first window will automatically be copied into a new layer in the second window.

 ✎ *Of course, you can always accomplish this same task by using the Copy and Paste commands from the Edit menu.*

Cropping Tool

Use the Cropping tool to select and cut out a rectangular area from the image, as shown in figure 4-19.

1. With the Cropping tool selected, drag diagonally over the area of the image you want to retain. Any part of the image left outside the rectangular bounding box will darken to indicate that it will be discarded.

Figure 4-19 Cropping tool selection.

Figure 4-20 Paintbrush tool.

2. To adjust the size of area to be cropped, drag any of the handles on the bounding box.

3. To rotate the area you want to crop, drag anywhere outside the bounding box.

4. To cancel cropping, press the Escape key; the bounding box will disappear. Alternatively, click on any of the toolbox icons. In the dialog box, click on the Don't Crop button. (Pressing Cancel will close the dialog box and leave the bounding box in place.)

5. To proceed with cropping the image, press the Return key. Alternatively, click on any of the toolbox icons. In the dialog box, click on the Crop button.

TIP: You can also use the Rectangular Marquee tool to crop an image. Drag to select the area you want to retain. Then, from the Image menu, choose Crop.

Paintbrush Tool

Use the Paintbrush tool to apply strokes of color to an image, as shown in figure 4-20.

1. Select a Foreground color.

2. Click on the Paintbrush tool.

3. In the Options Bar, choose a brush size and an opacity percentage.

4. Drag on the image to apply freehand strokes.

 ✎ *To constrain your brush strokes to straight lines, as shown in figure 4-21, click once on the image. Then press the Shift key and click again elsewhere on the image. A single straight brush stroke will appear between the two points on the image where you clicked. Repeat shift-clicking to extend the stroke in other directions.*

Figure 4-21 Brush strokes constrained to straight lines.

Pencil Tool

Use the Pencil tool to draw simple lines, as shown in figure 4-22.

1. Select a Foreground color.

2. Click and hold on the Paintbrush tool, then drag down to the Pencil tool.

3. In the Options Bar, choose a pencil size and an opacity percentage.

4. Drag on the image to apply freehand lines.

 As with the Brush tool, you can constrain your pencil strokes to straight lines. Click once on the image, then press the Shift key and click again elsewhere on the image. A single straight pencil line will appear between the two points on the image where you clicked. Repeat shift-clicking to extend the line in other directions.

Figure 4-22 Pencil tool.

Clone Stamp Tool

The Clone Stamp tool (formerly called the Rubber Stamp tool) is essentially a special type of brush that duplicates, or "clones," one area of an image, which you apply by dragging over another area of the image, as shown in figure 4-23. This command is especially useful for repairing damaged photographs or removing unwanted objects from an image.

1. Click on the Clone Stamp tool. In the Options Bar, choose a brush size and an opacity percentage, and check the Aligned box.

2. Press the Option key (Alt key) and click on a spot in the image to designate the source point where the cloning is to begin. Crosshairs will appear over that area, indicating the original source point.

Figure 4-23 Clone Stamp tool.

Figure 4-24 Pattern Stamp tool.

3. Drag anywhere else on the image to clone the image, starting from the source point. As you move the brush cursor, the crosshairs move in tandem, relative to the source point. The strokes you apply at any given point are a duplicate of the area of the image over which the crosshairs are positioned.

✎ *If the Aligned box is unchecked, cloning will begin from the original source point each time you release the mouse button and drag again.*

Pattern Stamp Tool

Use the Pattern Stamp to apply a pattern using brush strokes, as shown in figure 4-24.

1. Click and hold on the Clone Stamp tool, then drag to the Pattern Stamp tool.

2. In the Options Bar, choose a brush size, an opacity percentage, and a pattern.

3. Drag in the image to apply a brush stroke filled with the pattern you selected.

History Brush Tool

Use the History Brush to selectively restore an earlier state of the image from the History palette.

1. Click on the History Brush tool. In the Options Bar, choose a brush size, and opacity percentage.

2. From the Windows menu, choose History. In the palette, click on one of the left-hand buttons to choose the state to be restored. (Do not click on the state itself, which will cause the entire image to revert to that previous state.)

3. On the image, drag to apply brush strokes that will replace the current pixels with corresponding pixels from the selected history state.

TIP: You can achieve the same effect by holding down the Option key (Alt key) while using the Eraser tool.

Eraser Tool

Use the Eraser tool to eliminate areas of an image, as shown in figure 4-25. The tool erases to the background color on the background layer, and to transparency on other layers.

1. Select a background color.

2. Click on the Eraser tool. In the Options Bar, choose a brush size and set opacity to 100%.

3. On the image, drag over the area to be erased.

The Eraser tool can also return portions of an altered image to a selected history state or to the last saved version of the file.

Figure 4-25 Eraser tool.

1. From the Windows menu. choose History. In the palette, click on one of the left-hand buttons to choose the state to be restored. (Do not click on the state itself, which will cause the entire image to revert to that previous state.)

2. Click on the Eraser tool. On the Options Bar, choose a brush size and check the Erase to History box.

3. Hold the Option key (Alt key) and drag on the image. "Erased" areas will revert to pixels from the corresponding history state.

Gradient Tool

Use the Gradient tool to create a gradual blend from one color to another, as shown in figure 4-26. You can also create custom gradients that blend between a spectrum of colors.

1. Select foreground and background colors from the Color Picker.

2. Click on the Gradient tool. On the Options Bar, click on the Linear icon or the Radial icon.

3. Click on the arrowhead to the right of the Gradient icon on the Options Bar. In the Gradient Picker, choose the Foreground to Background option.

Figure 4-26 Gradient tool.

✎ *Alternatively, select one of the other gradient presets to create a more complex blend of colors. To customize a selected blend style, open the Gradient Editor on the Options Bar. Add or delete stop points on the gradient color bar. Drag a stop-point to reposition it on the color bar. Double-click on a stop point to change its color.*

4. Drag on the image to create a gradient from the foreground color to the background color.

✎ *The Gradient tool will fill the entire layer if there are no areas selected.*

Paint Bucket Tool

Use the Paint Bucket tool to fill an area of an image with the foreground color.

1. Select a foreground color.

2. Click and hold on the Gradient tool, then drag to the Paint Bucket tool. On the Options Bar, click on the Fill button and choose Foreground. Enter *32* in the Tolerance field. Click on OK.

3. On the image, position the cursor over the area you want to fill, and click. Adjacent pixels of similar color within the tolerance specified will be replaced by the foreground color.

TIP: To replace similar colors throughout the image, regardless of their location, uncheck the Contiguous box on the Options Bar.

Blur and Sharpen Tools

Use the Blur and Sharpen tools to blur or sharpen areas within an image.

1. Click on the Blur tool. Alternatively, click and hold on the Blur tool, then drag to the Sharpen tool.

2. On the Options Bar, choose Normal mode, choose a brush size, and specify a pressure between 1% and 100%.

3. Drag on the image to blur or sharpen the brushed area.

Smudge Tool

Use the Smudge tool to smear colors of an image together, as shown in figure 4-27.

1. Click and hold on the Blur tool, then drag to the Smudge tool.

2. On the Options Bar, choose Normal mode, choose a brush size, and specify a pressure between 1% and 100%.

3. Drag on the image to smudge the colors of the brushed area.

Dodge and Burn Tools

Use the Dodge and Burn tools to lighten or darken areas of an image.

1. Click on the Dodge tool. Alternatively, click and hold on the Dodge tool, then drag to the Burn tool.

2. On the Options Bar, choose a brush size, range, and exposure percentage.

3. Drag on the image to lighten or darken the colors of the brushed area.

Type Tool

Use the Type tool to create text on its own layer, as shown in figure 4-28. Until you "rasterize" the text (i.e., convert it to pixels—see below), text remains editable after you type it.

1. Click on the Horizontal Type tool.

2. On the Options Bar, choose a font family, size, and style.

3. Click on the image where the text should begin and start typing. The text will appear horizontally across the image in the foreground color.

 ✎ *You can also copy text from a word processing program and paste it into Photoshop.*

Figure 4-27 Smudge tool.

Figure 4-28 Type tool.

4. To reposition the text, move the cursor away from the text and start dragging. After text has been repositioned, you can continue typing.

5. After you finish typing the text, click on the Commit Any Current Edits button on the far right of the Options Bar. You can always go back and edit this text.

✎ *To create vertical type, as shown in figure 4-29, hold on the Horizontal Type tool, and drag to the Vertical Type tool. Begin typing.*

MOVING TEXT

- To change the *orientation* of the text while you type, click on the Text Orientation icon on the Options Bar. This will toggle between a horizontal and a vertical orientation.

- To change the *angle* of the text after you have created the text layer, choose Transform > Rotate from the Edit menu and drag outside the bounding box. Alternatively, choose Rotate 180°, Rotate 90° CW, or Rotate 90° CCW from the Transform submenu.

- As with any other layer, you can reposition a text layer with the Move tool after it has been committed.

EDITING TEXT

- To adjust letterspacing, drag across the text with the Type tool to highlight it. Toggle the Character palette on the Options Bar, and click on the arrowhead to the right of the Set Tracking button. To spread the letters further apart, click on a positive number; to push them closer together, click on a negative number.

- To adjust the size of type, drag across the text with the Type tool to highlight it. Click on the arrowhead to the right of the Set Font Size button on the Options Bar. Choose a new point size from the menu.

Figure 4-29 Vertical type.

- In a similar manner you can also change character and paragraph attributes, such as font family, style, leading, color, degree of anti-aliasing, and justification.

SPECIAL TYPE EFFECTS

- To warp the type, as shown in figure 4-30, click on the Create Warp Text button on the Options Bar. In the dialog box, click on the Style button. In the palette menu, choose a style and move the sliders for Bend, Horizontal Distortion, and Vertical Distortion. Click on OK.

- To add a drop shadow to text, choose Layer Style > Drop Shadow from the Layer menu. In the dialog box, adjust the opacity, angle, distance, spread, and size of the shadow. Click on OK.

 ✎ *In addition to Drop Shadow, there are a variety of Layer effects that can be applied to text, such as Bevel and Emboss.*

- To fill type with an image, as shown in figure 4-31, use the Horizontal or Vertical Type Mask tools. First you must open and copy an image that is large enough to occupy the area you want to fill. Then click on a blank canvas and type some text with a Type Mask tool. After you commit to the text you typed, the selection marquee will appear in the shape of that text. Finally, use the Edit > Paste Into command to fill the selection area with the image you copied previously.

RASTERIZING TEXT

Most layers in Photoshop are composed of **raster** data—that is, a discrete number of individual pixels at a set resolution. If you increase or reduce the size of an image, pixels will be added or removed from the image, which can affect the quality and sharpness of the output. Raster data is *resolution-dependent.*

Figure 4-30 Warped type.

Figure 4-31 Type filled with image.

By contrast, Type and Shape layers in Photoshop are made up of **vector** data—that is, a mathematical description of the object on the layer. Vector data is *resolution-independent*. The advantage of vector art is that it can be resized without compromising image quality or sharpness. However, many commands in Photoshop cannot be used with a vector layer until it is converted into pixels, or "rasterized."

To rasterize a type layer, choose Rasterize > Type from the Layer menu.

Pen Tool

Use the Pen tool to define a path that can be filled or converted into a selection, as shown in figure 4-32.

1. From the Windows menu, open the Paths palette.
2. Click on the Pen tool.
3. On the Options Bar, click on the Paths icon.
4. On the image, click once to establish a starting point. Click elsewhere to create a straight-line segment. Each time the mouse is clicked, an **anchor point** is created, and a new line segment is added to the path.
5. Click and drag to create a curved line segment.

TIP: To change a curved segment to a straight-line segment, click on the last anchor point. From a new location, click again to create a straight-line segment.

6. Click on the starting point of the path to close it.
7. If you want to save a path to use later on, click on the arrowhead in the upper right corner of the Paths palette and choose Save Path.

Figure 4-32 Path created with the Pen tool.

EDITING A PATH

- To move an anchor point, click and hold on the Path Selection tool, then drag to the Direct Selection tool. Click on an anchor point and drag it to a new location.

- To add an anchor point, click and hold on the Pen tool, then drag to the Add Anchor Point tool. Click on any anchor point on the path, and drag to a new location.

- To delete an anchor point, click and hold on the Pen tool, then drag to the Subtract Anchor Point tool. Click on any anchor point on the path.

- To change a corner point to a curve point, and vice versa, click and hold on the Pen tool, then drag to the Convert Point tool. Click on an anchor point.

- To delete a path in its entirety, go to the Paths palette and drag the Path or Working Path icon to the Trash icon at the bottom of the palette.

CONVERTING A PATH INTO A SELECTION

1. In the Paths palette, click on the arrowhead in the upper right-hand corner.

2. In the palette menu, choose Make Selection. The path will change to a selection.

 ✎ *To change a selection back into a path, select Make Work Path from the Paths palette menu.*

FILLING A PATH

1. In the Paths palette, click on the arrowhead in the upper right-hand corner.

2. In the palette menu, click on Fill Path.

3. Click on OK. The path will fill with the foreground color.

 ✎ *Converting a Path to a selection and filling a Path can also be accomplished by clicking on the icons at the bottom of the Paths palette.*

Shape Tools

The shape tools enable you to create shapes and paths and fill them with the foreground color or an image, as shown in figure 4-33. They include the Rectangle, Rounded Rectangle, Ellipse, Polygon, and Custom Shape tools. These tools create a layer with vector data, which means that the shapes created are always sharp and resolution-independent. If the image resolution changes, the sharpness of the shape remains. The shape can also be exported to another program that reads vector data, such as Adobe Illustrator. The disadvantage of vector shapes is that they cannot use all of the commands in Photoshop.

1. Select a Foreground color.

2. Click on the Rectangle tool.

3. On the Options Bar, click on the Fill Pixels button. Click on a shape.

4. On the image, drag to create the shape.

5. If the shape is created on a separate layer, it can have a layer style added to it (such as Drop Shadow, Bevel, and Emboss) by selecting Layer Style from the Layer menu.

6. To convert a vector shape to pixels, choose Rasterize > Shape from the Layer menu.

Line Tool

Use the Line tool to draw straight lines, as shown in figure 4-34. Unlike the Pencil tool, it cannot draw freehand lines.

1. Select a Foreground color.

2. Click and hold on the Rectangle tool, then drag to the Line tool.

Figure 4-33 Star shape filled with an image.

3. On the Options Bar, click on the Fill Pixels button. Enter a number of pixels (line thickness) in the Weight field and choose an Opacity percentage.

4. On the image, drag to create a straight line.

5. To restrict lines to a horizontal, vertical, or 45° diagonal direction, hold down the Shift key while dragging.

CREATING LINES WITH ARROWHEADS

1. On the Options Bar, click on the Geometry Options arrowhead.

2. Activate the Start and/or End buttons. Enter a percentage in the Width, Length, and Concavity fields.

3. On the image, drag to create a straight line. Depending on the options you selected, an arrowhead will be created at either end of the line drawn.

Figure 4-34 Line tool effects.

Eyedropper Tool

Use the Eyedropper tool to choose a foreground color from a section of the image.

1. Click on the Eyedropper tool.

2. Position the cursor over the desired color in the image and click. The foreground color will change to the color under the cursor.

 ✎ *To reverse the foreground and background colors, click on the double arrows near the Foreground/Background Color Picker on the Toolbox.*

Hand Tool

Use the Hand tool to reposition the image on screen.

- To quickly force an image to shrink or expand so as to fill the space available for viewing on the monitor, double-click on the Hand tool.

• Drag with the Hand tool to reposition on screen an image that is too large to fit completely in the confines of the window.

✎ *You can also use the scroll bars on the window to reposition an image.*

Zoom Tool

Use the Zoom tool to magnify or reduce the screen size of an image.

• To magnify an image (zoom in), position the Zoom tool over the area of the image to be magnified and click. To increase magnification, click again.

• To reduce magnification (zoom out), position the Zoom tool over the image. Hold down the Option key (Alt key) and click.

• To quickly zoom in or out to 100% of the image size at full resolution ("View All Pixels"), double-click on the Zoom tool.

✎ *The screen size of an image can also be magnified with the Cmd/Ctrl + keyboard shortcut. To reduce the screen size, the shortcut is Cmd/Ctrl – (hyphen).*

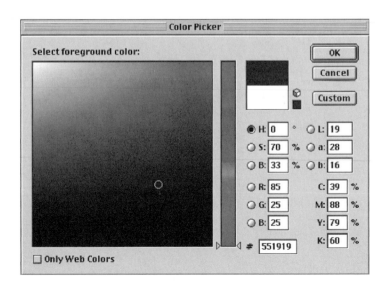

Figure 4-35 Color Picker.

Foreground/Background Color Picker

The Foreground/Background Color Picker lets you specify colors to be applied by the various tools and commands. The following tools use the Foreground Color Picker to apply color: Paintbrushes, Type, Paint Bucket, Shapes, and Lines. The Delete command uses the Background Color Picker to apply color to deleted areas. The Fill command gives you the option to apply either a background or a foreground color. By default, the Gradient tool creates a blend between the foreground and background colors.

- To specify colors, click on either the square Foreground or Background button to open the Color Picker, as shown in figure 4-35. In the dialog box, choose a color by moving the vertical slider and clicking on the color desired in the Select Foreground/Background Color square on the left. Click on OK.

- Alternatively, click on a color swatch in the Swatches palette (Window menu) to specify a foreground color. You can also use the Color palette to choose a color: drag any of the sliders in the palette, or click anywhere on the spectrum bar at the bottom of the palette. The Swatches and Color palettes are shown in figure 4-36.

 ✎ *In Grayscale mode, color selections in the Toolbox are displayed in shades of gray.*

- Clicking anywhere on an image with the Eyedropper tool will pick up the color from that area of the image and make it the foreground color.

 ✎ *With some tools, holding down the Option key (Alt key) will temporarily turn the tool into the Eyedropper tool, enabling you to quickly pick up a new foreground color.*

- To return the foreground and background color settings to their defaults (black and white), click on the small set of overlapping squares at the lower left of the Foreground/Background Color Picker.

Figure 4-36 Swatches and Color palettes.

Figure 4-37 The File menu.

• To reverse the foreground and background colors, click on the double arrow at the upper right of the Foreground/Background Color Picker.

Screen Mode Tools

Use the three Screen Mode buttons near the bottom of the Toolbox to control monitor display. The Standard Mode button shows the image and displays the menu bar, window borders, and all open palettes. The Full Screen Mode with Menu Bar button (middle) hides the window border and centers the image on a gray background. The Full Screen Without Menu Bar button (right) hides the menu bar and centers the image on a black background.

TIP: Pressing the Tab key will toggle between hiding and showing the Toolbox and palettes.

Menus and Commands

Menus

Photoshop's commands are available from the menu bar across the top of the screen, as shown in figure 4-37. Click on a menu title to view all the commands in the menu. Some of these commands have submenus, which are indicated by an arrow next to its name.

Keyboard Shortcuts

Many menu commands have easy-to-remember keyboard equivalents. If you are a Macintosh user, press Command, Shift, ~ and/or Option in combination with the appropriate key to invoke the command. If you are a PC user, press Con-

trol and/or the Alt key. For a list of the most commonly used keyboard shortcuts, see Appendix B.

Dialog Boxes

A dialog box displays options and adjustment settings for some menu commands. The box can be repositioned by dragging the bar at the top of the box. No other tasks can be performed when a dialog box is open. Click on either OK or Cancel to close the dialog box.

Basic Menu Commands

Image Size

The Image Size command enlarges or reduces the size of an image.

1. From the Image menu, choose Image Size.

2. In the dialog box, shown in figure 4-38, check the Constrain Proportions and Resample boxes at the bottom.

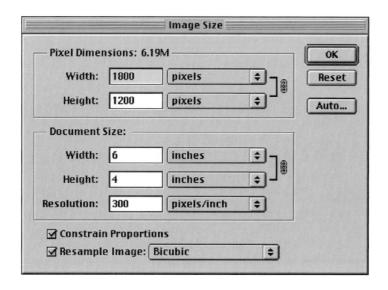

Figure 4-38 Image Size dialog box.

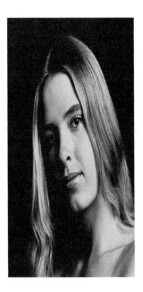

Figure 4-39 An image compressed horizontally.

3. Enter a new value in either the Width or Height field. The other field will change proportionally. The overall file size (in kilobytes) will also change. Click on OK.

✎ *To distort the dimensions of an image by compressing or expanding only its width or height, uncheck the Constrain Proportions box. Changing the horizontal dimensions of the image in the Width field will not affect the vertical dimensions in the Height field. The image will shrink or stretch according to the dimensions specified in the dialog box, as shown in - figure 4-39*

Canvas Size

The Canvas Size command enlarges or reduces the work space of the picture file without changing the actual size or dimensions of the image itself. When you use this command to enlarge the canvas, it creates a border around the image using the background color. When you reduce the canvas

Figure 4-40 Canvas Size dialog box.

size, it crops part of the current Image. An alert dialog box will appear to warn you that clipping will occur. Click on the Cancel or Proceed button.

1. Select a background color.
2. From the Image menu, choose Canvas Size. In the dialog box, shown in figure 4-40, enter new values in the Width and Height fields.
3. Click on any of the nine anchor squares to set the relative reposition the image on the new canvas. Click on OK.

Rotate Canvas

The Rotate Canvas command in the Image menu flips or rotates the entire canvas to a new orientation, as shown in figure 4-41.

- To flip the canvas horizontally or vertically, choose Flip Horizontal or Flip Vertical in the submenu.
- To rotate a canvas a preset number of degrees, choose 180º, 90º CW (clockwise), or 90º CCW (counterclockwise).
- Select Arbitrary if you want to specify the exact angle of rotation. When the dialog box appears, enter a number value for degrees (from 0° to 359.99°) and click on OK.

Transform

The Transform command lets you change the size, shape, orientation, or angle of a layer or selected area, as shown in figure 4-42. This command cannot be used on the background layer unless you make a selection first, and some of the transformations (such as Rotate) will expose background areas of the image.

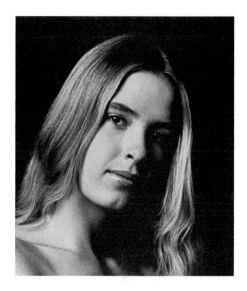

Figure 4-41 Flip Horizontal command.

Figure 4-42 An image selection with the Transform > Rotate command applied.

1. In the Layers palette, click on a layer name or select an area using any selection tool.

2. From the Edit menu, choose Transform, and then choose one of the following commands from the sub-menu: Scale, Rotate, Skew, Distort, Perspective, Flip Horizontal, or Flip Vertical. The first five commands create a bounding box with handles around the image.

3. Drag the handles to adjust the transformation, then press the Enter or Return key to apply the transformation. To cancel a transformation, press the Escape key.

 ✎ *To maintain the proportions of the image with transformations that resize the image, hold down the Shift key while dragging the corner handles. Holding the Shift key while rotating the image will constrain the rotation angle to multiples of 45°.*

Copy and Paste

- The Copy command copies a selected area of an image but leaves the selection intact.

- The Cut command copies a selected area of an image and deletes the original selection.

- The Paste command pastes a copied selection onto a new layer.

- The Paste Into command pastes a copied selection inside a new selected area and places it on its own layer with a layer mask.

The basic procedure for copying and pasting goes as follows.

1. From the Select menu, choose All, or select an area of the image using any selection tool.

2. From the Edit menu, choose Copy.

3. Open a second image.

4. From the Edit menu, choose Paste. A new layer will automatically be created with the image you copied previously.

✎ *To soften the edges of a selected area of an image to be copied, choose Feather from the Select menu before using the Copy command. The Feather command opens a dialog box that lets you specify the amount of feathering.*

You can also copy and paste using the Move tool.

1. Open two images. Position them on screen so they are both visible.

2. Activate the window of the image you want to copy from. In the Layers palette, click on the layer to be copied. If you only want to copy part of the image, make a selection first.

3. Click on the Move tool.

4. Drag from the active window to the inactive window. The selected image from the first window will automatically be copied and pasted onto a new layer in the second window.

Once an image has been pasted, you can reposition it with the Move tool or edit it with one of the Transform commands.

Fill

The Fill command fills a layer or selection with a color or pattern, as shown in figure 4-43.

1. From the Edit menu, choose Fill.

2. In the dialog box, click on the Use button. In the pop-up menu, choose Foreground Color, Background Color, Pattern, or another option. If you choose Pattern, click on the Custom Pattern arrowhead. In the Pattern Picker, choose a pattern.

3. Choose a blending mode and an opacity percentage. Click on OK.

Figure 4-43 Fill command dialog box.

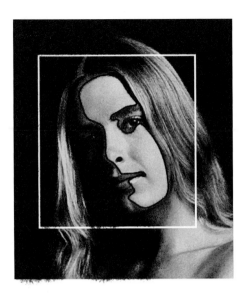

Figure 4-44 Stroke command.

Figure 4-45 Canvas filled with a pattern created using the Define Pattern command.

Stroke

The Stroke command outlines an entire layer or a selected area with the foreground color, as shown in figure 4-44.

1. Select an area using any selection tool.

2. Select a foreground color.

3. From the Edit menu, choose Stroke.

4. In the dialog box, enter a value in the Width field. Click on the Color button to change the foreground color. Click on the Location button to specify whether the stroke will be applied inside, outside, or centered on the selection. Select a Mode and enter a percentage in the Opacity field. Click on OK.

Define Pattern

The Define Pattern command lets you create a pattern from a section of an image, as shown in figure 4-45.

1. Click on the Rectangular Marquee tool. In the image, drag to define the area of the image to be converted into a pattern.

2. From the Edit menu, choose Define Pattern.

3. Deselect.

4. Create a new, blank canvas that is significantly larger in size or resolution than the image selection used to define the pattern.

5. From the Edit menu, choose Fill. In the dialog box, click on the Use button. In the pop-up menu, click on Pattern. In the Pattern Picker, click on the pattern you previously defined. Click on OK.

✎ *If no area is selected, the entire image will be defined as the pattern.*

You can "paint" an image using either a predefined pattern or a custom pattern.

1. Click and hold on the Clone Stamp tool and drag to the Pattern Stamp tool.

2. Select a brush size, opacity percentage, and a pattern.

3. Drag on the image to apply the pattern with brush strokes.

Colorize

The Colorize command converts the tones of an RGB image to monochrome.

1. From the Image menu, choose Adjustments > Hue/Saturation.

2. In the dialog box, check the Colorize box. Adjust the Hue, Saturation, and Lightness sliders to get the desired effect. Click on OK.

 ✎ *See plate 11 of the color insert.*

Desaturate

Desaturating an RGB image converts colors to grayscale values.

- To desaturate an entire layer, choose Adjustments > Desaturate from the Image menu.

- To convert areas of an RGB image to grayscale, return the foreground/background colors to their defaults (black and white), and drag with a brush set to Saturation blending mode.

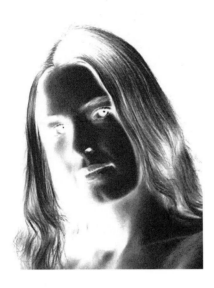

Figure 4-46 Invert command.

Invert

To reverse the tonal values of an image so that it looks like a negative (see figure 4-46), choose Adjustments > Invert from the Image menu.

Threshold

The Threshold command converts the tones of an RGB or grayscale image to black-and-white values, as shown in figure 4-47.

1. From the Image menu, choose Adjustments > Threshold.

2. Move the slider to adjust the relative amounts of black and white. Click on OK.

Posterize

The Posterize command reduces an RGB or grayscale image to large, flat areas of color or brightness values, as shown in figure 4-48.

1. From the Image menu, choose Adjustments > Posterize.

2. In the dialog box, check the Preview box, and enter a number between 2 and 255 in the Levels field. The lower the number, the fewer the tonal values. Click on OK.

Figure 4-47 Threshold command.

Figure 4-48
Posterize
command.

Modes

Depending on how it will be used, an image can be converted to a variety of modes. For example, a CMYK image can be output on a 4-color press, while an RGB version of that same image could be put on a Web page.

1. From the Image menu, choose Mode.

2. In the Mode submenu, choose one of the following.

 ✗ *Bitmap:* A black-and-white mode with no gray values, as shown in figure 4-49. It is often used for graphic design. Before being converted to a bitmap, a color image must first be converted to grayscale.

 ✗ *Grayscale:* A continuous-tone black-and-white mode offering 256 levels of gray.

 ✗ *Indexed Color:* A special color mode using a defined palette of up to 256 colors. It is often used to create special effects. Before being converted to Indexed Color, a color image must first be converted to RGB. An indexed color image must be converted back to RGB or CYMK to be further manipulated using filters and other commands in Photoshop.

 ✗ *RGB:* The default color mode for editing images on screen in Photoshop. It is an *additive* mode that uses up to 256 levels of each of the three primary colors—red, green, and blue—to display potentially "millions" of different color combinations.

 ✗ *CMYK:* A color mode that simulates what happens on a commercial offset press when the four *subtractive* pigments—cyan, magenta, yellow, and black—are combined to form different color combinations.

Figure 4-49 Bitmap mode.

Palettes

Palettes are special "mini" windows with controls that let you monitor and modify the changes you make to an image on screen. You can open the different palettes from the Windows menu. You close them by clicking on the Close box on the Title bar. Reposition them on screen by dragging the title bar.

Layers Palette

Layers are transparent planes of an image that can be stacked one on top of another. Each layer in an image can be edited separately from the rest of the layers. The Layers palette, shown in figure 4-50, organizes layers so that they can be individually altered, reordered, and merged with other layers.

Figure 4-50 Layers palette.

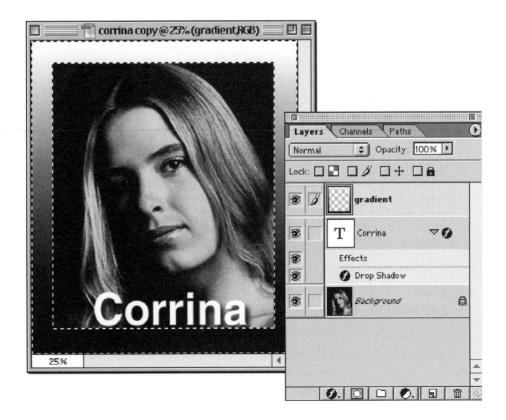

Creating a New Layer

There are a number of ways to create a new layer.

- From the Layer menu, choose New > New Layer, give the layer a name, and click on OK.

- Click on the Create New Layer icon at the bottom of the Layers palette. If you hold the Option key (Alt key) while clicking the icon, a dialog box appears that will let you name the layer.

- Click on the arrowhead in the upper right-hand corner of the Layers palette, and choose New Layer from the menu.

- In the Layer menu, choose New > Layer Via Copy.

Managing Layers

Use the Layers palette to hide, delete, duplicate, and rearrange the order of layers. You can also apply special blending modes and opacity effects with the palette.

- To hide a layer, deactivate the "Eye" icon to the left of the layer name in the palette.

- To delete a layer, drag it to the Trash icon at the bottom of the palette.

- To duplicate a layer, click on the arrowhead in the upper right-hand corner of the palette. In the menu, choose Duplicate Layer.

 Alternatively, select Duplicate Layer from the Layers palette menu.

- To rearrange the order of layers, drag a layer name up or down in the list and release.

- To change the blending mode of a layer, click on the mode button and choose a new blending mode from the pop-up menu.

- To change the opacity of a layer, adjust the Opacity slider near the top of the palette to the desired percentage.

- To merge two layers, position the two layer names next to each other. Click on the top layer to highlight it. From the Layer menu, choose Merge Down.

 ✎ *Alternatively, choose Merge Down from the Layers palette menu.*

- To flatten all layers into a single background layer, choose Flatten Image from the Layer menu.

 ✎ *The more layers an image has, the larger the file size. An image with layers can only be saved as a Photoshop, PDF, or TIFF-format file.*

Adjustment Layers

Applying various image adjustments to a layer directly will permanently alter the image on that layer (unless you undo the adjustment or step backward with the History palette). An **adjustment layer** lets you "save" an image adjustment on a separate layer without altering the image on the original layer to which the adjustment was applied. The advantage of using adjustment layers is that they can be deleted without also deleting the layer that contains the actual image.

1. In the Layers palette, click on the layer name to be adjusted.

2. From the Layer menu, choose New Adjustment Layer, and then choose an adjustment type (e.g., Levels, Hue/Saturation, and so on). In the dialog box, make the desired adjustments. Click on OK.

3. To edit an adjustment layer, double-click the thumbnail icon next to the layer name, and then make the appropriate changes in the dialog box.

Layer Masks

A layer mask "erases" a portion of a layer with brush strokes, revealing the layer beneath it.

✎ *A layer mask cannot be used on the background layer.*

1. In the Layers palette, click on the layer name.

2. From the Layer menu, choose Add Layer Mask > Reveal All.

3. Select black as the Foreground color.

4. Click on the Paintbrush tool. On the Options bar, choose a brush size, Normal blending mode, and 100% opacity.

5. Drag the brush over the parts of the image you want to mask out. The area brushed will disappear to reveal the layer beneath it, and will appear as a black area in the Layer Mask thumbnail.

6. To reduce the masked area, perform either of the following actions.

 ✗ With the Paintbrush selected, change the foreground color to white and begin brushing.

 ✗ With the Eraser tool selected, change the foreground color to white and begin erasing.

Channels

The Channel palette, shown in figure 4-51, resembles the Layers palette, but the layers, or **channels,** contain all the color information for the image (one channel for grayscale, three for RGB, four for CMYK). Each channel can be adjusted separately. In addition, the palette can contain grayscale Alpha channels for creating sophisticated masking effects.

1. Use a selection tool to choose part of an RGB image.

2. In the Channels palette, click on the Save Selection as Channel icon at the bottom of the palette. A new grayscale channel named Alpha 1 will be created.

3. Deselect.

Figure 4-51 Channels and Paths palettes.

4. Click in the empty box to the left of the Alpha 1 channel so that the "Eye" icon appears. A red, translucent mask will become visible in the areas of the image that had previously been unselected.

5. Click on the Alpha 1 channel to make it active.

6. Use the Paintbrush to add to the mask, or the Eraser tool to remove part of the mask.

7. Click on the Load Channel as Selection icon at the bottom of the Channels palette. A selection marquee will surround the unmasked areas of the image.

8. Click on the "Eye" icon in the Alpha 1 channel to hide it.

9. Click on the RGB channel to make it active.

10. Deselect, and return to the Layers palette. Because the selection has been saved in the Channels palette, you can go back and reload it any time you want. Just choose Load Selection from the Select menu and choose the name Alpha 1 from the Channel dropdown menu in the dialog box.

Other Palettes

- The **Paths** palette lets you save and manage vector paths created with the Pen tool.

- The **History** palette maintains a chronological record of every adjustment you make to an image. If you need to return to a previous state of the image, just step back through the "timeline" created by the palette.

- The **Actions** palette comes pre-installed with a variety of "macros," or actions, which automate certain tasks in Photoshop. You can also record your own sets of actions and save them in the palette for reuse later on.

- The **Color** and **Swatches** palettes let you create, edit, and save colors.

Correcting Mistakes

As you manipulate an image in Photoshop, you are bound to make a few errors. Or perhaps some command or adjustment you applied to an image may not have turned out quite the way you had hoped. Never fear! In the digital darkroom, you can always fix your mistakes.

Undo Command

The simplest way to undo an adjustment is to choose Undo from the Edit menu. It will undo only the last adjustment you performed; but if you decide, on second thought, that you want to restore that adjustment, simply choose Redo from the Edit menu. The keyboard shortcut Cmd/Ctrl Z toggles between Undo and Redo. Once you save any image, however, neither option will be available in the Edit menu.

Step Backwards Command

The Edit > Step Backwards command is similar to the Undo command—except that it allows you to step backward through a series of multiple Undo's.

History Palette

The History palette, shown in figure 4-52, preserves a separate image state for each adjustment you apply, in the order in which it occurred, and names the state after the tool used or the command applied.

1. Open an image.

2. From the Windows menu, choose History.

Figure 4-52 History palette.

3. Make a series of adjustments to the image.

4. Click on a state name in the History palette to revert back to that state of the image in the sequence of adjustments you made.

5. To step forward through the History palette, click on a state name below the currently selected image state.

6. If you drag a state onto the Trash icon, it will be deleted, along with all subsequent states.

✎ *To delete a state without eliminating other states, click on the arrowhead in the upper right corner of hte History palette. Choose History Options from the palette menu. In the dialog box, check the Allow Non-Linear History box, and click OK.*

History Brush

Use the History Brush to paint over the current pixels of an image, replacing them with the corresponding pixel attributes of a previously defined state of the image.

1. Click on the History Brush tool. In the Options Bar, choose a brush size, mode, and opacity.

2. From the Windows menu, choose History. In the History palette, click on the blank square to the left of the state to be restored. The History Brush icon appears in that square.

3. Drag on the image to replace the current pixels with those from that history state.

Revert

The File > Revert command discards all changes and reloads the last saved version of an image.

Managing Files

All changes to an image are temporary until it has been saved. It is a good idea to save regularly to avoid losing work.

Save and Save As Commands

There are two options for saving an image (other than using the **Save for Web** option).

- The **File > Save** command saves the image to disk in its current state, discarding the last saved version.
- The **File > Save As** command will create a new file, leaving the last saved version intact.

When you choose the Save As command (and the Save command as well, if you are saving an image for the first time), you are prompted in the dialog box to give the image a name and to specify a file format for the image.

After an image has been saved, you can close it with the File > Close command. If you try to close an image that has not been saved, an alert dialog box will appear, asking if you want to save changes to your image.

To close the Photoshop application, choose File > Quit (Mac) or File > Exit (PC).

About File Formats

An unflattened Photoshop file with layers and alpha channels can only be saved in Photoshop, PDF, or TIFF format.

If you flatten a Photoshop file but leave any alpha channels in place, the Save dialog box gives you a number of file for-

mat options from which to choose. If you delete the alpha channels from a flattened image, you are given even more options.

The file size, or amount of storage space an image requires, will in part determine how and where it can be stored. The image can be saved as a **compressed** or **uncompressed** file. Uncompressed images (such as native Photoshop format, or uncompressed PICT and TIFF files) retain all image data, but they tend to be considerably larger than compressed files.

There are two main types of image compression: "lossless" and "lossy." **Lossless** compression condenses an image using mathematical algorithms; but all image data remains in place. Compressed TIFF format is an example of lossless compression. **Lossy** image compression actually discards small amounts of image data to reduce file size. An image saved as a JPEG file has undergone lossy compression.

Storing Images

Images can be stored on the hard drive of your computer or on removable media. However, to avoid the risk of original files becoming corrupted or deleted, make a habit of saving duplicate back-up files in a separate location. The following are specifications for the most commonly used storage media.

- *$3^1/_2$-inch floppy disk:* Holds 1.3 MB. Best suited for small, compressed files.

- *Zip disk:* Comes in 100 MB and 250 MB versions. A Zip drive is necessary to read and write a Zip disk. A 250-MB disk can be used only in a 250 MB drive. Ideal for medium-sized images.

- *CD-ROM:* Holds from 650 to 740 MB. A writable CD-ROM drive is necessary if you want to "burn" your own CD-ROM disks. A CD can hold extremely large files, as well as numerous medium-sized and small files.

Electronic Printing

Types of Prints Made from the Computer

There are a number of ways in which an electronic image can be printed. The following are among the possible printed output types.

- *Traditional photographic print:* Many commercial photography labs can print digital images directly onto photographic paper without using film. A digital image can also be transferred to film using a film recorder and then printed using conventional darkroom techniques.

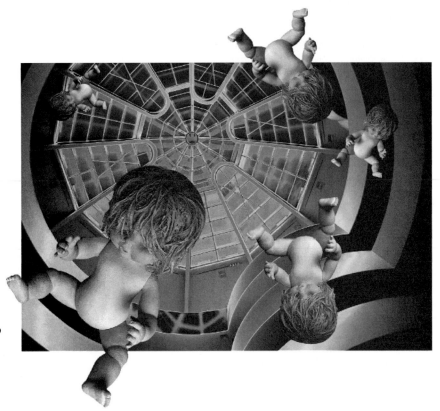

Figure 5-1 *Getting into the Gug* (original in color). *Digital image by Philip Krejcarek.*

- *Laser print:* This type of print can be output either in color or in black-and-white. Laser printers are capable of applying toner to a variety of paper surfaces.

- *Ink-jet print:* This print can also be output either in color or in black-and-white. The printer sprays ink onto the

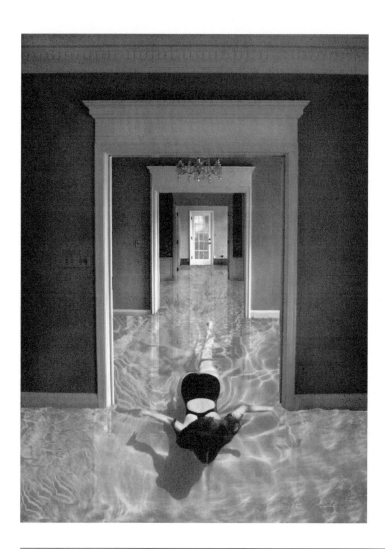

Figure 5-2 *Journey* (original in color). *Digital image by Patricia Goodan.*

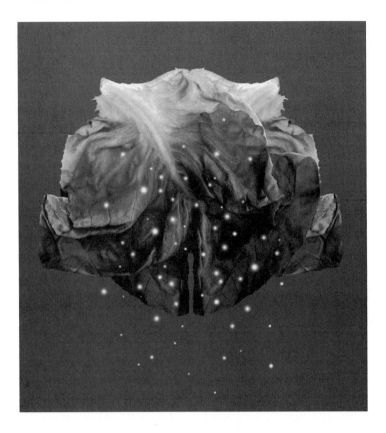

Figure 5-3 *Levitation* (original in color). *Digital image by Philip Krejcarek.*

surface of the paper. Most such printers are capable of printing on a variety of surfaces. Ink-jet printing is becoming comparable in quality to the traditional photographic process.

• *Lithographic print:* If the final print is to be output on a commercial press, the electronic image has to be separated into the primary pigments that will be used by the printer. The standard process colors for this type of print are CYMK (cyan, yellow, magenta, and black). To convert an RGB color image in Photoshop to a 4-color process equivalent, choose Mode > CMYK from the Image menu. To assure proper color balance, consult

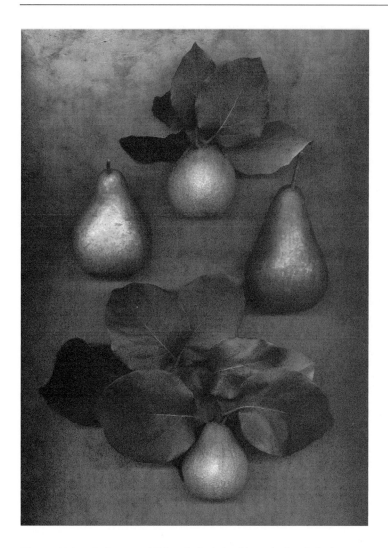

Figure 5-4 *Quince and Friends* (original in color). *Digital image by J. Seeley.*

the printer about what settings to use in the Color Setup preferences.

If you intend to use a service bureau to output film separations for offset printing, you will need to deliver the files on a portable medium. Most service bureaus accept both Zip and CD-ROM disks.

Printing from the Computer

The directions for using a desktop printer vary from one brand to another. However, the following are the basic steps for printing an image from Adobe Photoshop on both the Mac and PC.

1. From the Image menu, choose Image Size.

2. Check the Constrain Proportions box, but uncheck the Resample Image box.

3. Adjust the Width and Height settings so that the image will fit onto the size of the paper being used. Many printers cannot print to the very edge of the paper, so the dimensions of the image must be smaller than the paper being used.

4. Make sure the resolution is high enough to output a good-quality image—usually, 200 to 300 pixels per inch is adequate. If the resolution is much higher than that, printing can take considerably longer, with no perceptible improvement in quality. If necessary, check

the Resample Image box and enter a smaller number in the Resolution field. (Avoid entering a larger number if you can help it!) Click on OK.

✎ *In Photoshop 7, image size can also be adjusted by selecting the File > Print with Preview dialog box.*

5. From the File menu, choose Page Setup. In the dialog box, establish appropriate settings for your output:

 ✗ Paper size

 ✗ Orientation (portrait or landscape)

 ✗ Size percentage. Leave this field at 100% if the image size has already been adjusted.

6. From the File menu, choose Print. You may have to establish more settings in the Print dialog box, such as:

 ✗ Paper type

 ✗ Ink—color or black

 ✗ Resolution

7. Click on Print.

Assignments for Developing Creativity

You go to these schools, and the kids all show you gorgeous prints of water running over pebbles. I'd rather see a not-so-gorgeous mistake of a brilliant idea, an idea that maybe the kid didn't even know how to solve technically, but who cares, because he's talking about something incredible. It's not the medium, it's the message for me.

—Duane Michals (born 1932), fine art photographer

The assignments in this chapter are intended for the beginning student of photography. You can use either traditional or digital cameras. Cameras with adjustable shutter speeds and aperture are required for many of the assignments. Although the darkroom is not necessary for these assignments, all of them could be performed in conjunction with darkroom work.

The assignments come from a variety of sources and have been presented with various modifications. Their purpose is to stimulate creativity and imagination while exploring and discovering one's individual approach to photography.

One of the more difficult tasks that face an artist or designer is to trigger the imagination. One of the ways to do this is to set limitations and establish guidelines within which to work. The following assignments have all been used successfully in the classroom with actual students.

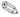 *The companion CD-ROM contains additional student examples and assignments.*

Assignments Using Traditional and Digital Cameras

The assignments that follow are intended to give you practical experience in using both traditional and digital cameras.

Assignment 6-1: Two People in a Relationship

Objectives

- Capture a relationship between two people in the same photograph.

- Experience working in both candid and posed situations.

- Concentrate on balance in the composition.

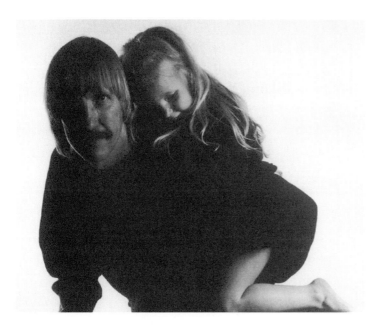

Figure 6-1 Two people in a relationship: father and daughter.
Photograph by Philip Krejcarek.

Guidelines

1. Photograph two people who are interacting with each other, such as:

 ✗ A mother and her baby

 ✗ A boy and girl holding hands

 ✗ Two elderly people playing checkers

 ✗ A teacher advising a student

 ✗ Two people engaged in a sports event

 ✗ Two people working cooperatively

 ✗ Two children playing

2. The relationship may be physical, emotional, or intellectual.

3. The two people do not have to be next to each other. Although more than two people may be in the photograph, the subject pair must be the center of interest.

4. Some of the photographs should appear to be candid, in that they appear not to sense the photographer's presence.

5. The subjects can be aware that they are being photographed, but try to *capture* the situation rather than *manipulate* it.

6. Some of the photographs should be posed, in that the photographer controls and directs the situation. Those photographs should seem more contrived and formal.

7. Try to balance all compositions so that each side has an equal weight or importance.

8. Some of the compositions should be balanced *symmetrically*—that is, one side is relatively identical to the other. Other compositions should be balanced *asymmetrically*—that is, one side is relatively different from the other, but the two sides have equal weight or importance.

Assignment 6-2: Asymmetrical Balance

Objectives

- Learn to form a composition from both 2D planes and 3D space.

- Experience the design possibilities involved in asymmetrical balance.

Guidelines

1. On one half of a roll of film, photograph compositions that exist on flat or relief surfaces—i.e., surfaces having some 3D texture or depth, but which are generally viewed from one side.

2. Look for such compositions on walls, billboards, ceilings, the ground, table tops, doors, sidewalks, old barns, water puddles, wet pavement, snow, windows, and so on.

3. On the second half of that the roll of film, photograph compositions that exist in space or in 3D areas.

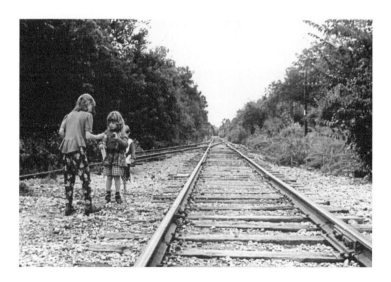

Figure 6-2 Asymmetrical balance. *Student photograph by Nancy Schultz.*

4. Such compositions should include areas or objects that are both nearby and far away, so as to reinforce a sense of spatial perspective. Look for such compositions on streets or sidewalks, up the sides of buildings, along railroad tracks, or wherever a distance or space can be composed in the viewfinder.

5. Through the viewfinder, move the camera and yourself until you have found a center of interest—i.e., a dominant area that draws the most attention.

6. Arrange all of your compositions so that the center of interest is not in the middle of the viewfinder. That is, arrange the compositions asymmetrically. This means that one half or side of the picture plane should be different from the other. However, for the two sides to be balanced, both should hold equal weight or importance. Asymmetrical balance is a "felt" (or perceptually analytical) balance, which is based on judgment rather than measurement

7. By moving the center of interest away from the middle of the viewfinder, the composition takes on dynamics not usually associated with the regimented order of symmetrical balance. To balance the opposite side of the composition, use a secondary center of interest, or simply a space that has been broken up by lines, shapes, forms, values, or textures.

8. Within each composition, look for a repetition of similar lines, shapes, forms, values, or textures.

9. If there are too many different elements to organize, concentrate on just a few of them by cropping (moving closer to the subject) or by shifting to another vantage point.

Assignment 6-3A: Light as the Subject

Objectives

- Experience making exposures in low-light situations.
- Become sensitive to the effects of available lighting.

Guidelines

1. Without using a flash unit, photograph under relatively low-light situations, either indoors or outdoors at night.

2. Use the available light as it normally exists, both naturally and artificially. Evaluate the lighting not only for its intensity but also for its quality. That is, how does the light illuminate objects and surroundings, and thus the tonal values in the composition?

3. Use a film with a high ISO rating, such as Kodak's Tri-X (ISO 400). Such films react to light quickly, making them ideal for use in low lighting situations.

4. Take light meter readings from the reflected light areas of your subject. Do *not* take the light reading directly from the light source, which would result in underexposure in all areas except the light source. In extreme low lighting situations, where the meter is not regis-

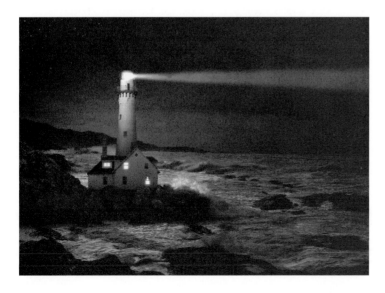

Figure 6-3 Light as the subject. *Lighthouse* (original in color). *Digital image by Steve Puetzer.*

tering, use the B shutter setting with the lens at the widest aperture. **Bracket** (take various exposures of the same scene) by using shutter speeds longer than the preset camera speeds.

Notes

1. The following are recommended exposures for Tri-X in lower light:

 ✗ *Fluorescent light: ƒ/4 at 1/60 second*
 ✗ *Incandescent light (light bulbs): ƒ/2 at 1/30 second*
 ✗ *Street lights: ƒ/2 at l/15 second*

2. With shutter speeds longer than 1/60 second, with a normal lens, use a tripod or support to prevent camera movement.

3. Use a cable release or self-timer to prevent camera movement during long exposures.

Optional

- After experiencing the effects of lighting in average low-light situations, try some extreme low-light situations. For example, try scenes lighted by candlelight, fireplace light, or moonlight.

- Often when photographing in low light, it is best to use the widest lens aperture to allow for the fastest shutter speed.

- Try photographing in a low-light situation with a small aperture opening (highest ƒ-stop number) to achieve a long depth of field, or distance in focus. Generally, this will require extremely long exposures.

- When photographing moving objects or people in low light (such as sports events at night), it is often impossible to use a fast enough shutter speed to stop the action or prevent a blurred image.

- By increasing the ISO of the film beyond its normal rating, the shutter speed can be increased. The film then has to be specially processed to compensate for the exposure. This is called **push processing.**

Assignment 6-3B: Painting with Light

Objective

- Explore light for its experimental design potential.

Guidelines

1. Using the lighting in an outdoor night situation, create photographic designs by moving the camera during the exposures.

2. Set the shutter speed on the B setting and the aperture at $f/5.6$ as a starting point for ISO 400 film.

3. Move the camera in front of the lights during a 2- to 5-second exposure. Because it is difficult to determine

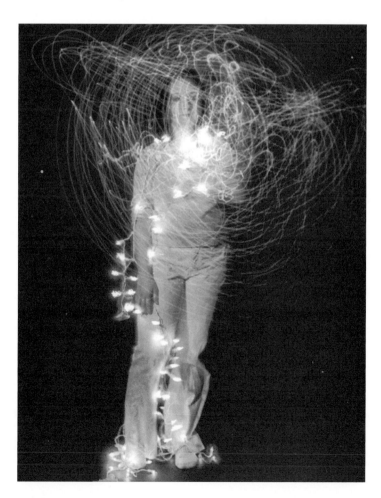

Figure 6-4 Painting with light. *Student photograph by Sarah Lasee.*

the correct exposure, vary the time or the ƒ-stop used—in other words, *bracket* the exposures.

Notes

1. When using a single-lens reflex camera, it is often difficult to control the composition because the viewfinder is blank during the exposure.

2. Plot out the movement of the camera before the exposure to pre-visualize the effect that camera motion will have on film. Even when the viewfinder is not blank, as with a rangefinder camera, designing using light can be difficult, because light by its nature is evanescent.

3. Often, the success of the exposures can be determined only after the film has been processed.

4. The selection or editing of the photographs taken can become as much a part of the creative process as the actual taking of the photograph. Because of the experimental nature of the exercise, unanticipated outcomes often make for the most interesting photographs. Therefore, learning to identify those photographs in which the elements "work together" successfully is an important aspect of the assignment.

5. If the lights in the scene make the surroundings too bright, the background of the photograph will not remain black, which will give the overall composition an overexposed look.

Optional

• When "painting with light," an alternative to moving the camera is to move the light source instead.

• Mount a stationary camera on a tripod. Point it at a dark scene with a minimum of lights. Position portable light sources within range of the viewfinder. Such lighting will produce a pattern of lines that appear to float. Often, the image of other moving objects will not be recorded, but the stationary areas of the scene will.

Colorplate 1
Late. Digital image by Maggie Taylor

Colorplate 2
Summerset. Digital image by J. Seeley

Opposite, top: Colorplate 3
Paintbox. Digital image by J. Seeley

Opposite, bottom: Colorplate 4
Red Wing. Digital image by J. Seeley

Right: Colorplate 5
Indiana Vultures. Digital image by Karen Thompson

Below: Colorplate 6
Goodbye Halloween. Digital image by Karen Thompson

Below, right: Colorplate 7
Fearless. Digital image by Karen Thompson

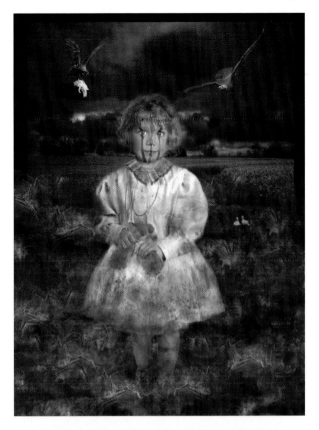

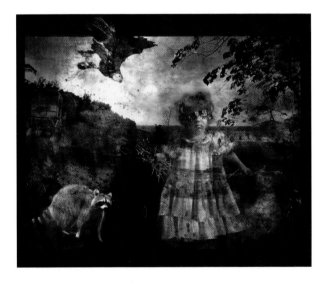

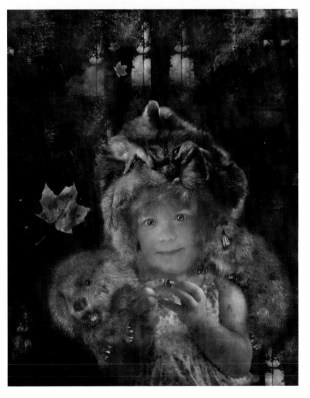

Colorplate 8
Lady Pepper, Sgt. Pepper, Penny Pepper, and Peter Pepper. *Digital images by Richard O'Farrell*

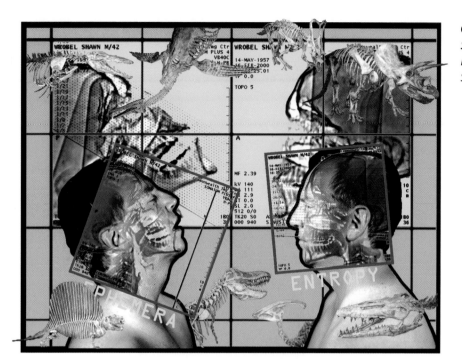

Colorplate 9
Self portrait.
Digital image by
Shawn Wrobel

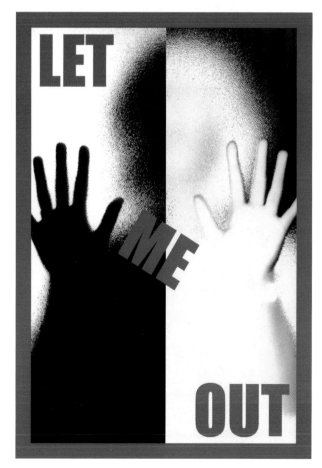

Colorplate 10
Let Me Out. Student image by
Emily Busch

Top left:
Colorplate 11
Portrait of Abbey.
Toning. By Sandy
McGee

Top right:
Colorplate 12
Portrait of Abbey.
Hand Coloring.
By Sandy McGee

Bottom right:
Colorplate 13
Buterfly. Digital
image by Steve
Puetzer

Colorplate 14
Best of Both Worlds. Digital image by Gerald Guthrie

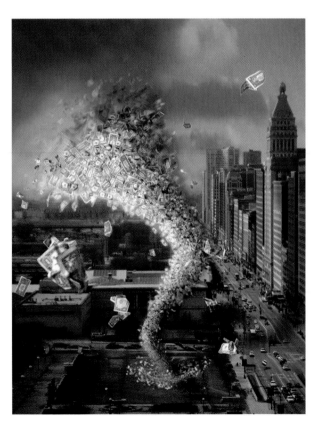

Top left: Colorplate 15
Particle Veil. Digital image by Lane Last

Bottom left: Colorplate 16
Fall of Man. Digital image by Lane Last

Bottom right: Colorplate 17
Money Tornado. Digital image by Steve Puetzer

Assignment 6-4A: Short Depth of Field

Objectives

- Learn to manipulate camera settings and camera distances so that only a short distance is in focus.
- Learn to control the placement of the depth of field.

Guidelines

1. Take all photographs with a short depth of field. To achieve this, use the lowest f-stop number possible, and always be close to something in the photograph. The center of interest in every picture should be in focus, with everything else out of focus.

2. Photograph a center of interest that is close to the camera, with everything behind it out of focus. The closer the point of focus, the shorter the depth of field. Be no farther away than 5 feet.

3. Photograph a center of interest that is in the background, keeping objects and areas in front of it out of focus. Set the camera focus to infinity (∞) when it is possible to still have the center of interest in focus.

4. Photograph the center of interest in a middle area, with objects and areas in both the foreground and background out of focus. The center of interest should be about 5 to 8 feet away. If the point of focus gets farther away than that, it would be difficult to get an out-of-focus area in the background.

Notes

1. Another way to shorten the depth of field is to use a telephoto lens rather than the standard lens.

2. Conversely, a wide-angle lens would not be as good a lens to use because it tends to increase the depth of field. The aforementioned distances would be longer when using a telephoto lens.

Figure 6-5 Short depth of field. *Student photograph by Guy Russ.*

3. Low *f*-stop numbers can be achieved using faster shutter speeds.

4. It would be difficult to use a film such as Tri-X (ISO 400) outdoors with a low *f*-stop number (the average exposure for a sunny day is *f*/22 at 1/250 second).

5. A film with a lower ISO number, such as Plus-X (ISO 125), would be easier to use because it reacts to light slower, therefore requiring a greater exposure (lower *f*-stop number). When taking photographs in the shade, indoors, or in any darker lighting, a lower *f*-stop number could be used. Finally, a dark camera filter, such as a neutral density filter, could cause the *f*-stop number to be lowered to allow more light to enter the camera.

Assignment 6-4B: Long Depth of Field

Objectives

- Learn to manipulate camera settings and camera distances so that a long distance is in focus.
- Better understand the use of a long depth of field as a philosophical approach to photography.

Guidelines

1. Take all photographs with a long depth of field (long distance in focus).

2. To achieve a long depth of field, use the highest *f*-stop on the lens, and do not be too close to anything in the photograph. Close-ups, by their nature, make it difficult to have a long depth of field.

Notes

1. Another way to lengthen the depth of field is to use a wide-angle lens, rather than the standard lens. Conversely, a telephoto lens would not be as useful as a wide-angle lens, because it tends to decrease the depth of field.

2. To use the highest *f*-stop number on the lens, a long exposure might be necessary.

3. Use a tripod for all exposures longer than 1/60 second. A cable release or the self-timer on the camera is recommended to prevent camera movement. For extremely long exposures, a cable release with a lock can be used. To create a photograph in which all areas are in sharp focus, the subject matter should be limited to non-moving people or objects.

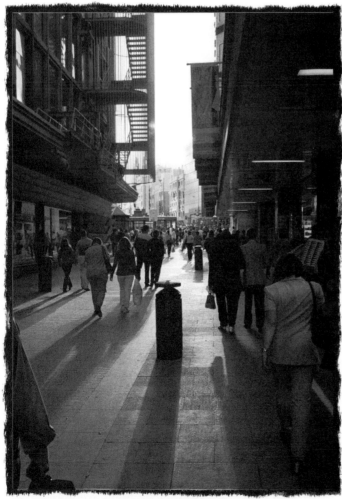

Toward Puerta Del Sol, Madrid, Spain, June, 2000

Figure 6-6 Long depth of field. ***Toward Puerta del Sol.*** *Photograph by Shawn Wrobel.*

If the photograph of a human being does not show a deep psychological insight, it is not a true portrait but an empty likeness. Therefore my main goal in portraiture is neither composition, nor play of light, nor showing the subject in front of a meaningful background, nor creation of a new visual image.

—Philippe Halsman

Assignment 6-5: Portrait

Objective

Strive for a variety of photographs of one person that depart from the standard studio (head-and-shoulders) portrait.

Guidelines

1. Consider the traditional high school graduation portrait: straight on, head-and-shoulders view; plain background; well-groomed and usually atypically dressed subject.

2. Then photograph one person in as many different ways as you can conceive and are able to execute.

3. The entire roll of film should be about one person only.

4. The person you select may be any age. Other people may appear in the pictures, but the one person should always be the center of interest.

5. The portraits can range from close-ups to full-figure.

6. Close-ups can be of parts of the face or body. The person's face does not have to appear in every picture.

7. The surroundings can range from a simple, plain background to a panoramic vista or landscape.

8. Consider various places in which to photograph a portrait. Try to take pictures in more than one setting. Would the surroundings have to be attractive in order to make a portrait? What about an alley, a dump, or a peeling sign as a background?

9. Try different types of lighting, such as the following.

 x *Diffused light:* As on a cloudy day, with no hard shadows.

 x *Back lighting:* As with a silhouette in a sunset, or against a window, or from artificial light.

 x *Direct lighting:* As from the sun.

 x *Dramatic (Rembrandt) lighting:* As light from one window into a room, or from a spotlight.

 x *Low light:* As from outside lights at night, or candlelight, or fireplace light.

10. Try different types of poses, from very contrived poses to natural, informal, candid poses.

11. Try different types of moods or expressions, from silly to pensive, from contrived to natural.

12. Try different types of clothing, from formal to casual, from natural to fantasy.

13. Consider using costumes or masks.

14. Look at portraits by contemporary and historical photographers, such as Matthew Brady, Edward Steichen, Arnold Newman, W. Eugene Smith, Diane Arbus, and Annie Leibovitz.

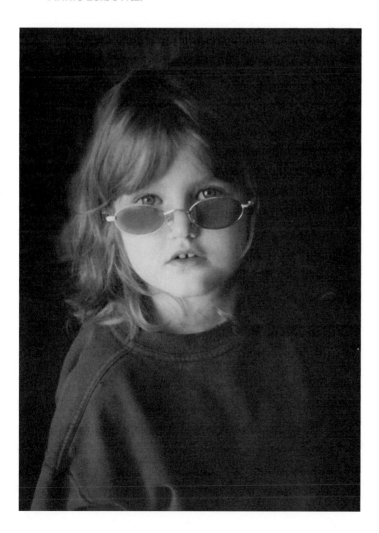

Figure 6-7 Portrait. *Abbie.*
Photograph by Sandy McGee.

I am my own investigation territory.

—Lucas Samaras (born 1936), fine art photographer

Assignment 6-6: Self-portrait

Objectives

- Experience the tradition of self-portraits in the history of art.
- Gain insight into one's own character, personality, and appearance.

Guidelines

1. Briefly investigate the history of self-portraits in an art history anthology.

2. What was the purpose or motivation of the artist to make a self-portrait? Look through photography books to find examples of photographers who made self-portraits. In what ways do the photographic self-portraits differ from those made in other media?

3. Photograph yourself.

4. What aspects of your character, personality, and appearance would you show to explain yourself to others? How do you see yourself? How would you depict yourself in a photograph?

5. The logistics of photographing yourself are more difficult than photographing someone else.

6. In some cases it is necessary to have someone other than yourself actually take the photograph. This should be done after you have made all decisions regarding composition, exposure, and focus.

7. Consider the following ways to take self-portrait photographs.

 a. Photograph your reflection in various mirrors (hand mirrors, bathroom mirrors, full-length mirrors, automobile rear-view mirrors, convex mirrors, carnival mirrors). Photograph your reflection in water (pools, lakes, rivers, puddles). Photograph your reflection

from shiny surfaces (cars, windows, chrome, glass, china dinnerware).

b. Make photograms of parts or all of your body. Use photographic paper, or sensitized paper or cloth for cyanotype or Van Dyke brownprint.

Figure 6-8 Self-portrait. *Student photograph by Heidi Schweitzer.*

c. Photograph your shadow or silhouette. Use both natural and artificial light. Create special effects by the placement of one or more artificial lights.

d. Using a wide-angle lens, photograph yourself at arm's length. Because a long depth of field can be achieved with a wide-angle lens, it would be possible to get both yourself and the background in focus.

e. Using the self-timer on the camera and a tripod, photograph yourself in a predetermined composition. An alternative to the self-timer would be a long cable release.

f. Pose a friend as if he were you. Decide upon the composition, the exposure, and the focus. Then, change places with the person. Give your helper explicit directions concerning the composition and then have that person photograph you.

g. Using the standard lens of the camera, photograph parts of your own body (arms, legs, feet, hands, or torso).

8. Study portraits by contemporary and historical photographers who have done self-portraits, such as Cindy Sherman, Arno Minkkinen, and Duane Michals.

Assignment 6-7A: Blurred Motion

Objectives

- Create the sense of motion within a static plane.
- Understand the effects of motion when employing a slow shutter speed.

Guidelines

1. Photograph people or objects in motion using a slow shutter speed.

2. Use 1/15 second or slower. Depending on the speed of the motion, a more dramatic blur might be possible with a longer exposure.

Notes

1. Some films, such as Kodak's Tri-X (ISO 400), cannot be easily used outdoors at a shutter speed of I/5 second or slower (the average exposure on a sunny day is f/16 at 1/500 second). To adjust for this, photograph in lower lighting; use a dark camera filter (such as a polarizing filter) to cut down the amount of light entering the camera; or use a lower ISO (which would require a longer exposure to change to light).

2. Use a tripod or support for the camera.

3. At slower shutter speeds, use a cable release or a self-timer to help prevent camera movement. At such speeds, it takes very little motion to create a blur.

4. When motion is too rapid, film cannot record a distinct image. Likewise, motion that is too slow for the shutter speed might create only a slight blur. Because it is difficult to visualize the effect motion will have on the film, bracketing shutter speed exposures is recommended.

5. Photographing at a slow shutter speed could mean using a high f-stop number, resulting in a long depth of field with everything in focus except the objects or people that are moving.

Figure 6-9 Blurred motion. *Student photograph by Heidi Schweitzer.*

Assignment 6-7B: Panning

Objectives

- Create the sense of motion within a static plane.
- Understand the effects of camera motion that follows a moving object or person.

Guidelines

1. Photograph people or objects in horizontal motion while moving the camera to follow the action.

2. The shutter should be released when the moving person or object is directly in front of the camera. The camera should not stop moving during the exposure but rather should continue to follow the motion. It is necessary that the camera move at a speed consistent with the motion of the subject being photographed. The

Figure 6-10 Panning. Milwaukee Journal Sentinel *photograph by William Meyer.*

result should have the center of interest in focus, with the background a series of blurred horizontal lines. Sports photographers often use this technique to photograph auto races, horse races, and track events.

3. Use a shutter speed of between 1/30 and 1/60 second.

4. Faster speeds might stop all action, causing everything to be in focus. Slower speeds could result in nothing being in focus. As with assignment 7A, depending on the speed of the subject being photographed, the shutter speeds could vary. Bracketing the shutter speeds on various exposures would help ensure at least one successful photograph.

5. Pre-focus the camera on a spot the action will cross.

6. It is difficult to focus while action is taking place. Pre-focusing allows you to be free to concentrate on the panning itself.

Assignment 6-7C: Stop Action

Objectives

- Create the sense of motion within a static plane.
- Understand the effects of a fast shutter speed on a moving object or person.

Guidelines

1. Photograph people or objects in motion using a fast shutter speed to stop or capture the movement at a particular moment in time.

2. When motion is occurring very quickly, it is often difficult to see individual stages of the movement. A fast shutter speed can record these separate moments, which are often not clearly registered by the human mind. Motor drive cameras, which can expose a num-

ber of frames of film in a single second, are used by photographers who want to photograph a number of stages in one total motion. These are also used when a photographer wants to be sure that a particular point in the motion is recorded; and rather than taking a chance on one exposure, a series is made from which to choose that one individual moment in time.

3. Use a shutter speed of 1/500 or 1/1000 second, or faster, to stop the action at a decisive moment.

Figure 6-11 Stop action.
Photograph by Mark Avery.

Assignment 6-8: Artificial Light

Objectives

- Become acquainted with the uses of artificial light in a studio situation.
- Understand the rules of natural lighting.

Guidelines

1. Photograph a still life or model under artificial light using one or two photoflood bulbs in reflectors. Position the lights so that the following rules of natural lighting are followed:

 ✗ There is only one main light source.

 ✗ All shadows go in the same direction.

 ✗ The main light is always above eye level.

 ✗ A secondary light should be used to give detail to the shadowed sides.

Figure 6-12 Artificial light.
Photograph by Philip Krejcarek.

✎ *When using color films with this lighting, a blue camera filter (80A) should be used to correct the color for most films except such films as Ektachrome 160T, which is color-balanced for incandescent bulbs.*

2. Include photographs that demonstrate the following lighting.

 ✗ *Studio portrait lighting:* A direct lighting in which the main light is aimed at a 45° angle to the subject from the front side, with a secondary light of less intensity (further back) from the opposite angle. This secondary light will give detail to the shadowed side.

 ✗ *Rembrandt lighting:* A direct lighting in which one main light is used from the side to create a dramatic high contrast between the lighted and the shadowed sides of the subject.

 ✗ *Silhouette lighting:* An indirect lighting in which both lights are bounced off the background to create a flat, black silhouette from the subject.

 ✗ *Diffused lighting:* An indirect lighting in which both lights are bounced off the ceiling to create an evenly diffused lighting without shadows.

Optional

• Photograph against a seamless background paper, which can be curved to fit the wall and the floor for a simple, non-distracting background. Such paper is available in a variety of colors and widths at artist's supply stores.

• Photograph an unnaturally lighted setting in which the rules of natural lighting are not followed. For example, position the lights so that they are coming from below the subject to create a mysterious "monster movie" type of atmosphere.

Assignment 6-9: Famous Photographer

Objectives

- Develop your visual expertise by imitating the photographic technique of a well-known photographer.

- Better understand the personal photographic involvement of one recognized fine art photographer.

Figure 6-13 Cindy Sherman emulation. *Student photograph by Kaitlin Rathkamp.*

Guidelines

1. Become familiar with the work of a variety of historical and contemporary fine art photographers, such as:

Ansel Adams	Diane Arbus
Ruth Bernhard	Bill Brandt
Wynn Bullock	Harry Callahan
Paul Caponigro	Henri Cartier-Bresson
Bruce Charlesworth	Imogene Cunningham
Judy Dater	Emmet Gowin
Robert Heinechen	Leslie Krims
Dorothea Lange	Robert Mappelthorpe
Ray Metzker	Duane Michals
Cindy Sherman	Aaron Siskind
Sandy Skoglund	Paul Strand
Joyce Tenneson	Jerry Uelsmann
Edward Weston	Minor White
Joel Peter Witkin	Garry Winogrand

2. Choose one of the photographers to investigate more thoroughly and to emulate in your own photographs.

3. Study a number of photographs by that one artist. What do you feel was the major concern in that photographer's work? What was the emphasis of the imagery? Are the intentions or purposes of the photographer clear and understandable? Is there a stylistic consistency throughout the photographs? What was particularly unique about the work?

4. Take photographs that imitate the style of that artist. The subject matter may be similar or it may be of your own choosing. Even though the subject matter may be different, photograph with the same approach or technique the famous artist would have used.

5. Create one image that replicates the composition of one of the famous photographer's works.

Assignment 6-10: Macro, Larger Than Life

Objectives

- Develop skills in close-up photography.
- Learn to visualize the macro world.

Guidelines

1. Using a macro lens (some zoom lenses are equipped with this), close-up lens attachments, or extension tubes, create macro photographs in which part of an object is not visible. In other words, do not photograph an entire object.

2. Use the highest f-stop number on the camera. This will produce the longest depth of field. A tripod will give the best results, because any movement close up will cause a blur. Using a bright light source will permit faster shutter speeds.

3. Focus toward the front. The depth of field is greater behind the point of focus than in front of it.

4. Make a print in which the subject photographed is larger than life.

Figure 6-14 Macro. *Student photograph by Elizabeth LaRoche.*

Assignment 6-11: Documentary/ Performance Photography

Objectives

- Experience and better understand documentary photography.

- Learn to document a person's life or activity in a meaningful way.

- Experience creating a "world" for a performance photograph.

Documentation: Recording history, photographing what exists, showing the world as it is, the real, candid, photographs that don't lie.

Guidelines: Documentation

1. Obtain two photographs you consider good documentary photographs.

2. Be prepared to explain why you chose these particular photographs. What is it about them that transcends the typical snapshot?

3. With documentation, you may pose something or somebody, but the result should look natural and candid.

4. Probably the biggest problem with this assignment is that people tend to photograph "memories" and forget about composition and creativity.

5. Photograph your friends, family, pets, and environment.

6. Think about how you would want to remember them. Make the setting important.

7. These are not to be portraits. Nobody should look into the camera.

8. Even though the image is to look natural or spontaneous, plan out the composition. This makes it much easier to set up the shot.

9. Photograph from a variety of angles and distances.

Guidelines: Performance

1. Obtain one photograph you consider representative of a good performance photograph.

2. Be prepared to explain why you chose this photograph.

3. With performance, you create a composition that would not occur naturally, but which you put together.

Performance: Creating a fantasy, photographing what doesn't exist, the unreal, posed, a dream world, the subconscious, Surrealism, photographs that LIE.

Figure 6-15 Documentation. Milwaukee Journal Sentinel *photograph by William Meyer.*

4. Juxtaposing two unrelated things or people would be a good way to get started. Incongruities become the performance. Try brainstorming for ideas.

5. Create a performance photograph using a chair, bench, stool, or couch.

6. Place these pieces of furniture in locations in which they normally would not appear.

Figure 6-16 Performance. ***Are Our Children Watching Too Much Television?*** (original in color). *Photograph by Philip Krejcarek.*

Assignments Using Electronic Imaging

The following assignments are intended to provide you with practice in digital artistry.

Assignment 6-12: Gulliver's Travels

In the tradition of *Gulliver's Travels* and *Honey, I Shrunk the Kids,* create images that illustrate disproportionate sizes.

Objectives

- Develop skills in selecting, copying, pasting, and pasting into.
- Learn how to scale.
- Create a composition with a repetition of shapes.
- Emphasize unnatural size relationships.
- Create the illusion of depth.

Guidelines: Image 1—Small Figures in a Large World

1. Scan a photograph of a small object or still life, and two or more photographs of human figures.

2. Use images from a book or magazine (fashion magazines are ideal for figures), or personal images.

3. Choose images in which the people are not "cut off" at the edge of the photograph. Figures may be in any position and could include props such as chairs. Figures against a plain background are easier to select using the Magic Wand tool.

4. Compose a digital image that shows disproportionate sizes.

 a. Open one of the figure images. Carefully select the figure using any of the selection tools.

Figure 6-17 Small figures in a large world (original in color). *Student image by Jessica Schuster.*

b. From the Edit menu, choose Copy.

c. Open the small object image. From the Edit menu, choose Paste. (Alternatively, use the Move tool, and hold and drag the selected figure onto the small object image.)

d. From the Edit menu, choose Transform > Scale, and adjust the size of the figure so that its scale relative to the small object is disproportionate. Hold down the Shift key while dragging the corner handles so as to maintain the height-to-width ratio of the scaled figure.

e. Using the Move tool, drag the figure to a position near or within the small object so that it looks like it naturally could have climbed there.

f. Adjust the Levels of the figure so that the tonal values of the figure and the object look similar.

g. Repeat steps a–f with the same figure, or add new figures to the composition, in different sizes, positions, or orientations.

h. Optionally, add a shadow cast from a figure using any technique. Make it look convincing.

Guidelines: Image 2—Large Figures in a Small World

1. Scan a photograph of an interior with open doors or windows, or a landscape.

2. Use the same figure images from the preceding assignment, or use different ones.

3. Compose a digital image using the following steps.

 a. Select and copy the figure.

 b. Use any selection command to select the doors or windows of the interior image, or the background

Figure 6-18 Large figures in a small world (original in color). *Student image by Jessica Schuster.*

(negative space) in the landscape image, and insert a figure into it.

c. From the Select menu, choose Paste Into.

d. Use the Move tool to position the figure within the selected area.

e. Use the Transform command to adjust the size of the image, and the Levels command to adjust the values.

f. Add two or more figures to the scene. They may be the same figures at different sizes.

g. Enlarge at least one figure and place it in the foreground. Cut off part of the body at the edges of the picture plane to enhance the feeling of depth in the composition.

h. Optionally, use an object instead of a figure.

Assignment 6-13: Words and Images

Barbara Kruger was known for appropriating images from media and adding words over the images. Her work is social/political in nature. After investigating her work, create a personal "Barbara Kruger" style message image.

Objectives

- Acquire skills in using type and scaling.
- Create an image that combines images and type.
- Become familiar with the work of Barbara Kruger.

Preparation

To begin the assignment, scan as RGB two high-quality magazine photographs, or use personal images that would be appropriate for a social/political statement.

Guidelines: Image 1—Boxes and Type

1. Use the Desaturate command to eliminate the color from the image.

2. Adjust the Levels so that there is a strong contrast range from black to white.

3. Create a new layer.

4. Use the Rectangular Marquee tool to create a box for the type.

5. From the Edit menu, choose Fill. Fill the box with either black or white.

6. Click on the Type tool. On the Options Bar, choose a bold font (Impact or Helvetica Bold) and large point size. Choose a color that is the opposite value of the filled box. Type words across the box.

7. From the Edit menu, choose Transform > Scale. Drag the corner handles so that the lettering fills the box.

8. Repeat steps 3 through 7 for additional boxes with words.

Guidelines: Image 2—Red Type, Directions, and Angles

1. Use the Desaturate command to eliminate the color from the image.

2. Adjust the Levels so that there is a strong contrast range from black to white.

3. From the Swatches palette, choose a bright red foreground color.

4. Click on the Type tool. In the Options Bar, choose a bold font and large point size. Type words in red. Alternatively, create a new layer and use the Rectangular Marquee tool to select rectangles and fill them with red. If red boxes are used, proceed with step 5. Otherwise, go to step 7.

5. Choose white as the foreground color.

Figure 6-19 Type in boxes (original in color). *Student image by Libby Amato.*

6. Using the Type tool, type words inside the red boxes in white letters.

7. Repeat for additional boxes with words or words alone.

8. Somewhere in the composition, use vertical or diagonal lettering.

Notes

1. Vary the sizes of the type.

2. Use a point size large enough to give the letters impact.

3. Keep the lettering style consistent.

4. Spacing and placement are important to the composition.

5. Scale the lettering to fit the boxes.

6. Avoid large, open areas.

7. Avoid "tangencies" and "cramped spaces," both in the boxes and the general composition itself.

8. Avoid lettering that "disappears" against the background.

Assignment 6-14: Pop Art Portrait
Objective

- Experience creating an image on the computer in the pop art style.

Preparation

1. Study the screened portraits of Andy Warhol.

2. Consider what about them made the style unique: bright, flat, unnatural colors; often, "painterly" lines drawn on top of the images; and a repetition of the image in various colors.

3. Scan in RGB two front-view, head-and-shoulders portrait photographs from a published source. Alternatively, use personal photographs.

Figure 6-20 Pop art portrait (original in color). *Student image by John Sezemsky.*

Guidelines: Image 1—Posterized Portrait with Brush Strokes

1. Use the Desaturate command to eliminate the color from the image.

2. Posterize with four levels. This will convert the image into flat values of white, black, and two grays.

3. Choose a foreground color that is dark in value.

4. Click on the Paint Bucket tool. In the Options Bar, uncheck the Contiguous box. Click on the black values of the image.

5. Choose a foreground color that is light in value.

6. Click on the Paint Bucket tool. Click on the white values of the image.

7. Repeat steps 5 and 6 for the two gray values. Each time, change the foreground color.

8. Create a new layer and name it *Brush strokes.*

9. Select a foreground color that already exists in the image.

10. Click on a Brush tool and apply lines on top of the portrait.

11. Repeat steps 9 and 10 with other colors from the image.

12. Optionally, use the Fade command (in the Brushes pop-up menu) on some lines. Use the Stroke command to add lines to selected edges.

Guidelines: Image 2—Four Posterized Portraits

In this assignment you will duplicate an image four times in the same file and colorize them. These duplicates may be aligned as a rectangular block, or side by side.

1. Open the second portrait and posterize it.

2. Use the Desaturate command to eliminate the colors in the image.

3. Posterize using four levels. This will convert the image into flat values of white, black, and two grays.

4. Select All, and choose Define Pattern from the Edit menu.

5. From the Image menu, choose Canvas Size. In the dialog box, double the size of the Width and Height fields (for a block), or quadruple the size of the Width field (for a line). Click on the upper left-hand anchor box.

6. Select All and fill with the pattern. Four complete portraits will be created.

7. Select a foreground color.

8. Select one portrait only with the Rectangular Marquee tool.

Figure 6-21 Multiple pop art portraits (original in color). *Student image by Katie Metcalf.*

9. Click on the Paint Bucket tool. On the Options Bar, uncheck the Contiguous box. Click on one value in the selected portrait.

10. Repeat steps 8 and 9 on the other portraits. Each time, choose different values to fill the same foreground color.

11. Choose another foreground color and repeat steps 7 through 9 on the other values in the image. In the end, no corresponding shape should be the same color.

To add painted lines to the four portraits, continue with the following steps.

12. Create a new layer and name it *Brush strokes.*

13. Click on a Brush tool. Apply lines on top of the portraits in colors that already exist in the composition.

Assignment 6-15: Genealogy

Objectives

- Learn to combine multiple images into single compositions.
- Experience using a digital camera.
- Create a genealogical composite.

Preparation

1. Collect photographs of yourself at various ages, along with photographs of your family, grandparents, ancestors, pets, and your house (interior or exterior, if possible).

2. Using a scanner, digitize these images from your past.

3. Photograph yourself using a digital camera. Include at least one silhouette of yourself.

4. Study the work of Martina Lopez. She creates composite images of portraits from the past in landscape settings.

5. Consider the following approaches:

 ✗ A composite of yourself at different ages. Possibly use a realistic background.

 ✗ A composite of your lineage, in which you are shown with your parents, grandparents, and ancestors.

 ✗ A composite of your gender lineage.

 ✗ An image of yourself as a baby being held by an older version of yourself.

 ✗ An image of you looking at, or presenting, your past.

Guidelines: Image 1—Composite

Create a composite of photographs from your past. Incorporate the following:

- A landscape or interior for the background. This could be from any source.

- One or more images of yourself, photographed with the digital camera.

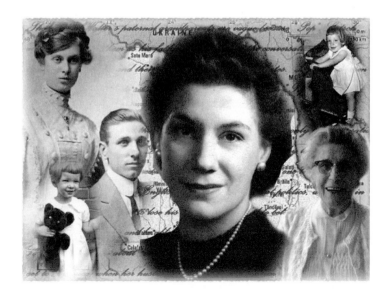

Figure 6-22 Genealogy (original in color). *Student image by Tara Strosin.*

- A double exposure, or transparent effect using the Layers palette. Soften the edges of the images using the Feather command.
- A border with an uneven edge.
- Pasted images that extend to the border.

Guidelines: Image 2—Silhouette

Create one image of your genealogy that incorporates a self-portrait silhouette photographed with the digital camera.

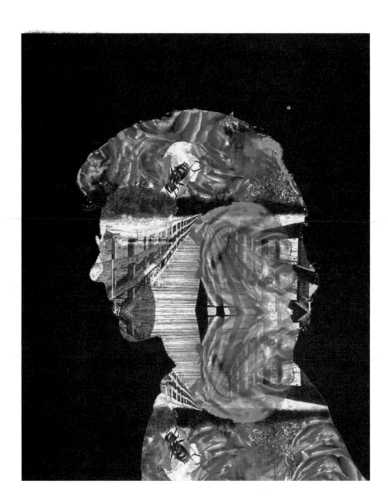

Figure 6-23 Silhouette (original in color). *Student image by John Sezemsky.*

Assignment 6-16: Toning, Hand-Coloring, and Gradients

Early black-and-white photographs were sepia-toned and hand-colored using oil paint. In Hollywood, old films have been colorized using computer technology. Color films have been "desaturated" to make them look old. This assignment involves digital toning, "hand-coloring" with the Hue/Saturation command, and using gradient blends.

Objectives

- Develop skills in colorizing images.
- Experience the traditions of sepia-toning and hand-coloring with electronic media.
- Acquire skills in using the Gradient tool.

 ✎ *Toning and coloring were introduced in exercises 3-15 and 3-16, respectively. This assignment incorporates the skills from those exercises.*

Preparation

Scan as RGB two high-quality magazine photographs, or use personal images.

Guidelines: Image 1—Sepia-Toning and Selective Coloring

 ✎ *See plates 11 and 12 of the color insert.*

1. Open a scanned photograph that might lend itself to application of an antique look.

2. From the Image menu, choose Adjustments > Hue/Saturation.

3. In the dialog box, check the Colorize box. Move the Hue slider to a brown color tint. Adjust the Saturation slider to choose an appropriate intensity of brown, and the Lightness slider to the point where the white areas have a brown tint. Click on OK.

✎ *This command does not require that the image first be desaturated.*

4. Using any selection tool, select areas to be "hand colored."

5. Feather the selection 5 pixels.

6. Repeat step 1 with a new color (Hue).

7. Select new areas and colorize them.

8. Show a repetition of any color used.

To hand-color with a brush, continue with the following steps.

9. Choose a foreground color.

10. Click on the Paintbrush tool. In the Options Bar, choose a soft brush and enter *50%* (or less) in the Opacity box. Drag to color the photograph.

Guidelines: Image 2—Gradient Background

1. Open a scanned photograph that has a plain sky or open spaces in the background.

2. Use the Desaturate command to eliminate the color.

3. Choose a foreground and background color.

4. Select the sky or open (negative) spaces using any selection tool.

5. Create a new layer.

6. Use the Gradient tool to fill the selected areas with a blend of the foreground and background colors. On the Options bar, choose Darken in the blending mode pop-up menu.

7. Deselect, and somewhere in the positive spaces of the composition, repeat the colors used in the gradient using a hand coloring technique.

Assignment 6-17: Colors of Autumn/Spring

This assignment involves composition centered around a color/image theme.

Objectives

- Create a double-exposure effect using layers.
- Blend an image to transparent.
- Create "halos" around figures.
- Use the Clouds filter and Drop Shadow layer effect.

Preparation

Photograph fall (or spring) colors using film or a digital camera. Include some of the following.

FOR FALL:
- Fall colors in landscapes
- Close-up of colored leaves
- Fall vegetables: pumpkins, gourds, dry corn, sunflowers, and so on
- Halloween themes: witches, ghosts, cemeteries, people in costumes, a haunted house
- Portraits or figures for the "spirit"

FOR SPRING:
- Spring colors in landscapes and/or Easter objects
- Close-up of flowers or grass
- Easter themes: colored eggs, lilies, bunnies, baskets with colored grass
- Portraits or figures for the "spirit"

Scan the following objects.

FOR FALL:

- Colored leaves

FOR SPRING:

- Flowers

Guidelines: Image 1—Montage

1. Create a complex collage of fall photos that appear to float above an autumn (or spring) landscape.

2. The background photo could have a border.

3. Incorporate the following techniques:

Figure 6-24 Colors of autumn montage (original in color). *Student image by Susan Abel.*

- ✗ Show a range of photograph sizes from large to small. Do not make them all the same size.

- ✗ Have some of the photographs overlap each other.

- ✗ Use the Stroke command to outline each photograph.

- ✗ Have each photograph cast a shadow. Make all shadows go in the same direction. Use the Copy Layer Style command.

- ✗ Include scans of three or more leaves in the composition.

Guidelines: Image 2—Spirit

Create a collage of two or more transparent figures, faces, or objects in the landscape using a lowered opacity setting in the Layers palette. Incorporate the following techniques:

- ✗ Soften the edges of the transparent objects by feathering the selection before copying.

- ✗ Blend one or more figures to transparent using the Quick Mask tool with a Gradient.

- ✗ Create a white glow or "halo" around one or more figures (see exercise 3-28).

- ✗ Somewhere in the composition, create a "clouds" effect using the Render > Clouds or Difference Clouds command in the Filter menu.

Figure 6-25 Spirit (original in color). *Student image by Jessica Schuster.*

Assignment 6-18: Photogram

A photogram is a shadow-like photograph made by placing objects between light-sensitive paper and a light source. In this assignment, you will create the electronic equivalent of a photogram.

Objectives

- Utilize photogram techniques with a scanner.
- Create harmony with "mirrored" images.
- Experiment with filters and special effects.

Preparation

Use a flatbed scanner to capture objects and transform them into electronic images. Scan the following.

- Your hand with an object(s) and the object itself
- Food item (not in the packaging)
- $20 bill

 ✎ *The background will show. If the objects are light, consider placing a dark cloth over them for contrast.*

Figure 6-26 Hand holding an object (original in color). *Student image by Stacy Wild.*

Guidelines: Image 1—Hand Holding Object

1. Combine the scans of your hand with an object and the object into a composition.
2. Create a center of interest.
3. Show a repetition of the object.

Guidelines: Image 2—Food

1. Use the food scan to create a mirrored image or "ink blot" look by using the Copy, Paste, and Flip commands.
2. More than one scan of the same food item may be used. Non-mirrored images may be added to the composition.
3. Use a filter or special effect to change the look of the food. This could include use of the Hue/Saturation command. Show a repetition of the effect.
4. Create a center of interest.
5. Show a repetition of colors.

Figure 6-27 Food (apples) (original in color). *Student image by Nicole Tibbets.*

Guidelines: Image 3—Jackson $20 Bill

Traditionally, copying currency has been illegal. Recently, the use of currency in advertising has been tolerated. This assignment is designed to develop creative solutions for advertisements that use currency.

1. Use only the scan of the $20 bill and your imagination.

2. No other images may be used (except for their shapes). Computer commands and type are to be utilized creatively.

3. Use only the colors that exist in the currency, plus black and white.

4. Use the Eyedropper tool to identify the colors.

5. Choose three of the following.

 ✗ The $20 bill(s) in perspective

 ✗ The $20 bill(s) in a landscape

Figure 6-28 Jackson $20 bill (original in color). *Student image by Joshua Jenkins.*

✗ The $20 bill(s) in a pattern

✗ The $20 bill(s) as a structure

✗ The $20 bill(s) divided or torn

✗ The $20 bill(s) with filters applied (but still retaining the original colors)

✗ The $20 bill(s) with type added

Assignment 6-19: Tabloid

Tabloid magazines are known for their "doctored" photographs. Scenes are created adding people that were never there. People are airbrushed out. Sometimes, heads and figures are combined in incongruous ways (e.g., alien heads on human bodies). Originally, this had been done with cutting and pasting techniques. Now, it is being done on computers.

Objectives

- Develop skills in "cloning" to electronically retouch a photograph.
- Experience composing a tabloid front page.

Preparation

For this assignment, use the Clone Stamp tool, which makes cloning shapes faster than copying and pasting. One use of cloning is to repair damaged photographs. Another is to remove unwanted or distracting elements in a photograph, such as a tree sprouting from a person's head.

Guidelines: Image 1—Repair

1. Choose an old or damaged photograph.
2. Improve the overall technical quality of the image without changing the composition.

Figure 6-29 Original and repaired photograph. *Student image by Deana Dorf.*

Guidelines: Image 2—Elimination

1. Remove an unwanted person or thing from the photograph. Challenge yourself—choose shapes to remove that are not simply against a solid background.

2. Replace the doctored area with the background that would have been there.

TIP: Selecting an area in which to work will allow the Clone tool to function without affecting adjacent areas.

Figure 6-30 Elimination. *Student image by Libby Amato.*

Guidelines: Image 3—Tabloid Cover

1. Create a new vertical file.

2. Using the Type tool, add headline lettering to make it look like the cover of a tabloid.

3. Choose a vertical photograph for the illustration.

4. Insert altered images of people, faces, or objects so that they look photographically real. This could include such elements as someone's head transplanted onto someone else's body, or an object that is dispropor- tionately large or small.

Figure 6-31 Tabloid cover (original in color). *Student image by Libby Amato.*

Assignment 6-20: Cartooning

Objectives

- Learn to use Photoshop as an animation tool.
- Acquire skill with the Burn/Dodge tool.
- Experience the tradition of juxtaposing photographic images with animated images.
- Create images that combine animation and photography.

Guidelines: Image 1—Cartoon Characters in Photograph

1. Choose a color photograph that includes an exterior or interior scene along with people.
2. Create "cartoon" characters to interact in the photograph. (See the cartoon figure in Chapter 11.)
3. Use the traditional cartooning techniques of black outlines and relatively flat colors.
4. Show a repetition of colors already in the photograph.
5. Consider adding shading and highlighting using the Burn/Dodge tools.
6. Make it dramatic enough to show a change from light to dark.
7. Using the Edit, Transform, and Scale commands, adjust the size of the cartoon figures to fit the scene.
8. Optionally, add cartoon objects to the scene.

Figure 6-32 Cartoon character in photograph (original in color). *Student image by Walter Witten.*

Guidelines: Image 2—Photograph into Cartoon

1. Choose a color photograph that includes an exterior or interior scene.

2. Change the background (negative spaces) into a cartoon scene.

3. Start by outlining the background areas in black using the Select > All and Edit > Stroke commands. Then fill the scene with solid colors that are already in the photograph.

4. Show a repetition of colors from the photo.

Figure 6-33 Photograph converted into cartoon (original in color). *Student image by Libby Amato.*

Guidelines: Image 3—Cartoon Series

1. Without using a photographic image as a model, create a cartoon series of three or more frames.

2. The backgrounds may stay the same from one frame to the next.

3. Create figures and/or objects that repeat and change direction, position, expression, and so on through the frames.

4. Show a repetition of colors throughout.

Figure 6-34 Cat Scan. Cartoon series (original in color). *Digital image by Richard O'Farrell.*

Assignment 6-21: Absolut Photoshop

Absolut Vodka has been known for its innovative advertising. Many of the advertisements created for them appear digitally produced. Develop an advertisement concept that would fit the style of the Absolut Vodka Company.

Objectives

- Investigate the digital advertising of one company's campaign.
- Create a "spec" ad for an actual company.

Figure 6-35 Absolut advertisement (original in color). *Student image by Keith Beutin.*

Guidelines

1. Looking through magazines, find at least three Absolut Vodka advertisements.

2. Of these ads, make sure some of them appear digitally enhanced on a computer. Be prepared to discuss the following:

 ✗ Which ones appear created electronically?

 ✗ What special electronic techniques were probably used?

 ✗ Describe the general concepts in advertising involved. What type of audience is it meant to appeal to?

 ✗ Produce a number of "thumbnail" sketches to develop an idea for an Absolut advertisement.

 ✗ Select one sketch and develop three different images on the same theme. Use any of the Photoshop skills you have acquired.

 ✗ Describe how these images might have been produced traditionally.

Assignment 6-22: Campus of the Future

Objectives

- Learn to utilize the digital camera as a tool for creating imaginary environments.

- Incorporate commands that produce special image effects.

Guidelines

1. Spend some time creating images using a digital camera.

2. The images are to be of a college campus. Take pictures both indoors and outdoors. If there is enough light to

take pictures without the flash, turn it off. Keep in mind that the images you take will be used to create a kind of "science fiction" environment.

3. Using the images that you made with the digital camera, along with any other images that are either appropriate or personally photographed, digitally build the college of the future. Consider the following:

 ✗ What will the environment look like?

 ✗ What will the students look like?

 ✗ What aspects of technology could be present?

 ✗ If you are unfamiliar with science fiction images, study Star Trek, Star Wars, Road Warrior, and Blade Runner memorabilia.

 ✗ Make the scene look futuristic.

Figure 6-36 Campus of the future (original in color). *Student image by Angel Perez.*

4. Incorporate two or more of the following commands in your construction:

 ✗ Curves

 ✗ Lighting Effects

 ✗ Lens Flare

 ✗ Displacement maps

 ✗ Any filters that distort an image (Solarization, Find Edges, Displace)

 ✗ Include text somewhere in the composition.

 ✗ Create a center of interest.

 ✗ Show a repetition of colors and effects in both the positive and negative spaces.

Assignment 6-23: Mixed Media

This assignment involves combining various image media types into a single composition.

Objectives

Discover ways of integrating traditional photography with digital imaging, and other media, such as drawing, painting, and sculpture.

 See plate 1 of the color insert.

Guidelines

Incorporate four or more of the following creative techniques into one final image or sculpture:

✗ Create a drawing, painting, or rubbing.

✗ Photograph a landscape or interior space.

✗ Scan something two-dimensional that is not a photograph.

✗ Scan an object or objects.

✗ Photograph an ink-jet print in a new and creative way—do not simply copy it.

✗ Draw or paint on an object.

✗ Draw or paint on an ink-jet print.

✗ Create a sculpture that has both two-dimensional and three-dimensional elements.

The following is a sample of steps you might perform.

1. On an $8^1/2 \times 11$-inch sheet of art paper, create a textured surface with a watercolor wash, charcoal, pastel, opaque watercolor, or rubbings.

2. Scan the textured design as RGB.

3. Open a photographic image.

4. Copy and paste the textured image onto the photographic image.

5. Move the Opacity slider on the textured layer to 50%.

6. Make an ink-jet print.

7. Create a small still life in which the print is included in the composition.

8. Photograph the still life with a digital or film camera.

9. Make a print from the file or negative.

Composition and Aesthetics

Good composition is only the strongest way of seeing the subject.

—Edward Weston (1886–1958), fine art photographer

In photography, there is enough technology to be learned to distract the beginner from studying the aesthetics involved. What can easily happen is that the student can learn the technology without developing an understanding of design or composition. The study of photography and electronic imaging should involve more than a mechanical understanding. Rather, as with other art media, photography should provide the means for developing the visual creativity of the individual. It should enrich and broaden horizons. It should turn what might otherwise be routine, predictable experiences into the excitement of discovery.

Composition: The Tradition

My contact sheets become a kind of visual diary of all the things I have seen and experienced with my camera. They contain the seeds from which my images grow…. Ultimately, my hope is to amaze myself. The anticipation of discovering possibilities becomes my greatest joy.

—Jerry N. Uelsmann (born 1934), contemporary fine art photographer

One photographer who considers in his work the formal concerns of balance and composition is Jerry N. Uelsmann. His photographs illustrate an understanding of aesthetics that encompasses the tradition of Western art. In his darkroom manipulation of multiple image prints, Uelsmann creates photographs that possess deep qualities of arrangement and continuity, as shown in figure 7-1.

Elements of Design

While not every photograph will include all of the elements of design, one or more of the elements are usually emphasized. A good exercise for the student to become sensitive to each of the elements of design is to take photographs that emphasize only one of them at a time.

Figure 7-1 Jerry N. Uelsmann combines negatives in the darkroom to create surrealistic compositions.

The tools of composition are called the **elements of design.** For the artist, these tools are the substantive elements that go into creating a composition. To a writer, such tools would include nouns, verbs, adjectives, punctuation, and so on. To a visual artist, such tools include the following (examples of which are shown in figures 7-2 through 7-6):

- Line
- Shape (two-dimensional quality)
- Form (three-dimensional quality)

Figure 7-2 Line. *Photograph by Jason Stollenwerk.*

Figure 7-3
Shape.
Milwaukee
Journal Sental
*photograph by
William Meyer.*

Figure 7-4
Form.
*Photograph
by Jason
Stollenwerk.*

- Texture (tactile quality)
- Value (light/dark quality)

These elements are what the artist works with to formulate a work of art. The arrangement of these elements becomes the composition. The artist looks for these elements in what is being photographed. Sometimes they exist in the subject

Figure 7-5 Texture. *Eyebird Z* (original in color). *Digital image by J. Seeley.*

matter as it is, and sometimes they are manipulated. In either case, the photographer/artist is trained to become visually aware—to see rather than only look, and to use these tools to investigate the visual world. In this way the artist begins to transform the visual world into lines, shapes, forms, textures, and color.

Figure 7-6 Value. *Black Trees, Switzerland. Photograph by William Lemke.*

Principles of Design

The elements of design are used to create a composition. Traditionally, composition comes from the careful use of principles of design as applied to considerations of the elements of design. These principles might be said to be similar to the traditional rules of grammar. In art, these rules began to achieve prominence and to be codified roughly in the Renaissance, largely by the great Italian artists of that period, who sought to recapture the aesthetic ideals of ancient Greece. Renaissance was, in part, an attempt to bring about a harmony between man and nature. This section discusses principles of design associated with the following aspects of imagery:

- Balance
- Harmony
- Dominance
- Variety
- Space
- Movement
- Proportion
- Economy
- Craftsmanship

A good photograph or digital image usually has to combine a number of the principles within its composition to be effective. In the beginning, it is difficult to keep them all in mind and working together at the same time. One approach to dealing with composition is to concentrate on one principle of design at a time within a single work. Probably the most basic element, and a good place to begin exploration, is balance.

Balance

A composition should be balanced. That is, one side should have an equal weight or importance in regard to the other. When the two sides are compositionally identical, or close to being identical, the balance is symmetrical. When the two sides are not compositionally identical, but still exhibit equal weight or importance, the balance is asymmetrical. Figures 7-7 and 7-8 show, respectively, examples of symmetrical and asymmetrical balance.

Figure 7-7 Symmetrical balance.
Photograph by Jerry N. Uelsmann.

Figure 7-8 Asymmetrical balance.
Unknown Quantity. Digital image by Gerald Guthrie.

Harmony

A composition should be harmonious. That is, it should contain some unifying factors. Harmony (an example of which is shown in figure 7-9) can be achieved by the recurrence or repetition of similar or related parts. Whenever an element of design is used in the composition, it should be repeated somewhere else.

Dominance

A composition should have at least one dominant area, or center of interest, that draws the viewer's eye. A center of interest can be created by making it larger respective to other elements in the composition. It can have a contrasting value or color respective to surrounding areas. Or it can be the area that is most in focus. An example of the use of dominance is shown in figure 7-10.

Figure 7-9 Harmony. Milwaukee Journal Sentinel *photograph by William Meyer.*

Figure 7-10 Dominance. *Digital image by Steve Puetzer.*

Variety

Except where monotony is the objective, a composition should include variety—that is, contrast among its components. An example of variety is shown in figure 7-11. If everything in a composition is of the same nature, the effect will be one of visual monotony. To achieve variety, vary such elements as the size and direction of lines and shapes, as well as other elements such as tonal values, textures, color, and the use of space.

Figure 7-11 Variety. *Photograph by William Lemke.*

Space

A composition should have a consistency of positive shapes and negative space (open areas) throughout, as shown in figure 7-12. If one dominates the other, the composition might feel too tight (positive shapes too dominant) or too open (negative spaces too dominant).

Figure 7-12 Space. *Photograph by Sandy McGee.*

Movement

A composition should convey a feeling of "movement" that leads the eye around without leading it out of the picture plane. The element of movement can draw the eye into the composition, as is evident in figure 7-13.

Proportion

A composition should have a proportional range of sizes from large to small. If all components are of roughly the same size, the composition will be static. An example of the element of proportion is shown in figure 7-14.

Figure 7-13 Movement. *Photograph by Philip Krejcarek.*

Figure 7-14 Proportion. Milwaukee Journal/Sentinel
photograph by William Meyer.

Economy

A composition should demonstrate economy or simplicity,
as seen in figure 7-15. In the beginning it is much more effi-
cient to think in terms of restricting the composition to fewer
as opposed to a greater number and range of elements.

Figure 7-15 Economy. *Photograph
by Philip Krejcarek.*

Craftsmanship

A composition should demonstrate good craftsmanship, or attention to and neatness of technical proficiency. In photography, a well-crafted print is one that is in focus, demonstrates a range of values, and is impeccably free of defects such as dust spots, scratches, chemical stains, and so on.

Asymmetrical Balance

The "snap shooter" tries to balance pictures by placing the main subject in the center of the picture, with equal space on each side. In other words, the attempt is to create symmetrical balance. The photographer/artist knows that a picture can also be balanced asymmetrically. This is achieved by placing the main subject off center and balancing the composition with something on the opposite side.

The Rule of Thirds

The seventeenth-century Dutch painters believed that symmetrical balance was static and lacked the dynamic quality of asymmetrical balance. Such painters as Rembrandt van Rijn (1606–1669) and his contemporaries formulated a theory of balance called the "rule of thirds," an example of which is shown in figure 7-16. The rule stated that a composition should never be divided into equal parts or halves. Rather, it was better to divide a picture compositionally into thirds, both vertically and horizontally.

The Dutch painters felt that the placement of horizontal elements (such as the horizon) and vertical elements (such as a standing figure) should be considered within the grid formed by the intersection of the horizontal and vertical divisions. They went further to state that the center of inter-

est (or main subject) of the painting should not be centered but be placed closer to one of the two horizontal or one of the two vertical dividing lines, or both.

Although the rule of thirds provided a "safe" mechanical means of creating asymmetrical balance, most artists and photographers rely on a "felt" balance when imposing an asymmetrical design. A photographer will position the camera until the balance "feels" right. He or she may ask such questions as:

Figure 7-16 Rule of thirds. *Photograph by Philip Krejcarek.*

- Does the center of interest on the right hold as much importance as the space on the left?
- At what point in moving the camera does the composition have an equal weight from one side to the other?
- Does the shape that is in focus balance with the space that is out of focus around it?

Asymmetry: A Starting Point

With asymmetrical balance, the decisions are more difficult because the photographer has to make appraisals or evaluations as to the validity of the balance. Although it is not essential or even more aesthetically correct to balance a composition asymmetrically, it is a good exercise for a beginning photographer to restrict photography to asymmetrical compositions.

Asymmetrical composition enables the beginning photographer to explore and discover what is beyond the "snap shooter's" ability to control in regard to symmetry. In this way, the beginner challenges his or her creativity in encountering a less safe, less sure, less guaranteed way of balancing a photograph. After a number of asymmetrical photographs, try creating symmetrical compositions that are not static. Search for the lively and exciting, and try to use the strengths of symmetry.

Now, to consult rules of composition before making a picture is a little like consulting the law of gravitation before going for a walk.

—Edward Weston (in <u>Seeing Photographically</u>, 1943)

The Fine Print Aesthetic of Edward Weston

Although it is true that the principles of design can be seen at work in Edward Weston's photographs, this early practitioner of photography as an art argued that creating memorable pictures ultimately has much less to do with techniques of composition than with an eye for what constitutes a good picture. Weston felt that rules of composition

"are the products of reflection and after-examination, and are in no way part of the creative impetus." He believed that to become a good photographer meant learning to "see."

For Weston, it was much more important to explore the visual world through the camera viewfinder than to try to photographically recreate the rules of composition. Weston stated that the camera

> provides the photographer with a means of looking deeply into the nature of things, and presenting his subjects in terms of their basic reality. It enables him to reveal the essence of what lies before his lens with such clear insight that the beholder may find the recreated image more real and comprehensible than the actual object.

To the beginning photographer/artist, who is just becoming comfortable with the principles of design, this might be a difficult testimonial to embrace. It does not provide the student with a set of rules to follow and guidelines for evaluation. However, the statements are coming from an acknowledged master of artistic photography, and three things should be taken into account here.

First, Weston is certainly knowledgeable about the rules of composition, and is certainly not naive as to their tradition. Second, all of the principles of design can be found in his work, even though he testifies that they are not consciously used. Third, Weston's philosophy provides the photographer with another approach to the question of aesthetics. He does not say that his philosophy is the only direction photographers should take. Rather, he suggests that the artist ultimately incorporates consideration of "the rules" subconsciously, or intuitively, and in that way is free to concentrate on the artistic objective itself.

Composition must be one of our constant preoccupations, but at the moment of shooting it can stem only from our intuition, for we are out to capture the fugitive moment, and all the interrelationships involved are on the move.

—Henri Cartier-Bresson (in The Decisive Moment, 1952)

Henri Cartier-Bresson's Decisive Moment

For French photographer Henri Cartier-Bresson, the most significant compositions can only be made at what he has called "the decisive moment." He described this as "one moment at which the elements in motion are in balance." It is the photographer's role to watch for this moment and to record it on film. The photographer has to make many decisions regarding such elements as distance, angle, and timing in creating compositions. Cartier-Bresson argues that often these decisions have to be made during a fleeting moment in time.

The Cartier-Bresson Approach

Cartier-Bresson believed so strongly that the strength of a composition was in the taking of the picture that he seldom did any cropping of compositions in the darkroom. Further, he held little value in the posed or arranged composition. He said, "The thing to be feared most is the artificially contrived, the contrary to life." ("Henri Cartier-Bresson on the Art of Photography," *Harper's Magazine*, November 1961).

As with Weston, the principles of design can certainly be seen in Cartier-Bresson's photographs. However, like Weston, Cartier-Bresson believed that the composition should be created instinctively, based on intuition rather than methodical reasoning. Although both felt that composition recorded a transitory moment in time, Cartier-Bresson showed more emphasis here, whereas Weston concentrated on revealing the subject's essence during that moment.

Exploring the Intuitive Approach

Cartier-Bresson's technique of photographing is not an easy one for beginners to emulate. Because of the often numerous decisions that have to be made during a short period of time, achieving a harmonious composition can be difficult. However, this method of developing one's sense of intuition and an awareness of changing moments in time gives the photographer another approach to dealing with composition.

Thinking should be done beforehand and afterwards— never while actually taking a photograph.

—Henri Cartier-Bresson (in "Henri Cartier-Bresson on the Art of Photography," <u>Harper's Magazine</u>, November 1961)

Going Beyond the Rules with Diane Arbus

The American poet e.e. cummings wrote verse in traditional form, but he is best known for writing without capitalization, for using unpredictable punctuation, and for sometimes making up his own words. Yet he was rarely criticized for *not* following the rules of grammar. Cummings was not a naive artist who was unfamiliar with the rules of grammar. He consciously declined, in much of his work, to follow the traditional rules in favor of establishing his own framework in which to work. Diane Arbus was a photographer who also chose to ignore the rules. One critic described her work as "artless" because it apparently showed little concern for the guidelines of art as most people knew it.

Unlike the work of Weston and Cartier-Bresson, in which the principles of design could easily be identified, the pictures of Diane Arbus often did not illustrate the rules. The notion of a harmonious composition was not a priority in her work. What was important was the subject she was photographing, and it was almost always people.

For me the subject of the picture is always more important than the picture. And more complicated. I do have a feeling for the print but I don't have a holy feeling for it. I really think what it is, is what it's about.

—Diane Arbus (in <u>Diane Arbus: An Aperture Monograph</u>, 1972)

Many of the people Arbus photographed might be described as "other than normal." They would include prostitutes, transvestites, and circus freaks. Capturing the person at a moment in time was of little interest to Arbus. She was concerned with revealing something about the person that went beyond the surface appearance. Her pictures were intimate and sometimes a little embarrassing, as if the viewer were seeing something about the person that was private.

The result is that these pictures have a strong emotional impact, and therein lies their meaning and purpose. The photographs go beyond the rules of art and create new definitions as to what art is, and can be. Arbus's approach challenges the viewer as to its acceptance and raises questions as to the evaluation of art. It encourages the viewer to discover the intentions of the photographer before making a

judgment of the work. The question then becomes one of evaluating the photographer's purpose in making the photograph and the success achieved in communicating that purpose.

It should become evident that there is no one aesthetic of photography. There simply is not room in this book to mention all of the many other legitimate and interesting philosophies regarding what constitutes photography as an art form. My best advice to beginners is to become familiar with the formal rules of composition, to acquire experience in using them, to study them—and only then to feel free to depart from them. Consider what other photographers' opinions on aesthetics have been, and then discover your own feelings as to a philosophy of art.

Legal and Ethical Considerations of Image Making

Photographers need to be aware not only of their rights as creators but also of their responsibilities. One definition of ethics is "the study of standards of conduct and moral judgment." For photographers, the issue of ethics poses questions such as:

- Who and what can be photographed?
- When is consent necessary in photographing?
- What is copyright?

These topics are discussed in the sections that follow.

Who and What Can Be Photographed?

Consideration of who and what can be photographed involves issues of what is legal and what is ethical. Yet what is legal is not always ethical.

The Legal Picture

Legally, anyone or anything present in a public environment, unless expressly prohibited by law and posted as such, can be photographed. The term *public* refers with few exceptions to any space not privately owned. A photographer can, strictly speaking from a legal standpoint, even stand in a public area and photograph a private one. The issue of the use of that picture of a private entity is another matter.

Figure 8-1 *Photograph by Mark Avery.*

The Ethical Picture

Ethical considerations are more complicated. Whether or not it is ethical to take a picture should be viewed in terms of the following types of questions:

- Should one feel free to photograph anyone or anything?

- Should the photographer obtain permission from the person or thing before actually taking the photograph?

- Is there anything that should *not* be photographed?

- What responsibility does the photographer have to the people affected by the photograph?

Figure 8-2 Portable Vietnam Memorial. Milwaukee Journal Sentinel *photograph by William Meyer.*

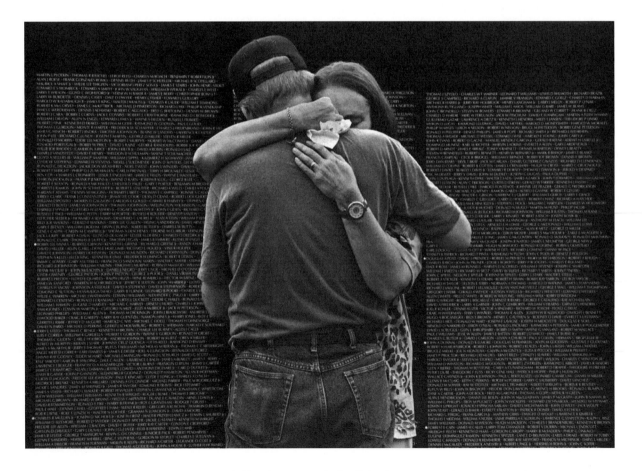

When Is Consent Necessary In Photographing?

The following sections discuss the issue of consent in terms of what is legal and what is ethical. Again, the two can be, but are not necessarily, synonymous in any given case.

The Legal Picture

Consent is never legally necessary to photograph someone or something in public when the photographer does not intend to disseminate the image. Permission is generally not necessary when the photograph is being used as fine art, or in an editorial context. (This is only true when the photograph does not damage an individual's reputation or show a person in a compromising situation.) Consent *is* necessary, however, when the photograph is being used for advertising or commercial purposes. In that case, a signed model release is required.

The Ethical Picture

Ethically, the photographer should consider the following questions:

- Should anyone be asked to sign a model release before seeing the photograph?
- Should the person photographed be told the probable use of the photograph before a model release is signed?
- If the photograph is being sold, should the individual signing the model release receive a portion of the profit?

What Is Copyright?

The meaning and implications of copyright are well stated in the following excerpt from *A Legal Guide for the Visual Artist*, by Tad Crawford:

> If you are a creator of images (whether Photoshop user, photographer, designer, or fine artist), copyright protects you from having your images stolen by someone else. As the copyright owner, you may either allow or prevent anyone else from making copies of your work, making derivation from your work (such as a poster made from a photograph), or displaying your work publicly. Your copyrights last for your lifetime plus another 50 years, so a successful work may benefit not only you but your heirs as well. If you are a user of images, it is important that you understand the rights and obligations connected with their use so you don't infringe on the copyright of someone else and expose yourself to legal or financial liabilities.

Figure 8-3
Photograph by Mark Avery.

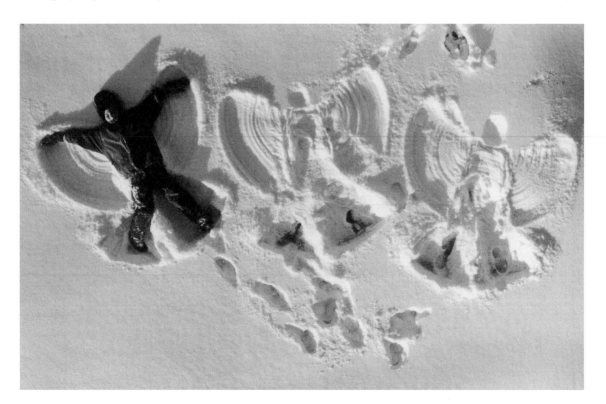

Copyright as Ownership

Copyright means that the person who created the photograph, either traditionally with a camera or electronically on a computer, is the owner of that image. Once the photographer has produced the image, it is copyrighted. It is not necessary to register every image with the U.S. Copyright Office. But in a legal dispute over ownership, a registered copyright would be useful.

> ✎ *NOTE: The current base rate for registering an image is $30.00. An applicant can group work and still pay only $30 for the group. To obtain Copyright Application Form VA, call 202-707-9100, or write to the U.S. Copyright Office, Library of Congress, Washington, D.C., 20559. Updated information on copyright can also be found on the internet at: www.loc.gov/copyright.*

Copyright Notice

Copyright notice takes the form of the word *Copyright,* followed by the copyright symbol (©), the name of the copyright holder, and the first date of publication. Since 1989, it is no longer a legal requirement under copyright protection law for the copyrighted item to bear this notice, but this is still a recommended practice in terms of warning and protection. The notice informs the viewer of the image that the item is copyrighted. It also serves the practical purpose of providing the viewer with the name of the copyright holder, should he or she wish to contact that person in order to obtain permission to use the image.

Figure 8-4 *Photograph by Jane Alden Stevens.*

Fair Use

When using an image that someone else has created, you are required to obtain permission to do so in most cases. However, another person's photograph may be used without permission for educational or news purposes as defined under copyright code. This is called **fair use,** which itself has limitations defined under copyright law. In addition, generally images made in the United States that are older than 75 years may be used without permission. They have become part of the public domain.

There are limitations, however, even in these uses. Copyright law provides for various scenarios, but all of these scenarios are defined and limited legally. "Fair use" or any other part of copyright law cannot be defined strictly in terms of use. Fair use for educational purposes, for example, incorporates the notion of "limited use." Even if you credit the source, you cannot, for example, give someone else's three-hour lecture without first obtaining permission to do so.

What defines the limits of fair use, with rare exceptions, is governed by a combination of factors: how is the image being used, to what extent is it being used, how much of the image is being used, and similar factors. And all of these factors must be considered in the context of other laws, such as privacy statutes. For example, fair use allows you to quote a small percentage of a text without explicitly crediting the source or obtaining permission to use it. Moreover, for example, right-to-privacy laws might trump the copyright "fair use" statute in a court of law.

The extract that follows, from Tad Crawford, points out the difference between infringement of copyright and a provision under copyright "fair use." However, such legal use does raise the ethical question of crediting the original source of the altered image.

> The scanning itself is making a copy and so an infringement. As a practical matter, however, it is unlikely you will be sued for infringement if you change the photograph to the point where an ordinary observer would no longer believe your work was copied from the original photograph.

The Legal Picture

Another problem naturally arises in the use of manipulated photographs. At what point does an image of one party, when it is manipulated on a computer (or otherwise), become the property of a second party? The current thinking appears to be that once the original photograph is not recognizable by an "average observer" (as defined under law), it becomes the property of the second person.

Historically, artists creating "one-of-a-kind" works of art are permitted considerable latitude in fair use. Andy Warhol, for example, appropriated images (or likenesses) from material owned by others in much of his work. A classic example is his painting of Campbell's soup cans. Until a work of art is commercially published, an artist's use of another's image is generally tolerated.

With the ability of computers to capture, store, and send images around the world, photographers are concerned about their loss of ownership.

—Tad Crawford (in A Legal Guide for the Visual Artist)

The Ethical Picture

The issue of ethics in the area of image use should be viewed in terms of the following types of questions:

- Should another's image be used without permission, even when the risk of litigation is small?

- Should another's image be used without permission when there is no profit consideration or other copyright-protection issue involved?

- When can an image be appropriated ethically and incorporated into a new image?

Copyright-free Images

There are a number of sources from which to obtain copyright-free images. One example is Dover Press, which publishes historic illustrations that can be used without permission. More recently, photographic images published on photo CD-ROMs have been available for use without permission. One of these is the Corel Stock Photo Library, which contains thousands of photographs ready for use.

Chapter 9

Electronic Imaging: Careers

This chapter explores various types of career opportunities available to photographers who have mastered electronic imaging skills. These include commercial art; commercial layout, illustration, and design; press preparation; fine art photography; and photojournalism. Figure 9-1 shows an example of a practical application of the craft of creating electronic imagery in the advertising industry.

The career choices for the photographic artist have expanded because of electronic imaging. Not only can the photographer be the "shooter," but also the one who digitizes the image, enhances it, manipulates it, creates the layout, or prepares it for the printing press.

Commercial Arts

The greatest demand for electronic imaging skills can be found in the realm of commercial art production. This is actually a very traditional path for career-minded artists to follow. As in the past, photographic images must still be professionally corrected, manipulated, incorporated into layouts for publication, and then color-separated for output on an offset printing press. The only difference is that all these tasks, which used to be done by hand, can now be performed faster and more accurately on computers. As an example, figures 9-2 through 9-4 show how two original photographs can be quickly combined electronically to produce a quite different third image.

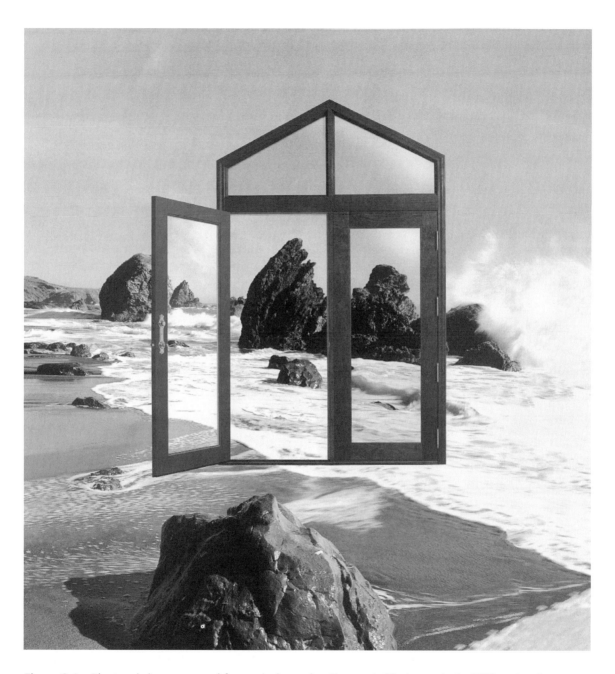

Figure 9-1 Electronic imagery used for a window advertisement. *Photographs by William Lemke. Computer image by Altered Images. (Courtesy of Weather Shield Windows.)*

Commercial Photography

Most professional photographic images are ultimately destined to appear in print advertising. In many ways, the skills demanded of today' commercial photographers are no different from what was demanded of them in the past. The quality of lighting used in the image is still important, as is the skill of the photographer to produce a technically proficient image. And as in the past, the photographer must be creative. What has changed is the kind of technical expertise required of the photographer above and beyond purely photographic skills, and his or her ability to visualize, organize, and execute a kind of "virtual shoot" electronically, not on location, but on the computer. Figures 9-1 and 9-6 show

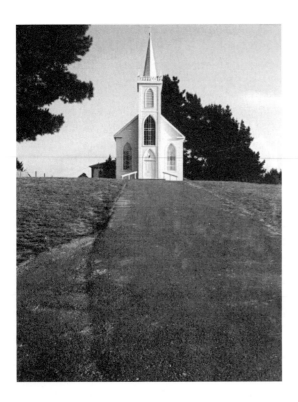

Figure 9-2 Original photograph of a church.

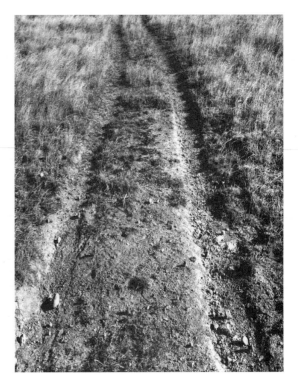

Figure 9-3 Original photograph of a dirt road.

examples of advertising imagery that combines traditional photographic skills with electronic imaging techniques.

Nowadays, commercial photographers must not only be knowledgeable about traditional studio lighting, darkroom techniques, film types, camera functions, and the offset printing process, but they must also constantly keep abreast of rapid advancements in the realm of digital photography and electronic imaging. In a professional setting, digital camera equipment will become more the rule than the exception. Photographers will find themselves dealing less and less with film even as they come to embrace digital media for recording images and the "digital darkroom" for processing and manipulating those images. The professional photog-

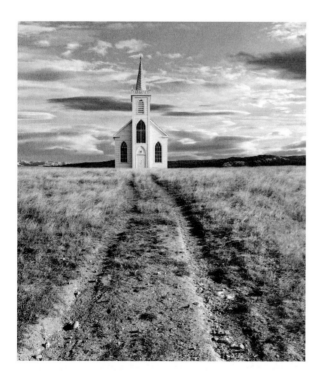

Figure 9-4 Photographs of church and dirt road combined, with new sky incorporated.

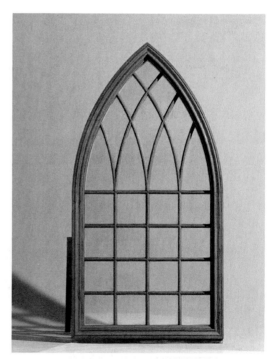

Figure 9-5 Window photograph taken in the studio.

rapher still needs to have vision and imagination; but in the commercial realm, those abilities must extend well beyond the photo-shoot itself and into a world where the most important phase of image composition occurs largely on a purely electronic plane.

Figure 9-6 Electronic imagery used for a window advertisement. *Photographs by William Lemke. Computer image by Altered Images. (Courtesy of Weather Shield Windows.)*

Commercial Illustration, Layout, and Design

Not only photographic imagery, but also much of today's commercial artwork is being produced on the computer. Adobe Illustrator, Macromedia Freehand, and Corel Painter are software programs that enable commercial artists and illustrators to practice their craft on the computer, and at a level of quality and professionalism that compares favorably to using more traditional methods and media. Nowadays, page layout and design are being handled almost exclusively on the computer. Software such as QuarkXPress and Adobe PageMaker allow page designers to lay out articles, type, illustrations, and photographs for such purposes as architectural illustration.

Prepress

Traditionally, commercial photography was prepared for the printing press by a technician with knowledge of halftone production and color separation. The same expertise is required today to produce lithographic plates for offset printing, but now the computer automates many of the chores involving page imposition and separation. These capabilities are also increasingly available on the desktop, using software programs such as Adobe Photoshop. Now it is not only the trained technician, but also the commercial photographer who can perform these specialized tasks.

Fine Art Photography

Artists have been using the computer to create original images since their capabilities in that area first became apparent. With each new advancement in the technology, the creative possibilities expand. The hardware and software

available to artists enable them to combine techniques and media into a new visual language.

The printed output from electronic images has now reached a level of sophistication that can equal, or even exceed, the quality of fine photographic prints. It is now possible to produce prints electronically on fine art paper with little or no telltale pixelization—an unsightly artifact of computer-based printing that in the past immediately revealed the high-tech provenance of such imagery. Figure 9-7, for example, shows a digitally produced fine art image of a baptism. Most viewers would be hard-pressed to distinguish this image from one using conventional photographic techniques.

Photojournalism

Newspaper and magazine photographers were quick to realize the benefits of "going digital" in their profession. For one thing, because of this approach, deadlines can be met with greater speed and efficiency. Many major newspapers no

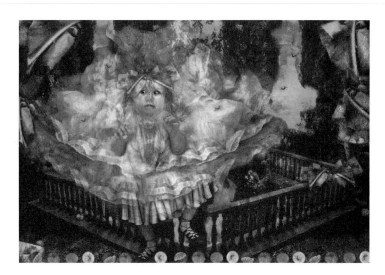

Figure 9-7 *Baptismal Font* (original in color). *Digital image by Karen Thompson.*

longer even use a darkroom or platemaker for producing prints. Some photojournalists have already stopped photographing on film altogether. Using only digital cameras and portable computers with wireless Internet connections, they are able to crop, enhance, and deliver their images in the blink of an eye, even from extremely remote locations.

The public relies on the integrity of the photojournalist to faithfully represent objective reality. This ethic is frequently violated by tabloid publications that routinely doctor photographs or misrepresent the subject matter. In the field of professional photojournalism, there are strict limitations on how an electronic image can be manipulated. Unlike "creative" commercial or fine art photography, news and editorial photography must confine itself to representing the truth. Although such an image may be cropped or technically improved, it cannot misrepresent the object or event it purports to record. The reality of the captured image must neither be distorted nor exaggerated, but rather be presented "as is." An example of a truly journalistic photograph from a typical mainstream newspaper is shown in figure 9-8.

Figure 9-8 Milwaukee Journal Sentinel *photograph by William Meyer.*

Developing Creativity and a Philosophy of Photographic Image Making

I think the important decision for a photographer is to choose a subject that intensely interests him or her.

—*Berenice Abbott (1898–1991), documentary photographer*

Perhaps the quality that most separates artists and creative individuals from others is their emphasis on exploration and acceptance of change. Many people are content with merely repeating that which has been successful in the past. By contrast, artists are constantly on the lookout for new solutions and different ways of perceiving, both in their everyday and in their professional lives—which is, of course, much more difficult than remaining within the safe confines of what one knows. It involves risk taking and the delicate task of nurturing one's imagination. The sections that follow discuss some of the tools that artists can bring to bear to develop a facility for discovering the new. It also considers how photographers can articulate a philosophy of image making that will enhance their creativity.

I wish that more people felt that photography was an adventure the same as life itself and felt that their individual feelings were worth expressing.

—*Harry Callahan (1912–1999), fine art photographer*

The Tools of Creativity

Creativity is largely a mode of being. However, even the most creative individuals can benefit from developing, exercising, and maintaining their "creative muscles." Here are some of the methodologies that students of photography can use to develop their creativity.

- *Become familiar with the work of other photographers.* Read books on photographers. Collect images created by photographers that inspire you. Attach copies in plain view on a wall or bulletin board. Attend exhibitions to view original photographs.

Figure 10-1 *Izzy with Horns* (original in color). *Digital image by Karen Thompson.*

- *Keep a journal.* Write about photographs you have seen. Maintain a list of ideas for photographs.

- *Be meticulous in your work.* Make detailed notes about how each photograph you make was taken, so that you can reproduce the process later on.

- *Photograph on a regular basis.* As with any skill, practice makes perfect. Do not let long periods of time elapse without having produced some images.

Figure 10-2 *In a Different Light* (original in color). *Digital image by Gerald Guthrie.*

- *Photograph the same subject over a period of time.* Attempt to photograph the subject a little differently each time. The first few times, it is easier to come up with new ideas; the challenge is to remain consciously original beyond the honeymoon period of initial inspiration.

- *Brainstorm.* Meet with two or more people to discuss possibilities for photographs. Limit the topic to a specific concept. Assign one person to record all ideas. Do not evaluate ideas during the discussion. At the end, select the best ideas, discuss them further, and then try implementing just one or two.

A Philosophy of Photography

At some point in their career, every photographer begins to develop a philosophy of what photography *is*—or perhaps, more accurately, of what photography *should be*. Sometimes this philosophy comes to the student of photography subconsciously; but more often, photographers consciously ask themselves questions about their work and its direction. Many photographers and scholars of photography have written about this experience, sometimes quite eloquently. The following are recommended books that deal with this subject.

- Hill, Paul, and Thomas Cooper, *Dialogue with Photography*. New York: Farrar Straus Giroux, 1979.
- Hattersley, Ralph, *Discover Your Self Through Photography,* Dobbs Ferry, NY: Morgan and Morgan, 1977.
- Coleman, A.D., *Light Readings*. New York: Oxford University Press, 1979.
- Lyons, Nathan (ed.), *Photographers on Photography*. Englewood Cliffs, NJ: Prentice-Hall, 1966.

The formula for doing a good job in photography is to think like a poet.

—Imogen Cunningham (1883–1976), fine art photographer

The photographer must possess and preserve the receptive faculties of a child who looks at the world for the first time.

—Bill Brandt (1904–1983), fine art photographer

I believe that the key to good photography is interest on the part of the photographer, not in photography but in his subject. Unless a subject "speaks to me," I wouldn't consider photographing it.

—Andreas Feininger (1906–1999), fine art photographer

Questions Toward a Philosophy

Although it is impossible to define a universal philosophy of photography, the individual photographer can confront a number of questions as part of the maturation process toward becoming an accomplished and resourceful photographer. The following are among such questions.

- What is the purpose of photography?
- Should photographers be concerned with traditional aesthetics (the organizing principles of design), or is photography different from other visual media?

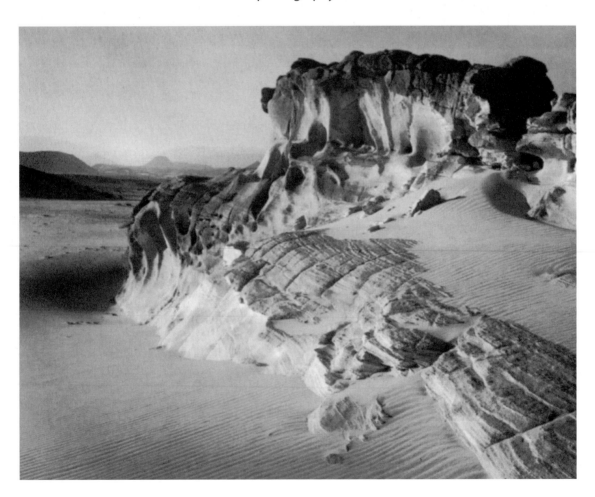

Figure 10-3 Sinai Desert, Egypt. *Photograph by William Lemke.*

- What constitutes a good picture? How do you evaluate photographs?

- Is the straight, unmanipulated print more valid in photography than the manipulated or contrived print?

Figure 10-4 *Lettuce Mask. Digital image by Philip Krejcarek.*

- What situations in photography are best for color? What for black-and-white?

- Excluding technical improvements, how have your photographs changed since you first began serious image making?

- How do your photographs differ from those of others?

- In what creative direction do you see yourself going with your photography?

- What are the purposes of your photographs? What are your images *about*?

- Does your photography say anything about you personally?

Figure 10-5 Milwaukee Journal/Sentinel *photograph by William Meyer.*

Figure 10-6 *Man in a Box* (original in color). *Digital image by Steve Puetzer.*

Special Image Effects in Adobe Photoshop

The basic commands for Adobe Photoshop were introduced in Chapter 4. This chapter explores techniques and tools associated with rendering special effects in the program.

Filters

Adobe Photoshop's Filter menu contains numerous commands for applying special effects, such as the "plastic wrap" look shown in figure 11-1. They can be applied to an entire image, a selection, or an unmasked area of a layer. Not all of the filters are available in all color modes. Only images in RGB mode can use all of the filter commands. When a command is unavailable (grayed out), convert the image to RGB.

The Filter menu is divided into thirteen categories with additional choices in the submenus. Most of the filters have dialog boxes for making adjustments and for previewing the effect of the filter on the image. A few of the more popular filters are explored in the sections that follow. In working with filters, you need to know how to perform two general tasks: enhancing a filter's effect and lessening its effect.

Figure 11-1　Plastic Wrap filter applied to an image.

Figure 11-2 shows an image in which a filter's effect was enhanced by adjusting contrast prior to applying the filter.

1. From the Image menu, choose Adjustments > Levels.
2. In the Levels dialog box, move the highlight and shadow sliders toward the middle to increase image contrast.
3. Proceed with selecting a filter.

Figure 11-2 Images with Reticulation filter applied: without previous Levels adjustment (left) and with Levels adjustment (right).

Use the Fade command to lessen a previously applied filter effect, as shown in figure 11-3.

1. From the Edit menu, choose Fade (last filter or command used).
2. In the dialog box, click on the Mode button and choose a blending mode from the pop-up menu.
3. Optionally, move the Opacity slider to adjust the percentage of opacity for the effect. Click on OK.

 ✎ *With the Fade command, only the last filter effect used can be faded.*

Artistic, Brush Stroke, and Sketch

The Artistic, Brush Stroke, and Sketch filters redraw an image to give it the look of faux artistic media.

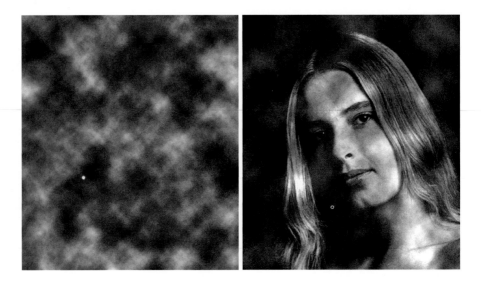

Figure 11-3 Image with the Clouds filter applied (left), and after "fading" the filter effect (right).

Palette Knife

1. From the Filter menu, choose Artistic > Palette Knife.

2. In the dialog box, adjust the Stroke Size, Stroke Detail, and Softness sliders toward the middle as a starting point. Click on OK.

Angled Strokes

1. From the Filter menu, choose Brush Stroke > Angled Strokes.

2. In the dialog box, adjust the Direction Balance, Stroke Length, and Sharpness sliders toward the middle as a starting point. Click on OK.

Charcoal

1. From the Filter menu, choose Sketch > Charcoal.

2. In the dialog box, adjust the Charcoal Thickness, Detail, and Light/Dark Balance sliders toward the middle as a starting point. Click on OK.

Figure 11-4 Palette Knife filter.

Figure 11-5 Angled Strokes filter.

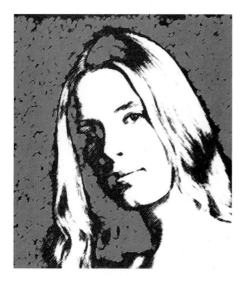

Figure 11-6
Charcoal filter.

Figure 11-7 Gaussian Blur filter.

Figure 11-8 Radial Blur filter.

Blur

Gaussian Blur

Use the Gaussian Blur filter to simulate a short depth of field. You can also use it to soften "pixelated" or halftoned images.

1. From the Filter menu, choose Blur > Gaussian Blur.

2. In the dialog box, enter a number in the Angle field or move the slider to adjust the amount of blur. Click on OK.

 ✎ *To soften a pixelated image with the Gaussian Blur filter, move the slider to 1.0 in the dialog box.*

Motion and Radial Blur

The Motion and Radial Blur filters create a sense of motion.

1. From the Filter menu, choose Blur > Motion Blur or Radial Blur.

2. In the dialog box, drag the outside of the Angle circle to choose a direction for the motion blur.

3. Drag the Distance slider to specify, in pixels, the length of the blur. Click on OK.

Distort

Displacement Maps

Displacement maps use one image file to map a special effect onto another. Photoshop comes pre-installed with a number of displacement maps, but you can also create your own.

1. From the Filter menu, choose Distort > Displace.

2. In the dialog box, click on OK. This will prompt you to locate a displacement map file on your hard disk.

3. In the dialog box, navigate to the Photoshop application folder. Open the Plug-Ins folder, then open the Displacement Maps folder.

4. Select a displacement map file from the list. Click on Open.

Twirl

1. From the Filter menu, choose Distort > Twirl.

2. In the Twirl dialog box, hold and drag the Angle slider to twist an image into a spiral. Click on OK.

Noise

Add Noise

Use the Add Noise filter to add a random pattern of pixels to an image, to create the look of a "grainy" photograph. You can also use this filter at a low setting to even out blemishes or imperfections.

1. From the Filter menu, choose Noise > Add Noise.

2. In the dialog box, move the Amount slider (the larger the number, the greater the graininess) to the desired setting. Choose either the Uniform or Gaussian option. Click on OK.

 ✎ *To even out imperfections in an image, move the Amount slider in the dialog box to a small number (1 or 2).*

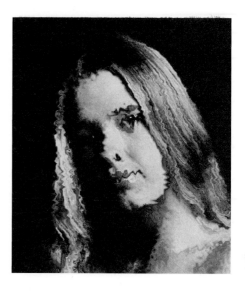

Figure 11-9 Image distorted using the Schnable displacement map.

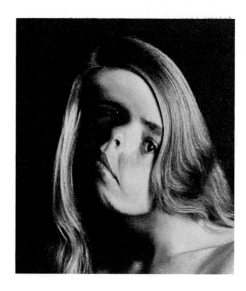

Figure 11-10 Twirl filter.

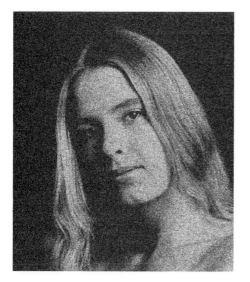

Figure 11-11
Add Noise filter.

Figure 11-12 Mosaic filter.

Despeckle

From the Filter menu, choose Noise > Despeckle. This filter decreases the amount of graininess in an image. However, the effect is quite subtle, especially at higher resolutions. There is no dialog box—the effect is immediate.

Dust and Scratches

The Dust and Scratches filter works much like the Despeckle filter, but it has a dialog box with adjustment sliders.

1. From the Filter menu, choose Noise > Dust and Scratches.

2. In the dialog box, as a starting point, move the Radius slider to 3 and the Threshold slider to 0. Click on OK.

Pixelate

Mosaic

Use the Mosaic filter to convert a continuous-tone image to a pattern of colored squares.

1. From the Filter menu, choose Pixelate > Mosaic.

2. In the dialog box, move the Cell Size slider to choose the size of the squares in pixels. Click on OK.

Render

Clouds and Difference Clouds

Use the Clouds filter to create an artificial sky with clouds using the foreground and background colors specified in the Color Picker. The Difference Clouds filter applies the Clouds filter in Difference blending mode, with the result that color values are dramatically altered, as shown in figure 11-13.

1. Select appropriate foreground and background colors.

2. From the Filter menu, choose Render > Clouds or Difference Clouds.

Figure 11-13 Difference Clouds filter.

Lens Flare

The Lens Flare filter simulates the appearance of light from the background reflecting in the lens of a camera, as shown in figure 11-14. This filter can only be used with an image in RGB mode.

1. From the Filter menu, choose Render > Lens Flare.

2. In the dialog box, enter a number in the Brightness percentage field, or move the slider to adjust the brightness.

3. On the thumbnail, drag the crosshairs to position the angle of the light.

4. Select a Lens Type, and click on OK.

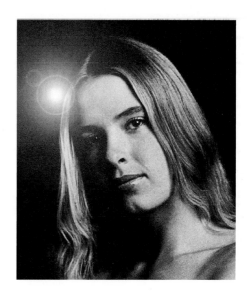

Figure 11-14 Lens Flare filter.

Lighting Effects

The Lighting Effects filter simulates the effect of light being projected onto the image from an external source, as shown in figure 11-15. This filter can only be used with an image in RGB mode.

1. From the Filter menu, choose Render > Lighting Effects.

2. In the dialog box, establish the following settings:

 Style: Select one of the 16 options.

 ✗ *Light Type:* Move the sliders for Intensity and Focus.

 ✗ *Properties*: Move the sliders for Glass, Material, Exposure, and Ambience.

3. To choose the color of light for both Light Type and Properties, click on the Color Picker buttons to the right of each. In the dialog box, choose appropriate colors and click on OK.

4. Drag any of the points on the outside ellipse or the center point to change the direction or placement of the light. Click on OK.

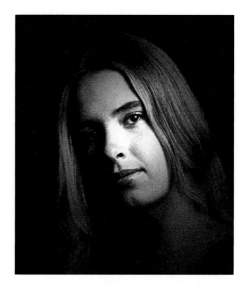

Figure 11-15 Lighting Effects filter.

Figure 11-16 Emboss filter.

Figure 11-17 Stained Glass filter.

Stylize

Emboss

The Emboss filter applies an embossed effect to an image. It reduces the tonal values of the image overall, but gives high-contrast areas a raised appearance, as shown in figure 11-16.

1. From the Filter menu, choose Stylize > Emboss.
2. In the dialog box, drag the Angle circle, the Height slider, and Amount slider. Click on OK.

Texture

Stained Glass

The Stained Glass filter applies a stained glass window pattern to an image, as shown in figure 11-17.

1. From the Filter menu, choose Texture > Stained Glass.
2. In the dialog box, move the sliders for Cell Size, Border Thickness, and Light Intensity. Click on OK.

Other Effects

Not all special image effects in Photoshop are achievable solely with the Filter menu. Blending modes, Layer styles, and Pattern Maker commands are a few of the other effects that can be applied to an image.

Blending Modes

Blending mode options are available in the Option Bars for many of the tools (e.g., Paintbrush, Paint Bucket, and Gradi-

ent), in the dialog boxes of some menu commands (e.g., Fill and Fade), and at the top left-hand side of the Layers palette. Use these blending modes to modify the way colors, textures, commands, and layers blend with the parts of the image to which they are applied. For example, selecting the Difference blending mode when using the Paintbrush tool with the default foreground/background colors reversed would produce a negative effect.

The default mode for tools, menu commands, and layers is Normal. Click on the Mode button to open a pop-up menu with a list of blending modes available. Blending Modes can be used in conjunction with the Opacity slider on any layer except a background layer. An easy way to see the effect of various blending modes is to apply one filter to an image and use the Fade command in the Edit menu, as shown in figure 11-18.

1. Reset the foreground and background colors to their defaults (black and white).
2. From the Image menu, choose Adjustments > Invert. The image will become a negative.
3. From the Edit menu, choose Fade Invert.
4. In the dialog box, click on the Mode button.
5. Select a blending mode from the list in the pop-up menu. Move the Opacity slider to change the amount by which the effect will be faded. Click on OK.

Figure 11-18 Inverted image after Fade Invert > 50% opacity > Difference Blending Mode.

Layer Styles

The Layer Styles command applies special effects to layers. However, these layer effects cannot be applied to a background layer. The effects include Drop Shadow, Inner Shadow, Outer Glow, Inner Glow, Bevel and Emboss, Satin, Color Overlay, Gradient Overlay, Pattern Overlay, and Stroke.

Layer Menu

1. From the Layer menu, choose Layer Style > Blending Options. Alternatively, in the Layers palette, double-click on the Layer icon.

2. In the dialog box, shown in figure 11-19, click on a Style name from the menu on the left.

3. In the style options, choose the settings for that effect. Activate the Preview button to see the adjustments. Click on OK.

Figure 11-19 Layer Style dialog box.

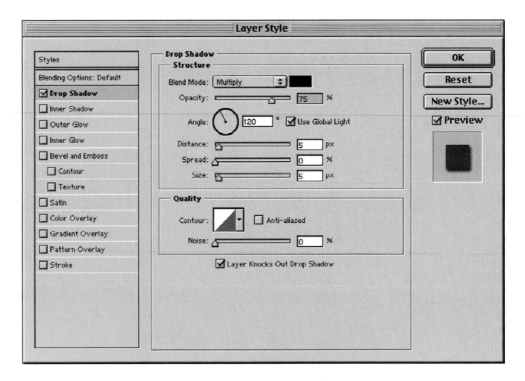

The layer name in the palette will now have an *f* inside a circle next to it, indicating an effect has been applied, and that it can still be modified. To add more styles to the layer, continue with the following steps.

4. In the Layers palette, double-click on the f icon.

5. In the dialog box, activate and adjust the desired layer effect.

To deactivate a style, continue with the following steps.

6. In the Layers palette, double-click on the f icon.

7. In the dialog box, uncheck the Style box to the left of the Style name that you want to deactivate.

Styles Palette

The Styles palette applies preset layer styles. However, these effects cannot be applied to a background layer.

1. From the Windows menu, choose Styles.

2. Click on a Style button.

To add Styles from the Styles library to the Styles palette, continue with the following steps.

3. In the Styles palette, click on the arrowhead in the upper right-hand corner.

4. In the pop-up menu, click on a Style library (Abstract Styles, Buttons, Image Effects, Texture Effect, Texture, and so on).

5. In the dialog box, click on the Append button. The selected effects will be added to the Styles palette.

To restore the Styles palette, shown in figure 11-20, continue with the following steps.

6. Click on the arrowhead in the upper right-hand corner.

7. In the pop-up menu, click on Reset Styles.

8. In the dialog box, click on OK.

Figure 11-20 Styles palette.

Liquify

The Liquify command lets you distort an image with a brush. The distortions include such effects as Warp, Twirl, Pucker, Bloat, Shift Pixels, and Reflection. An example of an image modified with the Liquify command is shown in figure 11-21.

1. From the Filter menu, choose Liquify.
2. In the dialog box, modify the Brush Size and Brush Pressure.
3. Select a Liquify tool (Warp, Twirl, etc.).
4. Brush over the areas to be distorted.

To mask or protect an area from the distortion, continue with the following steps.

5. Click on the Freeze tool.
6. Brush over the area to be protected.

To unprotect an area, continue with the following steps.

7. Click on the Thaw tool.
8. Brush over the area from which you want to remove the protection.

To remove all protection, continue with the following steps.

9. Click on the Thaw All button.

To selectively undo the Liquify effect, continue with the following steps.

10. Click on the Reconstruction tool.
11. Brush over the areas to be restored.

To reconstruct the entire image, continue with the following steps.

12. Click on the Revert box.

Figure 11-21 Liquify filter.

Pattern Maker

The Pattern Maker command is similar to the Define Pattern command. They both use a selected rectangular area to create a pattern. However, Pattern Maker blends the edges to a greater extent, making the pattern more seamless. Unlike the Define Pattern command, Pattern Maker applies the pattern to the current image and does not store it in the Pattern Picker.

1. From the Filter menu, choose Pattern Maker.

2. In the dialog box, select a rectangular space.

3. Click on the Generate button in the upper right-hand side of the dialog box to create a preview of the pattern. Click on OK. The pattern will be applied to the image.

Brush Commands

Commands for altering brush dynamics such as shape, spacing, fade, and texture are located in the Brushes palette in the upper right-hand side of the Brushes Options Bar.

1. Click on the Toggle to Brushes Palette button.

2. In the palette, click on the arrowhead in the upper right-hand corner.

3. In the pop-up menu, click on Expanded View.

To alter the diameter, hardness, and spacing of a brush stroke, continue with the following steps.

4. Click on the Brush Tip Shape button.

5. In the dialog box, move the Diameter, Hardness, and Spacing sliders to adjust the brush stroke. A preview of the brush will change as you make the adjustments.

To fade a brush stroke, continue with the following steps.

6. Click on the Shape Dynamics button.

7. In the dialog box, under the Size Jitter, click on the Control button.

8. In the pop-up menu, click on Fade.

9. Enter a number of pixels in the Fade field.

To change the angle and roundness of a brush, continue with the following steps.

10. Click on the Brush Tip Shape button.

11. In the dialog box, drag the arrow outside the circle to alter the angle of the brush.

12. Drag on either of the two anchor points on the circle to alter the brush's roundness.

To apply a texture to a brush stroke, continue with the following steps.

13. Click on the Texture button.

14. In the dialog box, click on the Pattern Picker arrowhead.

15. In the Pattern Picker, click on a Pattern icon.

16. Click on the Mode button.

17. In the pop-up menu, click on Multiply.

✎ *The Brush tool options can be reset to their defaults by clicking on the arrowhead to the right of the Brushes palette. In the pop-up menu, select Clear Brush Controls.*

Define Brush

Any selected area can be made into a custom brush, as shown in figure 11-22.

Figure 11-22 Custom brush, with spacing set at 100, stroked onto a blank canvas.

1. Click on a selection tool. Drag (or click with the Magic Wand tool) to select an area.

2. From the Edit menu, choose Define Brush. In the dialog box, click on OK.

3. Click on the Paintbrush tool. In the Options Bar, click on the arrowhead to the right of the Brush icon.

4. In the Brush Picker, click on the newly defined brush. (It will be the last brush in the brush picker.)

5. On the image, drag to apply brush strokes with the custom brush.

Brush Palettes

To load custom brush sets, use the Assorted Brushes palette, shown in figure 11-23.

1. In the Paintbrush Options Bar, click on the arrowhead to the right of the Brush icon.

2. In the Brush Picker, click on the arrowhead in the upper right-hand corner.

3. In the pop-up menu, choose a brush library— e.g., Assorted Brushes, or any of the brush libraries below it.

4. In the dialog box, click on Append to add the selected brush preset to the Brush Picker.

5. In the Brush Picker, click on an Assorted Brushes icon.

6. On the image, drag to apply brush strokes from the palette you just loaded.

Figure 11-23 Assorted Brushes palette.

Curves Command

The Curves command adjusts the values and colors of an image. It can also be used to apply interesting color effects, as shown in figure 11-24.

1. From the Image menu, choose Adjustments > Curves.
2. In the dialog box, click on the Pencil icon in the lower left, next to the Curved Line icon.

To create a negative image, continue with the following steps.

3. Click in the upper left corner of the graph box.
4. Hold down the Shift key and click on the lower right corner of the graph box. A straight diagonal line will appear. Click on OK.

To create a solarized image, continue with the following steps.

5. Click in the upper left corner of the graph box.
6. Hold down the Shift key and click in the center of the graph. Continue to hold down the Shift key and click on the upper right corner. Click on OK.

To create unusual values and colors, continue with the following steps.

7. Draw random line segments anywhere on the graph box.
8. To connect the segments, click on the Smooth button. Click on OK.

To create new colors within separate channels, continue with the following steps.

9. Click on the Channels button at the top of the dialog box.
10. Select a color channel.
11. Click on the Smooth button. Drag the diagonal line in the graph to alter the colors of the image.

Figure 11-24 Curves command.

Digital Panorama

Cameras with wide-angle lenses, and special panorama cameras, are used in traditional photography to create long, horizontal images. Alternatively, digital images can be "stitched" together to create a similar effect.

1. Photograph a series of adjacent scenes along a horizontal plane. Keep the camera at the same level, and overlap each composition in the viewfinder.

2. If a traditional camera was used, scan each print that will be used in the panorama, at the same size and resolution. If a digital camera was used, upload the images to the camera.

3. Open the image that will be used on the left side of the panorama.

4. From the Image menu, choose Canvas Size.

5. In the dialog box, increase the width of the canvas to leave space for all the images being used.

6. Click on the left center square in the Anchor field. Click on OK.

7. Open the second image from the left.

8. Click on the Move tool.

9. Drag the second image on top of the first (or use Copy and Paste).

10. With the Move tool, drag the second image to align the overlapping edges. If necessary, choose Transform > Scale from the Edit menu to correct any size differences.

11. Click on the Eraser tool.

12. Choose a large, soft brush and set the Opacity to 75%.

13. Brush the left edge of the pasted image to eliminate any visible stitch line.

14. Repeat steps 7 through 13 for subsequent images added.

Digital Negatives

Alternative contact printing processes, such as Platinum/Palladium, Van Dyke Brown, and Cyanotype, have traditionally utilized larger format negatives. The process of making the negatives has been tedious and expensive when using a service bureau. Dan Burkholder, author of the book *Making Digital Negatives for Contact Printing*, has developed a technique for digitally creating the negative for these processes. His book contains a CD-ROM with the recommended Curves settings. The steps in this process, as outlined below, are explored in greater detail in his book.

1. From the Image menu, choose Image Size. In the dialog box, enter 600 in the Resolution field. Click on OK.

2. From the Image menu, choose Adjustments > Invert.

3. From the Image menu, choose Adjustments > Curves. In the dialog box, click on the Load box. Locate the preset curves designed for making contact printing negatives (from the Burkholder CD-ROM). Click on OK.

4. From the Image menu, choose Mode > Bitmap. In the dialog box, choose Diffusion Dither. Click on OK.

5. Print on transparency film (Pictorico Premium OHP transparency film is recommended).

6. Contact-print the negative transparency onto any of the previously listed materials using ultraviolet light.

 ✎ *Digital negatives can also be contact-printed onto silver gelatin photographic paper. However, a different preset curve should be used in making the negative.*

Web Tools

ImageReady

Adobe Photoshop 7 includes a software utility called ImageReady. One of the functions of this software is to prepare images for the World Wide Web so that they will transmit efficiently. The program automates the process of

reducing image file size and saving it in a compressed format.

1. In Photoshop, open an image you might want to include on a Web page.

2. Click on the Jump To button at the bottom on the toolbox. The ImageReady software will launch, with the current RGB file automatically opened in a new window.

 ✎ *Alternately, from the ImageReady File menu, select Open. In the dialog box, locate the image and double-click it.*

3. From the Windows menu, choose Optimize. In the Optimize palette, click on the Settings button. In the pop-up menu, click on JPEG Medium and activate the Optimize button.

4. From the File menu, choose Save Optimized. In the dialog box, click on the Format box. In the pop-up menu, click on HTML and Images. Click on the double-arrow on the top button. In the pop-up menu, click on the location for saving the file. Click on Save.

 ✎ *More specific adjustments could be made on the image. The previous instructions will format the image automatically.*

Slice

The Slice tool divides an image into smaller parts so that it can download on the Web faster.

1. Click on the Slice tool.

2. Drag on the image. A rectangular slice will appear. Repeat in another area. A second slice will appear.

3. From the File menu, choose Save.

4. In the dialog box, choose a file location, a file name, and an HTML format option. Click on Save.

Exercises for Developing Skills and Creativity

The exercises you will perform in this chapter are an extension of those found in Chapter 3. Attempt them only after acquiring a basic understanding of Adobe Photoshop by reading Chapter 4.

Exercise 12-1: Photomontage

Create a collage of overlapping photographs, as shown in figure 12-1. You will add white borders and drop shadows to all the images and uneven edges to two of them.

COMPOSING THE IMAGE

1. From the File menu, choose New. Enter *8* inches in the Width field, *10* inches in the Height field, and *200* in the Resolution field. Select RGB in the Mode pop-up menu, and for the Contents option choose White.

2. Choose any foreground color other than black or white.

3. Click on the Paint Bucket tool and click on the blank file. It will fill with the Foreground color.

4. Open one of the photographs to be used in the montage.

5. Click on the Move tool and drag the image to the blank file, where it will automatically be copied and pasted.

6. From the Edit menu, choose Transform > Scale. Hold down the Shift key while dragging the corner handles to adjust the size of the image. Press Enter or Return.

7. Select white as the Foreground color.

8. From the Edit menu, choose Stroke. In the dialog box, enter *20* pixels in the Width field, and activate the Inside button. Click on OK.

9. Repeat steps 4 through 8 to add more photographs to the montage.

10. Use the Move tool to arrange the composition. Once images have been copied and pasted to the master file, the original picture files can be closed.

Figure 12-1 Montage of three images with cast shadows. Two of the images have uneven edges applied to them.

CREATING UNEVEN EDGES

1. Click on the Rectangular Marquee tool. Drag in the middle of the white border of one image created by the Stroke command. You may need to zoom in to get a better view of the image.

2. From the Select menu, choose Inverse.

3. From the Filter menu, choose Distort > Ripple. Move the slider to 150%. Click on OK.

4. Repeat steps 1 through 3 on the other images.

 ✎ *Note that Ripple is the last filter used and is therefore listed at the top of the Filter menu. You can re-execute the filter command by pressing Cmd/Ctrl + F.*

MAKING A DROP SHADOW

1. In the Layers palette, double-click on a layer name. In the dialog box, click on the Drop Shadow effect. Move the Distance and Size sliders to 35 pixels. Click on OK.

To apply the effect to other layers, continue with the following steps.

2. From the Layer menu, choose Layer Style > Copy Layer Style.

3. From the Layer menu, choose Layer Style > Paste Layer style.

Exercise 12-2: Perspective Type

Create type in perspective against a star-filled sky, as shown in figure 12-2.

1. From the File menu, choose New. Enter *6* inches in the Width field, *4* inches in the Height field, and *200* in the Resolution field. Click on OK.

2. From the Edit menu, choose Fill, and fill the new, blank canvas with black.

3. From the Filter menu, choose Noise > Add Noise. Move the Amount slider to 100%. Select the Gaussian option, and check the Monochromatic box.

4. From the Filter menu, choose Stylize > Diffuse. Click on the Darken Only button. Click on OK.

5. Repeat step 4 to reduce the number of "stars."

6. Increase contrast in the Levels dialog box by moving the white point toward the far left.

7. Click on the Horizontal Type tool. Select a bold font (e.g., Impact), white as the text color, and a large point size (e.g., 120 points). Click on the image where the lettering is to start. Press the Caps Lock key. Type a word. Click on the Commit Any Current Edits button.

8. From the Layer menu, choose Rasterize > Type.

9. From the Edit menu, choose Transform > Scale. Drag the handles to adjust the size of the rasterized type.

10. From the Edit menu, choose Transform > Perspective. Hold and drag the top right handle toward the middle of the bounding box. Press Enter or Return.

11. Use the Move tool to center the lettering on the image.

Figure 12-2 Transform > Perspective command applied to type to create a "Star Wars" look.

Exercise 12-3: "Attitude" Poster

Create a "successories" style company poster that combines white lettering over a black border, as shown in figure 12-3.

1. Open an appropriate photograph for the poster.

2. Reset the foreground and background colors to their defaults (black and white).

3. From the Image menu, choose Canvas Size. In the dialog box, increase the Width and Height fields each by .1 inch. Click on OK. A white border will appear around the edges of the enlarged canvas.

4. Reverse the foreground and background colors by clicking on the Switch Colors double-arrow icon. Black should now be the background color.

5. From the Image menu, choose Canvas Size. In the dialog box, increase the Width and Height fields each by 3 inches. Click on OK. A black border will be created around the image.

6. Repeat step 4, but this time only increase the height by 1 inch, and click on the top center box in the Anchor field. Click on OK. The black border at the bottom should now be 1 inch thicker than the border on the other three sides.

7. Click on the Horizontal Type tool. In the Options Bar, choose a bold lettering font (e.g., Helvetica Bold) and a large font size (60 points), then click on the Center Text button. Press the Caps Lock key. Click in the black border below the image and type an inspirational word (e.g., *TEAMWORK*). The lettering will be white. Click on the Commit Any Current Edits button.

8. Click on the Move tool. Use the Arrow keys to position the type just below the image.

9. Click on the Horizontal Type tool. In the Options Bar, choose the same font that was used before, but at a smaller size, and click on the Center button. Do not use Caps Lock. Click on the image below the title and type a sentence—e.g.,"Teamwork means working together." Click on the Commit Any Current Edits button.

10. Click on the Move tool. Use the Arrow keys to position the type below the title.

✎ *Consult the www.successories.com Web site for ideas. Then look at the parody posters featured on the www.despair.com site.*

Figure 12-3 In this image, the canvas size was increased and type added along the bottom margin.

Exercise 12-4: "Wish You Were Here" Postcard

Create a travel postcard with an image inside the type, as shown in figure 12-4.

1. From the File menu, choose New. Enter *6* inches in the Width field, *4* inches in the Height field, and *200* in the Resolution field. Click on OK.

2. Select black as the foreground color.

3. Click on the Horizontal Type tool. In the Options Bar, choose a bold lettering font, such as Impact, and a large font size (120 points). Click on the blank canvas in the area where the lettering is to start. Press the Caps Lock key. Type a word (for example, *ITALY*). Click on the Commit Any Current Edits button.

Figure 12-4 Postcard with an image pasted into the type.

4. From the Edit menu, choose Transform > Scale. Drag the corner handles of the bounding box so that the selection fills the picture plane. Press Enter or Return.

5. Click on the Magic Wand tool. In the Options Bar, uncheck the Contiguous box. Click on a black letter. All the letters will be selected.

6. Open a horizontal image that relates to the word you just typed.

7. Select All.

8. From the Edit Menu, choose Copy, then close the image.

9. Click on the original file with the black type still selected.

10. From the Edit menu, choose Paste Into.

11. Click on the Move tool. On the image, drag to position the pasted image inside the type selection.

12. From the Edit menu, choose Transform > Scale. Hold down the Shift key, and drag the corner handles of the bounding box to adjust the size of the image. Press Enter or Return.

13. Select red as the foreground color.

14. Click on the Horizontal Type tool. Select a script-style font and a medium font size. Click on the image in the lower right corner and type a greeting (for example, "Greetings from"). Click on the Commit Any Current Edits button.

15. From the Edit menu, choose Transform > Rotate. Drag the corner handles to rotate the lettering to a diagonal orientation. Press Enter or Return.

Exercise 12-5: Translucent Type over an Image

Type placed over an image can have the opacity reduced so that the image shows through, as seen in figure 12-5.

1. Open an image.

2. Select white as the foreground color.

3. Click on the Horizontal Type tool. In the Options Bar, choose a bold lettering font (Helvetica. Bold) and a large font size (120 points). Press the Caps Lock key. Click on the image where the lettering is to begin. Type a word. Click on the Commit Any Current Edits button.

4. From the Edit menu, choose Transform > Scale. Drag the corner handles to the outside of the image. Press Enter or Return.

5. In the Layers palette, move the Opacity slider to 50%.

6. To add an outline around the type, choose Layer Style > Stroke from the Layer menu.

Figure 12-5 Translucent type over an image.

Exercise 12-6: Mirrored Image

You can achieve a mirrored or "ink blot effect" by using the Copy and Paste commands. The effect can be applied horizontally and vertically, as shown in figure 12-6.

1. Open an image.

2. Select white as the background color.

3. From the Image menu, choose Canvas Size. In the dialog box, enter a number that is twice the original width. Click on the left center square in the Anchor field. Click OK.

4. Select All.

5. From the Edit menu, choose Copy.

6. From the Edit menu, choose Paste.

7. From the Edit menu, choose Transform > Flip Horizontal.

8. In the Layers palette, choose Darken blending mode pop-up menu.

9. From the Layer menu, choose Flatten Image.

10. Repeat steps 3 through 9, but double the canvas *height* in step 3 and flip the image *vertically* in step 7.

Figure 12-6 Image mirrored horizontally and vertically.

Exercise 12-7: Patterns

Patterns, like the one shown in figure 12-7, can be created using the Transform and Define Pattern command.

PATTERN 1

1. Open an image.

2. Click on the Rectangular Marquee tool. In the Options Bar, click on the Style button, then on Fixed Size. Enter *100* pixels in the Width field and *100* pixels in the Height field. Click on the image to designate an area from which the pattern will be taken. Drag inside the selection marquee to reposition it.

3. From the Image menu, choose Crop.

4. From the Image menu, choose Canvas Size. In the dialog box, enter *200* pixels in the Width field and *200* pixels in the Height field. Click on the upper right square in the Anchor field. Click on OK.

5. Select All.

6. From the Layer menu, choose New > New Layer Via Copy.

7. From the Edit menu, choose Transform > Flip Horizontal.

8. In the Layers palette, choose Darken in the Blending Mode pop-up menu.

9. From the Layer menu, choose Flatten Image.

10. Select All.

11. From the Layer menu, choose New > New Layer Via Copy.

12. From the Edit menu, choose Transform > Flip Vertical.

13. In the Layers palette, choose Darken in the Blending Mode pop-up menu.

14. From the Layer menu, choose Flatten Image.

15. Select All.

16. From the Edit menu, choose Copy.

Figure 12-7 Pattern created from a section of an image.

17. From the Edit menu, choose Define Pattern. In the dialog box, click on OK.

18. From the File menu, choose New. In the dialog box, enter *1000* pixels in the Width field, *1000* pixels in the Height field, and *72* pixels in the Resolution field. Select RGB in the Mode pop-up menu. Click on OK.

19. From the Edit menu, choose Fill. In the dialog box, choose Pattern from the Use pop-up menu. Click on the Custom Pattern arrowhead and locate the pattern you just created at the bottom of the Pattern Picker. Click on OK. The canvas will be filled with the mirrored pattern.

PATTERN 2

To create another pattern, like the one shown in figure 12-8, continue with the following steps.

20. From the Image menu, choose Rotate Canvas > 90° CCW.

21. From the Edit menu, choose Fill. In the dialog box, choose Pattern in the Use pop-up menu, and Difference in the Blending Mode pop-up menu.

PATTERN 3

To create yet another variation of the pattern, as shown in figure 12-9, continue with the following steps.

22. From the Image menu, choose Rotate Canvas > Arbitrary. In the Arbitrary dialog box, enter *45°* in the Angle field. Click on OK. The canvas size will expand to fit the diamond shape of the rotated image.

23 From the Image menu, choose Image Size. Reduce the width and height to the size of the last pattern.

24. Click on the Magic Wand tool. Click on a corner triangle. Hold down the Shift key, and add the other three corners to the selection.

25. From the Edit menu, choose Fill. In the dialog box, choose Normal blending mode and Pattern.

Figure 12-8 Same pattern as in figure 12-7, but rotated 90°, then filled with the original pattern using Difference blending mode.

Figure 12-9 Same image as figure 12-8, but rotated 45°. The corner triangles have been filled with the original pattern.

Figure 12-10 Add Noise, Ripple, and Dark Strokes filters applied in succession to an image to create a texture.

Exercise 12-8: Textures

You can use a variety of filters to create a texture like the one shown in figure 12-10.

1. From the File menu, choose New. In the dialog box, enter numbers in the Width, Height, and Resolution fields. Select RGB in the Mode pop-up menu. Click on OK.

2. From the Filter menu, choose Noise > Add Noise. Move the slider all the way to the right. Click on OK.

3. From the Filter menu, choose Distort > Ripple. In the Ripple dialog box, move the slider to +250. Click on OK.

4. From the Filter menu, choose Brush Strokes > Dark Strokes. In the Dark Strokes dialog box, move all three sliders to the middle. Click on OK.

Exercise 12-9: "Halo" Around a Shape

Create a white glow or halo around a selected area, as shown in figure 12-11.

1. Open an image.

2. Reset foreground and background colors to defaults.

3. Select an area of the image using any selection tools.

4. From the Edit menu, choose Copy.

5. From the Edit menu, choose Paste. This will create another layer containing the image.

6. Click on the Magic Wand tool. Click on the area outside the shape.

7. From the Edit menu, choose Fill. In the dialog box, choose Background Color (white) in the Use pop-up menu. The background will be filled with white.

8. From the Select menu, choose Modify > Contract. In the dialog box, enter *20* pixels in the Contract By field. Click OK.

9. From the Select menu, choose Feather. In the dialog box, enter *10* pixels in the Feather Radius field. Click OK.

10. Press the Delete key. The white border around the shape will fade into the background.

Figure 12-11 "Halo" effect created around a shape.

Exercise 12-10: Television Screen with Glow

Curve the sides of an image using the Spherize command. Then add a halo around the image to create a cartoon television screen glowing in a dark room, as shown in figure 12-12.

1. Open a horizontally oriented image.

2. From the Image menu, choose Image Size. In the dialog box, enter *8* inches in the Width field. Click on OK.

3. Select black as the background color.

4. From the Image menu, choose Canvas Size. In the dialog box, increase both the Width and Height fields by 5 inches. Click on OK.

5. Double-click on the Hand tool to view the entire image.

6. From the Filter menu, choose Distort > Spherize. In the dialog box, move the slider to 60%. Click on OK. The sides of the image will curve.

7. Click on the Magic Wand tool. Click on the black border. (If the selection includes the image itself, lower the Tolerance setting and repeat.)

8. From the Layer menu, choose New > Layer. In the dialog box, title the layer *Glow*. Click on OK.

9. From the Edit menu, choose Fill. In the dialog box, choose White in the Use pop-up menu. The black border will be covered by the white layer.

10. From the Select menu, choose Modify > Contract. In the dialog box, enter *20* pixels in the Contract By field. Click on OK.

11. From the Select menu, choose Feather. In the dialog box, enter *10* pixels in the Feather Radius field. Click on OK.

12. Press the Delete key. The white border will fade into black.

13. Deselect.

Figure 12-12 Spherize filter applied to an image with a white "halo" around it.

Exercise 12-11: Faded Arrows

Create faded arrows, likes those shown in figure 12-13.

1. Open an image.

2. Select black as the foreground color.

3. Click on the Quick Mask tool.

4. Click and hold on the Rectangle tool, then drag to the Line tool. In the Options Bar, click on the Filled Pixels button. Enter a number of pixels in the Weight field and choose 100% Opacity. Click on the Geometry Options arrowhead. Activate the Start button. Enter *300%* in the Width and Length fields. On the image, drag to create the arrow mask, which will appear in red.

5. Click on the Gradient tool. In the Options Bar, click on the arrowhead to the right of the gradient. In the Gradient Picker, choose the *Black, White* gradient. In the Options Bar, click on the Linear Gradient icon, and choose Lighten in the Mode pop-up menu. Drag from the point of the arrow to create the fade.

Figure 12-13 Faded arrow shapes with halos.

6. Click on the Standard Mode tool; a selection marquee should replace the mask.

7. From the Select menu, choose Inverse.

8. From the Edit menu, choose Fill. In the dialog box, choose Foreground Color in the Use pop-up menu. Click on OK. The selection will fill with a faded arrow using the foreground color.

To create a halo around the arrow, continue with the following steps.

9. From the Layer menu, choose New > Layer. In the dialogue box, title the layer *Halo*. Click on OK.

10. From the Select menu, choose Inverse.

11. From the Edit menu, choose Fill. In the dialog box, choose White in the Use pop-up menu.

12. From the Select menu, choose Modify > Contract. In the dialog box, enter *12* pixels. Click on OK.

13. From the Select menu, choose Feather. In the dialog box, enter *6* pixels in the Feather Radius field. Click on OK.

14. Press the Delete key.

15. Deselect.

Exercise 12-12: Sphere with Shadow

Create a 3D floating sphere that casts a shadow, as shown in figure 12-14.

1. From the File menu, choose New. In the New dialog box, create a new file. Click on OK.

2. From the Layer menu, choose New > Layer. In the Layer dialog box, enter the name *Sphere*. Click on OK.

3. Hold on the Rectangular Marquee tool and drag to the Elliptical Marquee tool. Hold down the Shift key while dragging on the image to create a circle selection.

Figure 12-14 Sphere with shadow.

4. Click on the small default Foreground/Background color squares (black and white).

5. Click on the double arrows to reverse the colors (white in the Foreground).

6. Click on the Gradient tool. In the options bar, click on the arrowhead to the right of the gradient. In the Gradient picker, click on the Foreground to Background icon (top left). In the Options Bar, click on the Radial Gradient icon. Starting toward the top of the circle, drag inside the selection. Make sure the gradient mode is reset to Normal after the previous exercise.

7. From the Layer menu, choose New > Layer. In the dialog box, enter the name *Shadow*.

8. In the Layers palette, drag the *Sphere* layer on top of the *Shadow* layer. The *Shadow* layer should still be highlighted.

9. Click on the Elliptical Marquee tool. On the image, drag to create an oval selection. Drag inside the selection to reposition it under the sphere.

10. From the Edit menu, choose Fill. In the dialog box, choose Black in the Use pop-up menu. Click on OK.

11. Deselect.

12. From the Filter menu, choose Blur > Gaussian Blur. In the dialog box, move the slider to adjust the blur of the shadow.

13. In the Layers palette, adjust the Opacity slider to lighten the shadow.

Exercise 12-13: Cone with Shadow

Create a floating 3D cone that casts a shadow, like the one shown in figure 12-15.

1. From the File menu, choose New. In the dialog box, create a new file. Click on OK.

2. From the Layer menu, choose New > Layer. In the dialog box, enter the name *Cone.*

3. Reset the foreground and background colors to their defaults.

4. Reverse the default colors by clicking on the Switch Colors icon. White will become the foreground color.

5. Click on the Rectangular Marquee tool. On the image, drag to create a vertical selection.

6. Click on the Gradient tool. In the Options Bar, click on the Reflected Gradient icon. Hold down the Shift key. Drag from the middle to the right inside the selection rectangle. A gradient will be formed across the box that is dark on its left and right sides.

7. From the Edit menu, choose Transform > Perspective. Drag a top corner handle toward the middle of the bounding box. Press Enter or Return.

8. Deselect.

9. Click on the Rectangular Marquee tool and drag to the Elliptical Marquee tool. At the bottom of the triangle, drag to select an oval. From inside the oval, drag so that the bottom of the oval is tangent to the bottom of the triangle.

10. From the Select menu, choose Inverse.

11. Click on the Eraser tool. Choose a large brush Size. On the image, drag to erase the bottom of the triangle.

Figure 12-15 Cone with shadow.

12. Deselect.

13. From the Layer menu, choose New > Layer. In the dialog box, enter the name *Shadow*.

14. In the Layers palette, drag the *Cone* layer on top of the *Shadow* layer. The *Shadow* layer should still be highlighted.

15. Click on the Elliptical Marquee tool. On the image, drag to create an oval selection. Drag inside the selection to reposition it under the cone shape.

16. From the Edit menu, choose Fill. In the dialog box, choose Black in the Use pop-up menu. Click on OK.

17. Deselect.

18. From the Filter menu, choose Blur > Gaussian Blur. In the dialog box, move the slider to adjust the blur of the shadow.

19. In the Layers palette, move the Opacity slider to lighten the shadow.

Exercise 12-14: Cube with Shadow

Create a 3D cube that casts a shadow, like the one shown in figure 12-16.

1. From the File menu, choose New. In the dialog box, create a new file. Click on OK.

2. From the Layer menu, choose New > Layer. In the dialog box, enter the name *Cube*.

3. Click on the Rectangular Marquee tool. Hold down the Shift key while dragging to create a square selection.

4. From the Edit menu, choose Fill. In the dialog box, choose 50% Gray in the Use pop-up menu. Click on OK.

5. Drag a rectangular selection tangent to and above the top of the square.

Figure 12-16 Cube with shadow.

6. From the Edit menu, choose Fill. In the dialog box, choose 50% Gray in the Use pop-up menu. Enter *50* in the Opacity field to create a lighter gray. Click on OK.

7. From the Edit menu, choose Transform > Perspective. Drag the top-center handle to one side to create a parallelogram. Press Enter or Return.

8. From the side ruler, drag a blue guideline to the outside corner of the parallelogram.

9. Drag a rectangular selection tangent to the side of the square and to the guideline.

10. From the Edit menu, choose Fill. In the dialog box, choose Black in the Use pop-up menu. Click on OK.

11. From the Edit menu, choose Transform > Perspective. Drag the middle handle to create another parallelogram that aligns with the first parallelogram. Press Enter or Return.

12. Deselect.

13. From the Layer menu, choose New > Layer. In the dialog box, enter the name *Shadow.*

14. In the Layers palette, drag the *Cube* layer on top of the *Shadow* layer. The *Shadow* layer should still be highlighted.

15. Drag to create a rectangular selection below the cube.

16. From the Edit menu, choose Fill. In the dialog box, choose Black in the Use pop-up menu. Click on OK.

17. From the Edit menu, choose Transform > Perspective. Drag the top-center handle to one side to create a parallelogram. Press Enter or Return.

18. Deselect.

19. From the Filter menu, choose Blur > Gaussian Blur. In the dialog box, move the slider to adjust the blur of the shadow.

20. In the Layers palette, move the Opacity slider to lighten the shadow.

Exercise 12-15: Cartoon Landscape

Use selection tools, fills, and gradients to create a cartoon sky and landscape, as shown in figure 12-17.

SKY

1. From the File menu, choose New. In the dialog box, enter *6* inches in the Width field, *4* inches in the Height field, and *200* in the Resolution field. Click on OK.

2. Click on the Rectangular Marquee tool. Drag from the upper left corner to approximately the middle right side of the image to select the "sky."

3. Select a foreground and background color, with a lighter color for the background.

4. Click on the Gradient tool. In the Options Bar, click on the arrowhead to the right of the gradient. In the Gradient Picker, choose the Foreground to Background icon. In the Options Bar, choose the Linear icon. Starting toward the top of the rectangle, drag down inside the selection.

5. From the Select menu, choose Inverse.

6. From the Edit menu, choose Fill. In the dialog box, choose Foreground Color in the Use pop-up menu. Click on OK.

7. Deselect.

ROAD

8. Click and hold on the Lasso tool, then drag to the Polygon Lasso tool. Create a triangular selection to represent a road.

9. Click on the Gradient tool. Repeat step 4, but this time drag from the bottom.

MOON AND STARS

10. Click and hold on the Rectangular Marquee tool, then drag to the Elliptical Marquee tool. Hold down the Shift key while dragging to create a circular selection. To create a crescent moon, hold down the Option key while dragging another circle (which overlaps the first) to subtract a portion of the "moon."

11. From the Edit menu, choose Fill. In the dialog box, choose White in the Use pop-up menu. Click on OK.

12. Deselect.

13. Choose white for the foreground color.

14. Click on the Brush tool. In the Options Bar, click on the arrowhead to the right of the Brush icon. In the Brush Picker, click on the arrowhead in the upper right-hand corner. In the pop-up menu, click on Assorted Brushes. In the dialog box, choose Append and click on OK. In the Brush Picker, choose the *Star—Large* brush. Click once on the image for each star.

Figure 12-17 Cartoon landscape of road, moon, and stars.

Exercise 12-16: Perspective Room Cartoon

Use selection tools, fills, and gradients to create a one-point perspective room cartoon, as shown in figure 12-18.

1. From the File menu, choose New. In the dialog box, enter *10* inches in the Width field, *8* inches in the Height field, and *200* in the Resolution field. Click on OK.

2. Click on the Rectangular Marquee tool. Drag a horizontal selection to define the back wall.

3. From the File menu, choose Stroke. In the dialog box, enter *5* pixels in the Width field. Select the Inside button. Click on OK.

4. Click on the Paintbrush tool. Click in the middle of the back wall to create a dot.

5. From the Layer menu, choose New > Layer. In the dialog box, enter the name *Perspective walls.* Click on OK.

6. Click on the Line tool. In the Options Bar, enter *5* pixels in the Weight field. On the image, drag to create lines that extend from the dot through each corner of the rectangle to the edge of the image.

7. In the Layers palette, click on the background layer name.

8. Click on the Magic Wand tool. Click on the back wall.

9. In the Layers palette, click on the *Perspective walls* layer name. Press the Delete key.

10. From the Layer menu, choose Flatten Image.

Figure 12-18 Cartoon room in one-point perspective.

Exercise 12-17: Cartoon Character

Use the Lasso tool and Stroke command to create a cartoon character, as shown in figure 12-19.

1. From the File menu, choose New. In the dialog box, enter *4* inches in the Width field, *6* inches in the Height field, and *200* in the Resolution field. Click on OK.

2. From the Layer menu, choose New > Layer. In the dialog box, enter the name *Cartoon figure*.

3. Click on the Lasso tool. Drag to create a shape for the character's torso. Hold down the Shift key and add selections for arms, legs, and head.

 ✎ *OPTION: Use the Elliptical tool to create an oval body and head. Use the Polygon Lasso tool to create the arms and legs.*

4. Select black as the foreground color.

5. From the Edit menu, choose Stroke. In the dialog box, enter *5* pixels in the Width field and click on the Outside button.

6. Select a foreground color other than black for the character's body.

7. Click on the Paint Bucket tool. Click on the body to fill it with the foreground color.

8. Reset the colors to their defaults (black and white).

9. Click on the Dodge tool, and drag to the Burn tool. Choose a large, soft Brush. Enter *50%* in the Opacity field. Drag to shade the sides of the body.

10. Click on the Burn tool, and drag to the Dodge tool. Choose a large, soft Brush. Enter *50%* in the Opacity box. Drag in the middle to highlight the body.

11. Click on the Brush tool. Choose a small, hard brush. Drag to add facial features and details.

Figure 12-19 Cartoon character with shading created using the Elliptical Marquee and Polygon Lasso tool.

Resources

Each click of the shutter becomes an emotional investment, and a part of the world becomes our visual possession.

—Jerry N. Uelsmann

Traditional/Digital Photographic Materials

The following are major sources of photographic materials and equipment. These include film, chemicals, paper, cameras, darkroom equipment and supplies, digital printers, and other photographic supplies.

Film, Chemicals, and Paper

Eastman Kodak Company
P.O. Box 621
East Rochester, NY 14445
Phone: 800-516-5666
Fax: 800-661-4444
Internet address: ek1218@catdir.com

Alternatively, contact your local Eastman Kodak retail outlet or distributor.

Ilford Photo
W. 70 Century Road
Paramus, NJ 07653
Phone: 201-265-6000
Fax: 201-599-4348

See also the *Ilford Instructor Newsletter* for teaching and material information.

Menin Gate. Photograph by Jane Alden Stevens.

Cameras, Darkroom, Digital Printers, and Supplies

Freestyle
5124 Sunset Blvd.
Los Angeles, CA 90027
Phone: 800-292-6137
A good source for economical photography and graphics materials.

Light Impressions
439 Monroe Avenue
P.O. Box 940
Rochester, NY 14603
Phone: 800-828-6216
Source for archival supplies and photography books.

Calumet
890 Supreme Drive
Bensenville, IL 60106
Phone: 603-860-7447
Internet address: www.calumetphoto.com

B+H Photo
New York, NY
Phone: 800-606-6969
Internet address: www01.bhphotovideo.com

Light Impressions
P.O. Box 22708
Rochester, NY 14692-2708
Phone: 800-828-6216

Butterfly (original in color). *Digital image by Joan Harrison.*

Electronic Imaging Materials and Services

The following are sources for ink-jet printer and other supplies and printing services.

Ink-Jet Printer Supplies

Digital Art Supplies
4901 Morena Blvd.
Suite 1109
San Diego, CA 92117
Phone: 877-534-4278
Internet address: www.digitalartsupplies.com
A major distributor of ink-jet printer supplies.

Printing Services

Image Transform, Ltd.
106A W. Second
Des Moines, IA 50309
Phone: 800-298-6118
Bulletin board/modem: 515/288-8308
A printing service that is ideal for artists. They specialize in IRIS printing.

Photo CD

Advanced Digital Imaging, Inc.
122 East Olive Street
Fort Collins, CO 80534
Phone: 800-888-3686
A specialist in CD-ROM technology.

Barn (original in color). *Digital image by Sandy McGee.*

Software and Documentation

The sections that follow provide sources of photography and digital imaging software, documentation, and other information.

Software

Adobe Systems, Inc.
P.O. Box 7900
Mountain View, CA 94039
Phone: 800-833-6687
Automated technical support: 1-800/235-0078

Adobe Systems is a major source of digital imaging software. This company publishes Photoshop, Illustrator, InDesign, and Premiere.

Book Publishers

The following are among the major publishers of texts on the photographic arts and digital imaging.

ThomsonDelmar Learning
Executive Woods
5 Maxwell Drive
Clifton Park, NY 12065
Phone: 800-998-7498
Internet address: www.delmar.com

Peachpit Press
2414 Sixth Street
Berkeley, CA 94710
Phone: 800-283-9444
Internet address: www.peachpit.com

Prentice-Hall
Against the Clock Performance Support and Training Systems
Upper Saddle River, NJ 07458
Internet address: www.prenhall.com

Periodicals

The following are leading and well-known periodicals on the photographic arts and digital imaging technology.

American Photo
P.O. Box 52616
Boulder, CO 80321

Black and White Magazine
Box 700
Arroyo Grande, CA 93421
Phone: 805-474-6633
Internet address: www.bandwmag.com

Camera and Darkroom
P.O. Box 341
Mt. Morris, IL 61054
Phone: 800-852-4616

Camera Arts Magazine
P.O. Box 2328
Corrales, NM 87048
Phone: 505-899-8054

Contact Sheet Magazine
Light Work
316 Waverly Ave.
Syracuse, NY 13244
Phone: 315-443-1300
Fax: 315-443-9516
Internet address: www.lightwork.org

LensWork Magazine
909 3rd Street
Anacortes, WA 98221-1502
Phone: 360-588-1343
Fax: 503-905-6111
Internet address: www.lenswork.com

The Photo Review Magazine
140 East Richardson Ave.
Suite 301
Langhorne, PA 19047
Internet address: www.photoreview.org

Photovision Magazine
P.O. Box 845
Crestone, CO 81131
Internet address: www.photovisionmagazine.com

Photography Organizations and Libraries

Below are organizations and libraries dedicated to photography and digital imaging.

Organizations

The Center for Photography at Woodstock
Internet address: www.cpw.org

CEPA Gallery
Internet address: cepa.buffnet.net

Digital Imaging Forum
Internet address: www.art.uh.edu/DIF

Digital Photography Exhibitions at Bradley University
Internet address: www.bradley.edu/exhibit

Fotofest
Internet address: www.fotofest.org

George Eastman House
Internet address: www.eastman.org

International Center of Photography
Internet address: www.icp.org

The Light Factory
Internet address: www.lightfactory.org

Light Work
Internet address: www.lightwork.org

Panopticon Inc.
Internet address: www.panopt.com

The Photographic Resource Center of Boston
Internet address: www.software2.bu.edu/prc

Photography in Paris
Internet address: www.speos.fr/defaulteng.html

Society for Photographic Education (National)
Internet address: www.spenational.org

Zone Zero
Internet address: www.zonezero.com

Internet Resource Guides

The following libraries and resource guides are leaders in the area of information on the photographic arts and digital imaging.

James G. Gee Library
Texas A&M University, Commerce
Commerce, Texas 75429
Internet address: multimedia.tamu-commerce.edu/Library/photo.htm

University of New Mexico
Fine Arts Library
Albuquerque, NM 87131
Internet address:
www.unm.edu/~nstephen/photog.html#schools

Photography and Digital Workshops Guide
Internet address: photoworkshops.shawguides.com

Kitchen (original in color). *Digital image by Kelli Connell.*

Basic Photoshop Keyboard Shortcuts

Command/Function	Mac	Windows
Select all	Cmd A	Ctrl A
Deselect an area	Cmd D	Ctrl D
Undo previous command	Cmd Z	Ctrl Z
Enlarge image size on monitor	Cmd +	Ctrl, Alt +
Reduce image size on monitor	Cmd -	Ctrl, Alt -
Create new file	Cmd N	Ctrl N
Open file	Cmd O	Ctrl O
Close file	Cmd W	Ctrl W
Save file	Cmd S	Ctrl S
Print	Cmd P	Ctrl P
Copy	Cmd C	Ctrl C
Paste	Cmd V	Ctrl V
Cut	Cmd X	Ctrl X
Quit	Cmd Q	Ctrl Q

Purgatory. *Student digital image by Jason Gosa.*

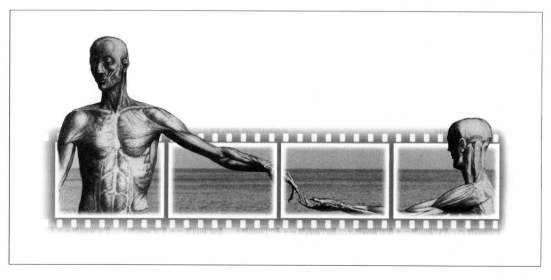

Recommended Reading

There's just so much to keep learning. You think you know something, and you realize you haven't really been looking that close yet.

—Annie Leibovitz (born 1950), commercial advertising and fine art photographer

Synapse (original in color). *Digital image by Shawn Wrobel.*

Bergsland, David, *Publishing with Photoshop*. Clifton Park, NY: Delmar Learning, 2002.

Blatner, David, and Bruce Fraser, *Real World Photoshop 6: Industrial-Strength Production Techniques*. Berkeley, CA: Peachpit Press, 2001.

Bouton, Gary, *Inside Adobe Photoshop 7*. Indianapolis: New Riders, 2002.

Burkholder, Dan, *Making Digital Negatives for Contact Printing*. San Antonio, TX: Bladed Iris Press, 1998.

Caponigro, John Paul, *Adobe Photoshop Master Class: John Paul Caponigro*. Berkeley, CA: Peachpit Press, 2000.

Ciaglia, Joseph, *Introduction to Digital Photography*. Englewood Cliffs, NJ: Prentice-Hall, 2002.

Dayton, Linnea, and Jack Davis, *The Photoshop 6 Wow! Book*. (Berkeley, CA: Peachpit Press, 2001.

Evening, Martin, *Adobe Photoshop 6.0 for Photographers*. Stoneham, MA: Focal Press, 2000.

Farace, Joe, *Digital Imaging: Tips, Tools, and Techniques for Photographers*. Stoneham, MA: Focal Press, 1998.

Haynes, Barry, and Wendy Crumpler, *Photoshop 7 Artistry: Mastering the Digital Image*. Indianapolis: New Riders, 2002.

London, Sherry, and Rhoda Grossman, *Photoshop 7 Magic*. Indianapolis: New Riders, 2002.

McClelland, Deke, and Katrin Eismann, *Real World Digital Photography: Industrial-Strength Techniques*. Berkeley, CA: Peachpit Press, 1999.

Meyer, Pedro, *Truths & Fictions: A Journey from Documentary to Digital Photography*. New York: Aperture, 1995.

Steuer, Sharon, *Creative Thinking in Photoshop*. Indianapolis: New Riders, 2002.

Weinmann, Elaine, and Peter Lourekas, *Photoshop 6 Visual Quickstart Guide*. Berkeley, CA: Peachpit Press, 2001.

Glossary

analog Real-world data that is not digital, as in a continuous-tone photograph.

byte A digital unit of information containing 8 bits of data.

CD-ROM *Compact Disk—Read Only Memory.* Computer storage medium that can be read (and sometimes written to) by a CD-ROM drive.

Four Eyes (original in color). *Digital image by J. Seeley.*

CYMK The four standard process pigments used in the subtractive color space: *cyan, yellow, magenta, and black.* The color mode in which digital files must exist to make color separations for lithographic printing.

digital Binary data that can be interpreted by computer. Opposite of analog.

digital camera Instrument that records images electronically without the use of film.

digital image Any image that has been digitally transmitted onto a computer.

disk drive The computer hardware that stores digital information.

dpi Computers measure image resolution in terms of *dots per inch.* The higher the number, the greater the resolution.

gigabyte Unit of digital information equal to 1,024 megabytes. Hard drive storage capacity is often measured in gigabytes.

hardware Computer equipment, including hard drives, printers, monitors, and memory.

input Process of converting analog data, such as text and images, into a digital form.

JPEG A digital file format, developed by the *Joint Photographic Experts Group,* that compresses image data into a much smaller file size.

kilobyte A basic unit of digital information equal to 1,024 bytes.

megabyte Unit of digital information equal to 1,024 kilobytes. Computer memory (or RAM) is often measured in megabytes.

menu List of available commands in a computer program.

output Process of converting digital information (usually text and images) into analog hard copy.

PC *Personal computer.* Usually denotes one that is "IBM-compatible."

photo CD-ROM A laser disk that contains digital images.

PICT An image file format (short for *picture*) unique to the Macintosh platform.

pigmented ink Archival ink used in some ink-jet printer models.

pixel *Picture element.* The smallest unit of an electronic image.

pixelated On a computer monitor, images without anti-aliasing (softening) of the edges are said to be pixelated. Low-quality printed output from a computer is said to be pixelated if the dots making up the image are easily discernible.

posterization Conversion of a continuous-tone image into one that has large, flat areas of solid colors or tonality.

PostScript A high-end page description language, developed by Adobe Systems, that has become the industry standard for rasterizing (outputting) digital files and separations to PostScript-equipped printers and imagesetters.

RGB *Red, green, blue.* The additive color space used by computer monitors and television tubes to display images.

scanning The process of converting an analog negative or print into a digital image.

software Programs that run on computers, including image processors such as Adobe Photoshop and word processors such as Microsoft Word.

solarization (Sabattier effect) The process of re-exposing a print to light during development, causing a partial reversal of values and often a white outline around the edges of the shapes.

TIFF Tagged Image File Format. A computer format for compressing images used in color separations.

toolbox A common interface component of many software packages. In Adobe Photoshop, the Toolbox contains most of the tool commands used to select and manipulate images.

vignette A soft focus or gradual lightening or darkening at the edges of a print. Often used in portraiture.

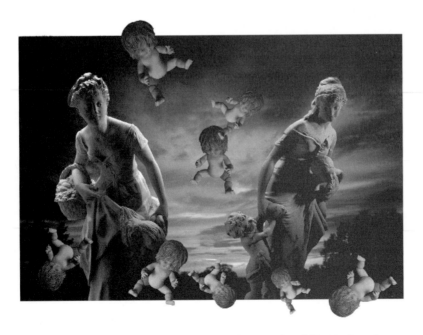

Night Mother (original in color). *Digital image by Philip Krejcarek.*

Index

A

Abel, Susan:
 colors of autumn montage, **176**
Absolut Photoshop, **187**, 187-188
abstract design:
 with gradient tool, 65-66, **65-66**
 with pen tool, 67, **67**
Actions palette, 122
Add Noise filter, **245**, 245
adjusting an image, 75-83, **76-82**
adjustment layer, 120
Amato, Libby:
 elimination, **182**
 photograph converted into cartoon, **185**
 tabloid cover, **183**
 type in boxes, **165**
anchor point, 102
angled strokes filter, 243, **243**
Arbus, Diane, 211-212
areas of similar values/colors, 44, **44**, **87**, 87-88
arrowheads, 105
artificial light, **155**, 155-156
assignments for creativity, 134
 Absolut Photoshop, **187**, 187-188
 artificial light, **155**, 155-156
 asymmetrical balance, **137**, 137-138
 blurred motion, 150-151, **151**
 campus of the future, 188-190, **189**
 cartooning, 184-186, **184-186**
 colors of autumn/spring, 175-177, **176-177**
 documentary/performance photography, 160-162, **161-162**
 gamous photographer, **157**, 157-158
 genealogy, 170-172, **171-172**
 Gulliver's Travels, **163**, 163-165, **164**
 light as the subject, **139**, 139-140
 long depth of field, 144-145, **145**
 macro, larger than life, 159, **159**
 mixed media, 190-191
 painting with light, **141**, 141-142
 panning, **152**, 152-153
 photogram, **178-180**, 178-181
 pop art portrait, **167**, 167-170, **169**
 portrait, 146-147, **147**
 self-portrait, 148-150, **149**
 short depth of field, **143**, 143-144
 stop action, 153-154, **154**
 tabloid, 181-183, **181-183**
 toning, hand-coloring, and gradients, 173-174
 two people in a relationship, **135**, 135-136
 words and iimages, 165-167, **166**
Assorted Brushes palette, 255, **255**
asymmetrical balance, **137**, 137-138, 206-208, **207**
"Attitude" poster, 264-265, **265**
Avery, Mark, **215**, **218**
 stop action, **154**

B

balance, 199, **199-200**

Barney, Meg:
 shape, **195**

Beutin, Keith:
 Absolut advertisement, **187**

bitmap, 117, **117**

bits, 6

blending modes, 248-249, **249**

blurred motion, 150-151, **151**

Blur tool, 98-99

books on digital imaging, 290

Boyd, Brooks:
 Midsummer's Night Dream, **VIII**

bracket, 140

Brightness/Contrast, 77, **77**

Brush commands, 253-255

Burkholder, Dan, 258

Burning In, 38

Burn tool, 99

Busch, Emily:
 Let Me Out, **Colorplate 10**

C

cameras, digital, 14-19

campus of the future, 188-190, **189**

Canvas Size, **110**, 110-111

careers, 224
 commercial arts, 224
 commercial illustration, layout, design, 229
 commercial photography, 226-228, **226-228**
 fine art photography, 229-230, **230**
 photojournalism, 230-231, **231**
 prepress, 229

Cartier-Bresson, Henri, 210-211

cartoon character, 283, **283**

cartooning, 184-186, **184-186**

cartoon landscape, 280-281, **281**

CD-ROM, 24

Channel palette, **121**, 121-122

Charcoal filter, 243, **243**

Clone Stamp tool, **95**, 95-96

cloning, 58-59, **58-59**

Clouds filter, **242**, 246

CMYK, 117

color adjustment, **80-82**, 80-83

color balance, 80, **80**

coloring, 54-55

colorize, 115

color palette, 122

Color Range, 90

colors of autumn/spring, 175-177, **176-177**

commands, **109-111**, 109-116, **113-114**, **116**

commercial arts, 224

commercial illustration, layout, design, 229

commercial photography, 226-228, **226-228**

composition, 192, **193**

compressed file, 126

compressing an image, 50, **50**

computer, 10

cone with shadow, **277**, 277-278

Connell, Kelli:
 Kitchen, **288**

consent, 217

constrained aspect ratio, 85

contact sheets, 62, **62**

contrast adjustment, 34-35, **34-35**

conventional photograph, 6
 converting to electronic image, 8-9

copying and pasting, **45-46**, 45-46, 112-113

copyright, 218
 notice, 219
 as ownership, 219

copyright-free images, 223

Corel Stock Photo Library, 223

correcting mistakes, 123-124

craftsmanship, 206

Crawford, Tad, 218, 221

creativity, 232. *See also* Assignments for creativity;
 Exercises for creativity

 tools of, 232, 234-235

cropping an image, 36-37, **36-37**

Cropping tool, **93**, 93-94

cube with shadow, **278**, 278-279

curves, **78**, 78-79, 256, **256**

D

decisive moment, 210-211

default, 28

Define Brush, **254**, 254-255

Define Pattern, **114**, 114-115

Desaturate, 115

design elements, 192, 194-197

design principles, 198-206

Despeckle filter, 246

dialog boxes, 28, 109

Difference Clouds filter, 246, **246**

digital cameras, 14-17

 advantages over film cameras, 17

 basics of, 17-19

 disadvantages over film cameras, 17

digital capture screens, 16

digital darkroom, 26

digital imaging, 6

 advantages of, 6

 converting conventional photo into electronic
 image, 8-9

 getting started with, guidelines, 11-13

 hardware for, 10-11

 printing electronic images, 9

digital negatives, 258

digital panorama, 257

digitizing images:

 digital cameras, 14-19

 digitizing film, 19

 digitizing prints: flatbed scanning, 20-22

 digitizing resources and alternatives, 23-24

digitizing prints, 20-22

displacement maps, 244, **245**

documentary/performance photography, 160-162,
 161-162

Dodge tool, 99

Dodging Out, 38, **39**

dominance, 200, **201**

Dorf, Deana:
 original and repaired photograph, **181**

double exposure, 53, **53**

Dover Press, 223

dpi, 9

drop shadow, 262

duplicating an image, 30

Dust and Scratches filter, 246

E

economy, **205**, 205

edges, selecting automatically, 87

electronic image:

 advantages over conventional photograph, 6

 converting conventional photo into, 8-9

 creating, 32-33, **33**

 getting started with, guidelines, 11-13

 printing, 9

electronic printing, **128-131**, 128-133

elements of design, 192, 194-197

Elliptical Marquee, 40-41, **41**, 84-85, **85**

Emboss filter, 248, **248**

Eraser tool, 97, **97**

ethical considerations:

consent, 217

fair use, 222

who and what to photograph, 216

exercises for creativity, 260

"Attitude" Poster, 264-265, **265**

Cartoon Character, 283, **283**

Cartoon Landscape, 280-281, **281**

Cone with Shadow, **277**, 277-278

Cube with Shadow, **278**, 278-279

Faded Arrows, **274**, 274-275

"Halo" Around a Shape, 272, **272**

Mirrored Image, 269, **269**

Patterns, 270-271, **270-271**

Perspective Room Cartoon, 282, **282**

Perspective Type, 262-263, **263**

Photomontage, 260-262, **261**

Sphere with Shadow, **275**, 275-276

Television Screen with Glow, 273, **273**

Textures, 272, **272**

Translucent Type over an Image, 268, **268**

"Wish You Were Here" Postcard, **266**, 266-267

exercises for getting started, 26

Abstract Design

with Gradient Tool, 65-66, **65-66**

with Pen Tool, 67, **67**

Adjusting Contrast, **34**, 34-35, **35**

Coloring, 54-55

Compressing and Expanding, 50, **50**

Contact Sheets, 62, **62**

Copying and Pasting, 45-46, **45-46**

Creating an Electronic Image, 32-33, **33**

Creating High-Contrast Effect, 51, **51**

Creating Layers, 60, **60**

Creating Short Depth of Field, 72, **72**

Creating Type, 47, **47**

Creating Uneven Edges, 71, **71**

Cropping an Image, 36-37, **36-37**

Dodging Out and Burning In, 38, **39**

Double Exposure and Sandwiched Negatives, 53, **53**

Duplicating an Image, 30

Fading an Image, 73, **73**

Guides, 61, **61**

Launching Photoshop, 28-29

Opening an Image, 29-30

Paint Bucket Tool and Paste Into Command, **63**, 63-64

Photoshop Interface, 26-28, **27**

Removing Color, 55

Resetting Tools, 29

Retouching and Cloning, 58-59, **58-59**

Rotating and Flipping, 48-49, **48-49**

Saving an Image, 30-31

Selecting Area by Color, 44, **44**

Selecting Freeform Shape using Lasso Tool, **42**, 42-43

Selecting Rectangular/Elliptical Area, 40-41, **40-41**

Solarization, 52, **52**

Special Effects Filters, 68-69, **69**

Toning, 54

Using Brush Tool, 56-57, **56-57**

Vignetting, 70, **70**

expanding an Image, 50, **50**

Eyedropper tool, 105

F

faded arrows, **274**, 274-275

fading an image, 73, **73**

fair use, 220

ethical considerations, 222

legal considerations, 221-222

famous photographer, **157**, 157-158

file formats, 125-126

file management, 125-127

fill, 113, **113**

film:

digitizing, 19

scanning, 22

filters, 240-248, **240-248**

fine art photography, 229-230, **230**

fixed size, 85

flatbed scanning, 20-22

Flipping an Image, 48-49, **48-49**

Foreground/Background Color Picker, **106-107**, 107-108

Free-Form Area Selection, **42**, 42-43, 86, **86**

G

Gaussian Blur filter, 244, **244**

genealogy, 170-172, **171-172**

getting started. *See* Exercises for getting started

glossary, 291-292

Goodan, Patricia:

Journey, **129**

Persephone, **18**

Gosa, Jason:

Bad Day, Number 1, **XI**

Bad Day, Number 3, **XII**

Purgatory, **289**

gradients, 173-174

Gradient tool, **65-66**, 65-66, **97**, 97-98, 107

grayscale, 117

guides, 61, **61**

Gulliver's Travels, **163**, 163-165, **164**

Guthrie, Gerald:

Best of Both Worlds, **Colorplate 14**

In a Different Light, **234**

Fear of the Unknown, **15**

Strength in Numbers, **12**

The Last Step, **XV**

Unknown Quantity, **200**

H

"Halo" Around a Shape, 272, **272**

hand-coloring, 173-174

Hand tool, 105-106

hardware, 10-11

harmony, 200, **201**

Harrison, Joan:

Butterfly, **285**

Cycladic Venus, **XVIII**

high-contrast effect, 51, **51**

History Brush tool, 96, 124

History palette, 122-124

Horizontal Type Selection, 88-89

Hue/Saturation, 81, **81**

I

Image: *See also* Electronic image

adjusting, 75-83, **76-82**

compressing and expanding, 50, **50**

cropping, 36-37, **36-37**

duplicating, 30

fading, 73, **73**

opening, 29-30, 74, **75**

printing, 132-133

rotating and flipping, 48-49, **48-49**

saving, 30-31, **83**, 83-84

solarizing, 52, **52**

storing, 127

ImageReady, 258-259

Image Size, **109**, 109-110

Indexed Color, 117

ink-jet print, 129-130

ink-jet printer, 9

input, 8

internet, 24

intuitive approach, 211

Invert, 116, **116**

J

Jenkins, Joshua:
 Jackson $20 bill, **180**
JPEG, 126

K

keyboard shortcuts, 108-109, 289
Kodak Photo CD, 24
Kost, Julianne:
 Untitled, **8**, **10-11**
Krejcarek, Philip:
 Are Our Children Watching Too Much Television?, **162**
 artificial light, **155**
 economy, **205**
 Getting into the Gug, **128**
 Goddess of the Lettuce, **13**
 Jesus and Georgia, **VI**
 Lettuce Dance, **21**
 Lettuce Mask, **237**
 Levitation, **130**
 movement, **204**
 Night Mother, **292**
 rule of thirds, **207**
 These Sets are Guaranteed, **3**
 two people in a relationship, **135**
Kruger, Barbara, 165

L

LaRoche, Elizabeth:
 macro, **159**
Lasee, Sarah:
 painting with light, **141**
laser print, 129
laser printer, 9
Lasso tool, **42**, 42-43, 86
Last, Lane:
 Chain of Life, **XIV**
 Fall of Man, **Colorplate 16**
 Particle Veil, **Colorplate 15**
launching Photoshop, 28-29

Layer menu, 250-251
Layers, 28
 adjustment, 120
 creating, **60**, 60, 119
 managing, 119-120
 mask, 120-121
Layers palette, **118**, 118-121
Layer Styles, 250, **250**
legal considerations:
 consent, 217
 fair use, 221-222
 who and what to photograph, 214
A Legal Guide for the Visual Artist (Crawford), 218
Lemke, William:
 Black Trees, **197**
 electronic imagery used for window advertisement, **225**, **228**
 Milwaukee Art Museum, **V**
 Sinai Desert, Egypt, **236**
 Variety, **202**
Lens Flare filter, 247, **247**
Levels, **76**, 76-77
light as the subject, **139**, 139-140
lighting, 146-147, 156
Lighting Effects filter, 247, **247**
light-jet printer, 9
Line tool, 104-105, **105**
Liquify, 252, **252**
lithographic print, 130-131
long depth of field, 144-145, **145**
Lopez, Martina, 170
lossless compression, 126
lossy compression, 126

M

Macro, Larger than Life, 159, **159**
Magic Wand, 44, **44**, **87**, 87-88
Magnetic Lasso, 87

Making Digital Negatives for Contact Printing
(Burkholder), 258

McGee, Sandy:
 Abbie, **147**
 Barn, **286**
 Portrait of Abbey (Hand Coloring), **Colorplate 11**
 Portrait of Abbey (Toning), **Colorplate 12**
 space, **203**
 Sunrise, **302**

Menus, 26, **108**, 108. *See also* Commands

Metcalf, Katie:
 multiple pop art portraits, **169**

Meyer, William:
 documentation, **161**
 harmony, **201**
 Milwaukee Journal Sentinel photographs, **195,
 231, 238**
 panning, **152**
 Portable Vietnam Memorial, **216**
 proportion, **205**

mirrored image, 269, **269**

mistakes, correcting, 123-124

mixed media, 190-191

Modes, 117, **117**

Mosaic filter, 246, **246**

Motion filter, 244

movement, 204, **204**

Move tool, 93

O

O'Farrell, Richard:
 Cartoon series, **186**
 Lady Pepper, **Colorplate 8**
 Penny Pepper, **Colorplate 8**
 Peter Pepper, **Colorplate 8**
 Sgt. Pepper, **Colorplate 8**

opening an image, 29-30

Options bar, 27

P

Paintbrush tool, **56-57**, 56-57, **94**, 94

Paint Bucket tool, **63**, 63-64, 98

painting with light, **141**, 141-142

Palette Knife filter, 243, **243**

palettes, 27, 118
 Channel, **121**, 121-122
 Layers, **118**, 118-121
 other palettes, 122

panning, **152**, 152-153

Paste Into, 64

pasting. *See* Copying and pasting

path:
 converting into a selection, 103
 editing, 103
 filling, 103

Paths palette, 90, 122

Pattern Maker, 253

patterns, 270-271, **270-271**

Pattern Stamp tool, 96, **96**

Pencil tool, 95, **95**

Pen tool, **67**, 67, 90, **102**, 102

Perez, Angel:
 campus of the future, **189**

perspective room cartoon, 282, **282**

perspective type, 262-263, **263**

philosophy of photography, 235-238

photogram, **178-180**, 178-181

photojournalism, 230-231, **231**

photomontage, 260-262, **261**

Photoshop:
 adjusting image in, 75-83, **76-82**
 interface, 26-28, **27**
 opening image in, 74, **75**

pixels, 14

Plastic Wrap filter, **240**

Polygon Lasso, 86, **86**

pop art portrait, **167**, 167-170, **169**

portrait, 146-147, **147**

Posterize, 116, **116**

prepress, 229

principles of design, 198-206

printer, 11

prints, digitizing, 20-22

proportion, 204, **205**

Puetzer, Steve:
 Butterfly, **Colorplate 13**
 CD Head, **14**
 Dominance, **201**
 Lighthouse, **139**
 Man in a Box, **239**
 Money Tornado, **Colorplate 17**

push processing, 140

Q

Quick Mask Mode, 89

R

Radial Blur filter, 244, **244**

RAM, 10

raster data, 101

Rathkamp, Kaitlin:
 Cindy Sherman emulation, **157**

Rectangular Marquee, **40**, 40-41, 84-85, **85**

removing color, 55

resetting tools, 29

resources:
 electronic imaging materials and services, 286
 photography organizations and libraries, 288
 software and documentation, 287
 traditional/digital photographic materials, 284-285

Reticulation filter, **241**

retouching, 58-59, **58-59**

Revert, 124

RGB, 117

Rotate Canvas, 111, **111**

Rotating an Image, 48-49, **48-49**

rule of thirds, 206-208, **207**

Russ, Guy:
 short depth of field, **143**

S

sandwiched negatives, 53, **53**

Save, 83, 125

Save As, 83, 125

saving an image, 30-31, **83**, 83-84

scanner, 8, 10

scanning service bureaus, 23

Schultz, Nancy:
 asymmetrical balance, **137**

Schuster, Jessica:
 large figures in a small world, **164**
 small figures in a large world, **163**
 Spirit, **177**

Schweitzer, Heidi:
 blurred motion, **151**
 self-portrait, **149**

Screen Mode tools, 108

Seeley, J,:
 Eyebird Z, **196**
 Four Eyes, **291**
 Paintbox, **Colorplate 3**
 Quince and Friends, **131**
 Red Wing, **Colorplate 4**
 Relics of the Order, **23**
 Summerset, **Colorplate 2**

Select All, 89

selection, 28

selection tools, 84-92, **85-87**, **92**

self-portrait, 148-150, **149**

Sezemsky, John:
 pop art portrait, **167**
 silhouette, **172**
shape tools, 104, **104**
Sharpen tool, 98-99
sharpness adjustment, 79, **79**
short depth of field, 72, **72**, **143**, 143-144
Single Column Marquee, 88
Single Row Marquee, 88
Slice tool, 259
Smudge tool, 99, **99**
solarization, 52, **52**
space, 203, **203**
special effects:
 blending modes, 248-249, **249**
 Brush commands, 253-255, **254-255**
 Curves command, 256, **256**
 digital negatives, 258
 digital panorama, 257
 filters, 68-69, **69**, **240-248**, 240-248
 layer styles, **250**, 250-251, **251**
 Liquify command, 252, **252**
 Pattern Maker command, 253
 Web tools, 258-259
sphere with shadow, **275**, 275-276
Stained Glass filter, 248, **248**
Steelman, Caitlin:
 Student Image, **IX, 25**
Step Backwards, 123
Stevens, Jane Alden, **220**
 Menin Gate, **284**
Stollenwerk, Jason:
 Form, **195**
 Line, **194**
stop action, 153-154, **154**
storage, 10, 127
straight-edged area, 86, **86**

stroke, 114, **114**
Strosin, Tara:
 Genealogy, **171**
Styles palette, 251, **251**
Swatches palette, 122

T

tabloid, 181-183, **181-183**
Taylor, Maggie:
 Late, **Colorplate 1**
 Southern Gothic, **7**
television screen with glow, 273, **273**
text:
 editing, 100-101
 moving, 100
 rasterizing, 101-102
 special effects, 101, **101**
textures, 272, **272**
Thompson, Karen:
 Baptismal Font, **230**
 Fearless, **Colorplate 7**
 Goodbye Halloween, **Colorplate 6**
 Indiana Vultures, **Colorplate 5**
 Izzy Clouds, **19**
 Izzy with Horns, **233**
 Storm over Baraboo, **7**
Threshold, 116, **116**
Tibbets, Nicole:
 food, **179**
TIFF, 126
toning, 54, 173-174
toolbox, 26, **84**, 84
traditional photographic print, 128
transform, **111**, 111-112
translucent type over an image, 268, **268**
Twirl filter, **245**, 245
two people in a relationship, **135**, 135-136
Type tool, **47**, 47, 88, **99-100**, 99-100

U

Uelsmann, Jerry N., **5**, 192, **193**
 symmetrical balance, **199**
 Threshold, **XVI**
uncompressed file, 126
Undo, 123
Uneven edges, **71**, 71, 262
Unsharp Mask, 79, **79**

V

value adjustment, 75-79, **76-78**
Variations, 81-82, **82**
variety, 202, **202**
vector data, 102
vertical type selection, 88-89
vignetting, 70, **70**

W

Warhol, Andy, 222
Web tools, 258-259
Weston, Edward, 208-209
wet darkroom, 26
Wild, Stacy:
 hand holding an object, **178**
"Wish You Were Here" postcard, **266**, 266-267
Witten, Walter:
 cartoon character in photograph, **184**
words and images, 165-167, **166**
Wrobel, Shawn:
 Self portrait, **Colorplate 9**
 Synapse, **290**
 Toward Puerta del Sol, **145**

Z

Zoom tool, 106

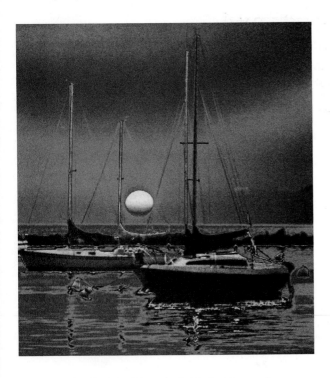

Sunrise (original in color). *Digital image by Sandy McGee.*